CW00952012

Wildlife Photography Workshops

Wildlife Photography Workshops

Ann and Steve Toon

GUILD OF MASTER CRAFTSMAN PUBLICATIONS

First published 2003 by
Guild of Master Craftsman Publications Ltd,
166 High Street, Lewes,
East Sussex, BN7 1XU

ISBN 1 86108 360 2

A catalogue record of this book is available from the British Library.

Publisher: Paul Richardson
Art Director: Ian Smith
Managing Editor: Gerrie Purcell
Commissioning Editor: April McCroskie
Editor: Dominique Page
Designer: Chris Halls, Mind's Eye Design Ltd, Lewes
Production Manager: Stuart Poole
Typeface: Franklin Gothic

Colour origination by Viscan Graphics Pte Ltd (Singapore)

Printed and bound by Kyodo Printing (Singapore)

DEDICATION

To Val and Keith Toon and Jack and Cynthia Warburton
for all their love, support and encouragement

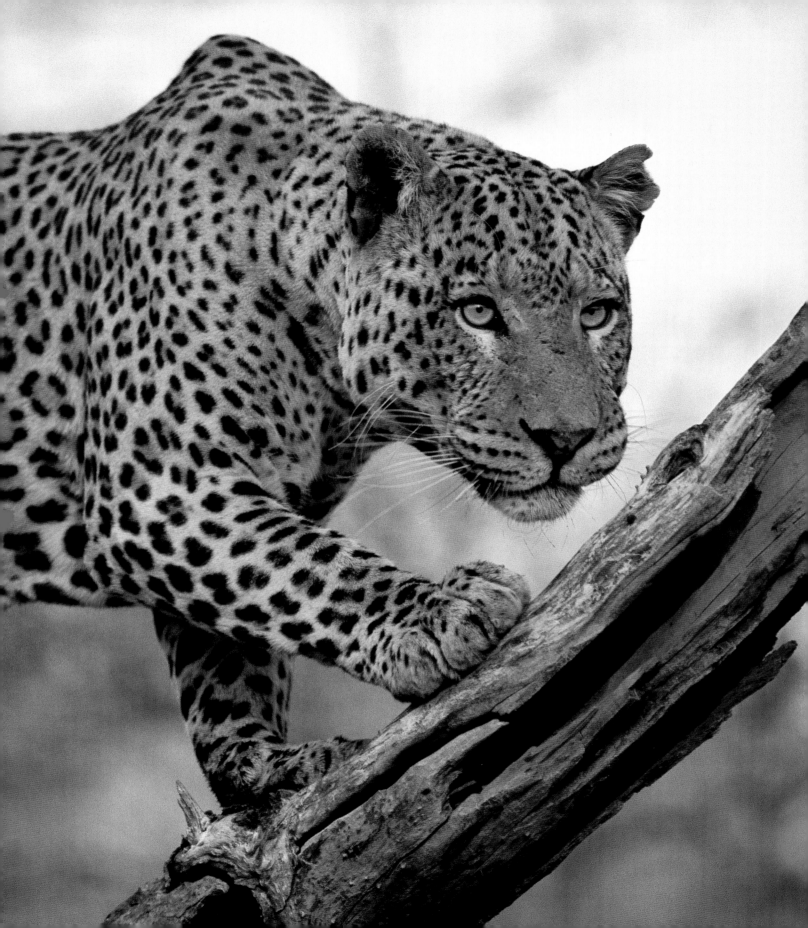

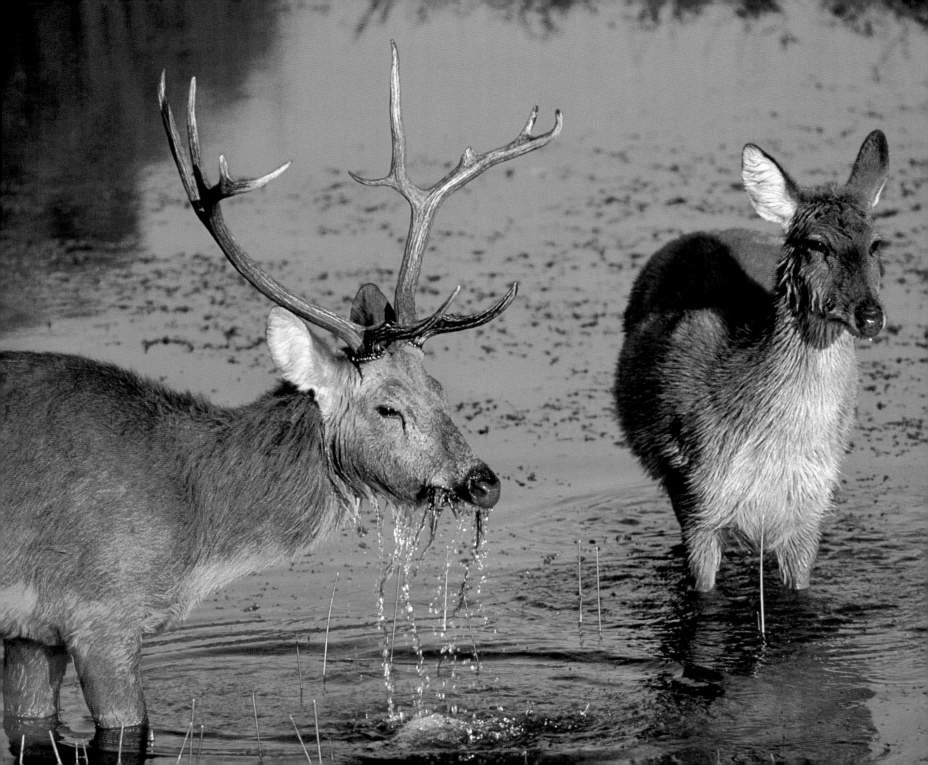

Introduction

This book is different. We're not making huge claims for it when we say this, because we don't really want you to spend too much time poring over it. In our experience, taking photographs is shedloads more fun than turning pages.

It's our belief that the best way to become a better wildlife photographer is by spending time in the field exploring your own response to the natural world with your camera, rather than searching for magic formulae on the printed page.

Finding out how to fix your mistakes *in situ*, achieve the effects you're looking for, and developing a creative awareness as you go along, is far more constructive and enjoyable than slogging through photographic manuals, getting exasperated about exposure, or strung out about shutter speeds in the belief you won't be able to expose a single frame satisfactorily until you can recite f-stop progressions like your times tables.

If you're anything like us, the reason you enjoy wildlife photography is because you love observing nature and spending time in the great outdoors. It isn't easy to hone our skills as wildlife photographers if we are removed from the raw materials that serve as our inspiration. The fastest way to make progress is to get out there and burn some film.

In our own work, we've found a project-based approach, learning 'on the job' about the techniques and creative process of wildlife photography, to be the most useful and rewarding.

Swamp deer feeding

It pays to exploit good photographic opportunities when you find them and not worry too much about what may or may not be happening round the next corner. In India's Kanha National Park our guide was keen to look for tigers, but we insisted on suspending the search to photograph these barasingha or swamp deer, a rare hard-ground subspecies unique to the park, feeding in beautiful light.

Canon EOS-1N with 300mm IS lens, Fuji Velvia 50 ISO, 1/200 of a second at f/6.3

Cheetah

The piercing amber eyes of this cheetah in the Kalahari held us spellbound for hours as we photographed it on a fresh ostrich kill one winter's morning. Adrenaline-fuelled encounters like this don't happen every day in wildlife photography, but they make the frustration of days when not much happens all the more worthwhile.

Canon EOS-1N with 400mm lens, Fuji Velvia 50 ISO, 1/250 of a second at f/5.6

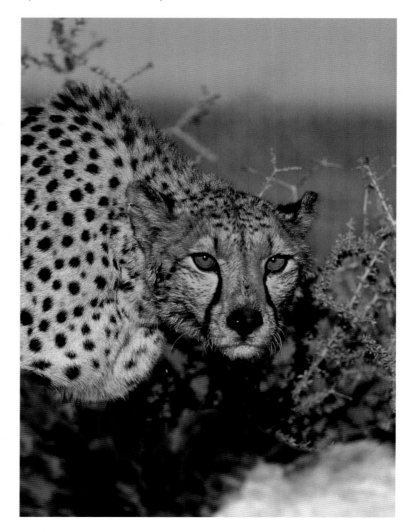

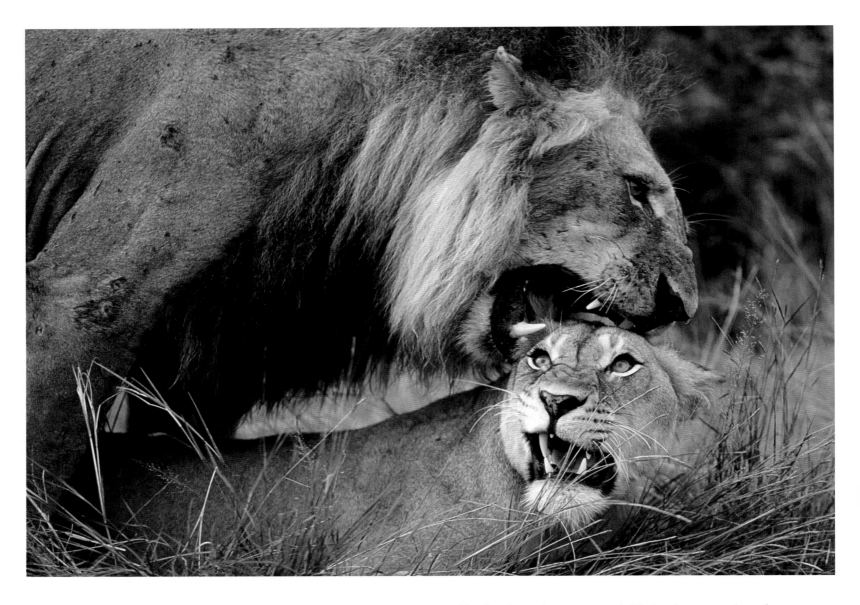

Mating lions

Capturing animal behaviour is challenging, but the more time you spend observing your subjects the better your end results will be. We've learned, for example, that when you find a male and female lion on their own together, courtship behaviour is on the cards. They are likely to stay in the same area for a couple of days, mating at regular intervals and providing plenty of photo opportunities.

Canon EOS-1N with 300mm lens, Fuji Sensia 100 ISO, 1/320 of a second at f/8

That's why we've structured this book as a series of photographic workshops based heavily on fieldwork.

Along with practical tips, ideas about what to shoot, and some handy warnings about possible pitfalls to watch out for, our aim in this workshop-style approach is simply to expand your understanding of the ways in which you can make key photographic techniques work for you, giving you creative control to produce the pictures you want.

In our experience, it's often simple mistakes that let down pictures – lack of sharpness or poor exposure, for example.

For this reason, we have included one or two early assignments that focus on improving these basic techniques. Most of the fieldwork exercises, however, are designed to encourage creative development, visual awareness, lateral thinking and, perhaps most importantly, help open you up to new ideas and fresh approaches in your wildlife photography.

This book is aimed at serious amateurs as well as beginners. You don't need to work through the chapters and assignments slavishly in consecutive fashion to get something out of it. What we had in mind was something a bit more 'pick and mix' that you could dip in and out of, skipping bits if you wanted and coming back to things as you felt the need.

Nor do you need a huge array of fancy lenses to carry out the assignments. There are always going to be new bits of equipment you will aspire to own, but, remember, these are simply the tools of the trade – it's you who makes the image.

Although a number of the photographs in the book are taken in Africa – a part of the world we have come to regard as a second home – the creative techniques and approaches apply as much to photographing wildlife subjects in our own back garden as they do to working in the bush. You can enjoy the fieldwork assignments wherever you live and whatever you choose to photograph.

None of the images in this book have been manipulated on a computer. The only image manipulation carried out in the field is the occasional use of filters, reflectors, or fill-in flash (details of which are discussed in the relevant chapters). All the subjects photographed are wild unless marked with a (C) in the caption to indicate when a shot was taken in captive or controlled conditions. Whatever the pros and cons of photographing captive animals we feel it's important to be honest about such pictures.

This assignment-based approach to discovering wildlife photography and your personal creative responses to the natural world is intended to be both helpful and fun. We hope the workshops and exercises provide you with a rich supply of inspiration and ideas for setting your own future assignments and projects, and will come to your aid on those days you simply can't decide what it is out there you want to photograph.

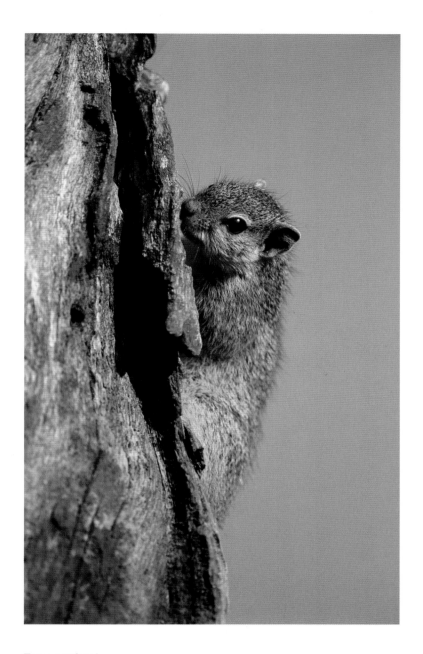

Tree squirrel
Patience is your best resource as a wildlife photographer. This appealing squirrel felt safer retreating behind the tree when he spotted a camera lens pointing at him, but after a while curiosity got the better of him, he peeped out to check on us, and we got our shot.
Canon EOS-1N with 500mm IS lens plus 1.4x converter, Fuji Velvia 50 ISO, 1/200 of a second at f/6.3

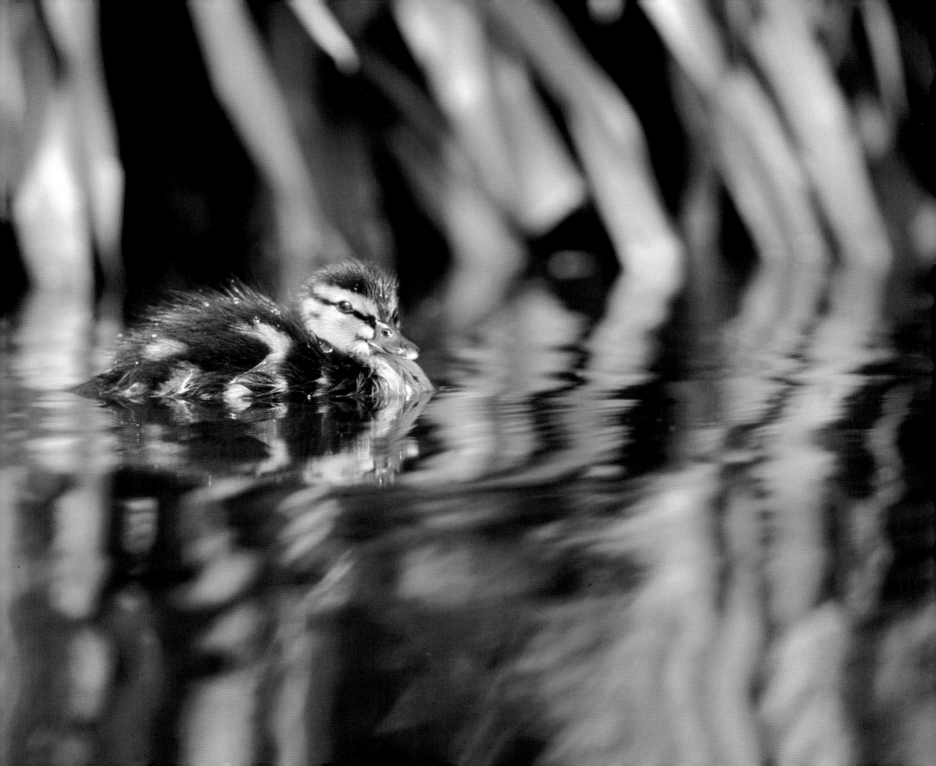

Equipment Essentials

Getting started

When we started out, we managed with a minimum of equipment, preferring to invest our limited resources in time spent on location. A new 600mm f/4 lens would have been nice, but set against visits to the game parks of southern Africa there was no contest. We made the best use of what we had, used fieldcraft and persistence to make up for gaps in our armoury, and came away with plenty of good quality images.

Equipment is expensive, and generally you get what you pay for, so it makes sense to prioritize your purchases based on your own special interests. Start by making the very best use of equipment you own, and add extra lenses and accessories only when you need them.

Buy the best lenses you can afford, however, as superior optical quality really is reflected in better quality photographs. Shop around, checking out the Internet as well as high street and specialist outlets. Consider buying secondhand, as it will allow you to buy higher specification equipment than you could afford new. Use established dealers, though, and make sure used equipment comes with a guarantee of at least three months.

Which camera system?

It is possible to get a great wildlife shot with a cheap point and shoot camera. But if you plan to specialize in wildlife photography, you will need a camera system that will give you full creative control over the picture-taking process and is adaptable for photographing a broad range of subjects.

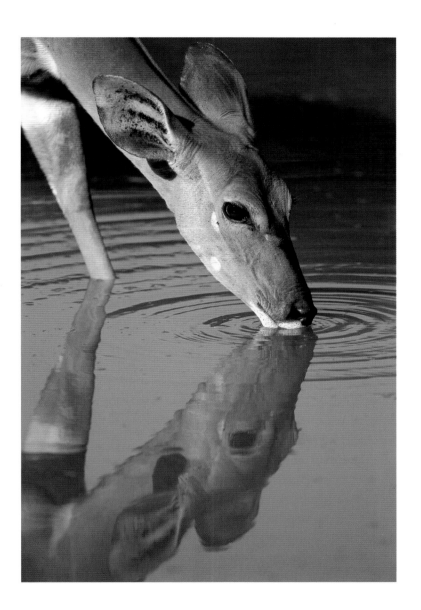

Mallard duckling
Don't overlook the wildlife close to home. Commonplace animals can still produce interesting images and don't always demand you use a huge range of expensive equipment.
Canon EOS-1N with 70–200mm lens, Fuji Sensia 100 ISO, 1/320 of a second at f/8

Nyala drinking
You get what you pay for with lenses. High quality optics will help you produce pin-sharp images, with minimal edge distortion and good contrast.
Canon EOS-1N with 400mm lens, Fuji Velvia 50 ISO, 1/160 of a second at f/8

The 35mm SLR camera is the system of choice for the overwhelming majority of professional and serious amateur wildlife photographers. It's compact, portable, simple to operate in the field, and lens changing and film loading is relatively easy. These cameras are equipped with lots of useful features, the range of lenses and accessories is huge, and film is quite cheap and easy to obtain. Because the 35mm system is so popular, mass production keeps prices reasonable compared with larger formats, and even bottom-end models can be capable of producing great images.

If you are setting up from scratch, you need to look for a brand with a wide range of lenses and accessories, so that you can add the bits you need as your interests develop. Canon and Nikon are the two most popular brands among wildlife photographers and both offer excellent systems. We use Canon.

Camera bodies

Before you rush out to buy the most expensive camera body you can afford, bear in mind the sophistication of your camera body is less important than the quality of your lens optics. Professional models offer better build quality, which is important if you plan to give your camera lots of use in tough conditions, but many of the extra functions may be of only occasional value. If your budget is tight, settle for a cheaper body and spend more on lenses. There are certain camera functions we recommend you look for:

Operating modes: SLRs invariably offer a range of modes, of which aperture priority and shutter speed priority are essential. Some of the fully programmed modes, such as 'sport', can be handy. More important is the ability to override automatic modes and set both aperture and shutter speed manually.

Exposure memory button: This allows you to take a meter reading from anything in or out of your frame, save the reading, then recompose on your subject.

Controls: Can you adjust important controls easily without taking your eye from the viewfinder?

Focus: Is there a choice of focus points to which you can link autofocus? This isn't essential, but can be a great help. Can dynamic autofocusing, where the camera locks onto a moving subject and keeps it in focus, be set up to shift

automatically between focus points as the subject's position in the frame changes? This is useful if you plan to do a lot of action shots.

Electronic cable release facility: A great aid to taking sharp pictures at slow shutter speeds.

Mirror lock-up: Another useful function that reduces in-camera vibrations when shooting at slow shutter speeds.

Depth of field preview button: A valuable tool for checking depth of field, the zone of sharpness from front to back in your picture, at different aperture settings before you take the picture. This is all too often missing from modern cameras.

Noise: Check how noisy the camera is during film wind-on and rewind. Is the autofocus-indicator beep loud, and can it be turned off?

Film or digital?

The image quality achievable with digital cameras is coming on in leaps and bounds, to the extent that the latest professional digital cameras now compete with traditional film on virtually equal terms, albeit at considerable cost. Current digital SLRs allow you to use the full range of lenses available to film cameras, and will save you money on film and processing in the long term. Cheaper digital SLRs do not offer such good image quality as film, but if your intended use is for relatively small prints, or publication on web pages, this may not be so crucial. Speed of operation can be an issue with cheaper digital cameras, so bear this in mind if you want to photograph action and behaviour. The chapters in this book deal with creative approaches to wildlife photography that are equally relevant to film or digital users. Decide what's best for you.

Lenses

It's not obligatory to use long telephoto lenses for wildlife photography. If your interest is in photographing fungi, flowers or insects you could manage very well with nothing bigger than 200mm. Generally, though, there's no getting away from the fact that you will be seriously restricted in the subjects you can tackle without longer lenses. What you buy depends on your personal interests and budget. We can only talk about the lenses we are experienced in using, at the same time pointing

you in the direction of some of the alternative options you may also like to consider.

Portability, keeping the weight and bulk of our equipment down, is a big priority for us, as we do a lot of our photography

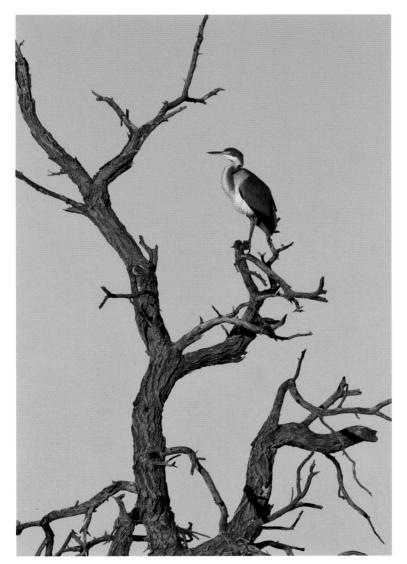

Blackheaded heron in dead tree

It's often tempting to use your longest lens and go for maximum subject size, but often a shorter lens can produce a more graphic image.

Canon EOS-1N with 70–200mm lens, Fuji Provia 100 ISO, 1/320 of a second at f/8

overseas. We need to work with a pared down lens selection we can easily carry. We cover the short end of the focal range with zoom lenses: an 18–35mm f/3.5–f/4 wide-angle, a 28–80mm f/2.8 short zoom and a 70–200mm f/2.8 medium zoom. They provide good coverage for working with animals in close proximity and for wider environmental shots.

Individually, zooms can be heavier and larger, but overall provide a weight and space saving compared with a range of fixed lenses. They do have drawbacks: to keep size and weight down, many are designed with fairly small maximum apertures, reducing maximum shutter speeds and making it difficult to freeze action or avoid camera shake in low light. For a wide-angle zoom of, say, 18–35mm, a maximum aperture of f/4 is perfectly adequate for most wildlife purposes, but for mid-range zooms it's worth investing in a 'faster' lens with a maximum aperture of f/2.8.

Zoom lenses produce slightly inferior image quality compared to similar-priced fixed lenses, but the quality gap has narrowed significantly as lens technology has advanced. Top-of-the-range zooms incorporate very high-quality glass (apochromatic, fluorite, low-dispersion, etc) which maximizes image sharpness and contrast.

For focal lengths longer than 200mm we prefer to use fixed lenses. At these longer lengths the quality gap between zoom and fixed lens becomes more apparent and the maximum aperture issue more important. A fast shutter speed is often essential to avoid camera shake with long lenses, and a maximum aperture of f/5.6 or f/6.3, as offered by many long zooms, just isn't enough for our needs. The extra speed offered by an f/4 fixed lens may not seem a lot, but frequently makes the difference between a sharp image and a soft one.

It's possible to go even faster than f/4, but speed costs. A 300mm f/2.8 Canon lens costs three times as much as a 300mm f/4 lens, and weighs over twice as much. The f/4 lens is much easier to work with, lighter to carry and more manoeuvrable in the cramped confines of a hide or vehicle. For us, this more than compensates for the smaller maximum aperture. In fact, the 300mm f/4 lens is one of our most heavily used pieces of kit, providing excellent optical quality, while being compact enough to handhold.

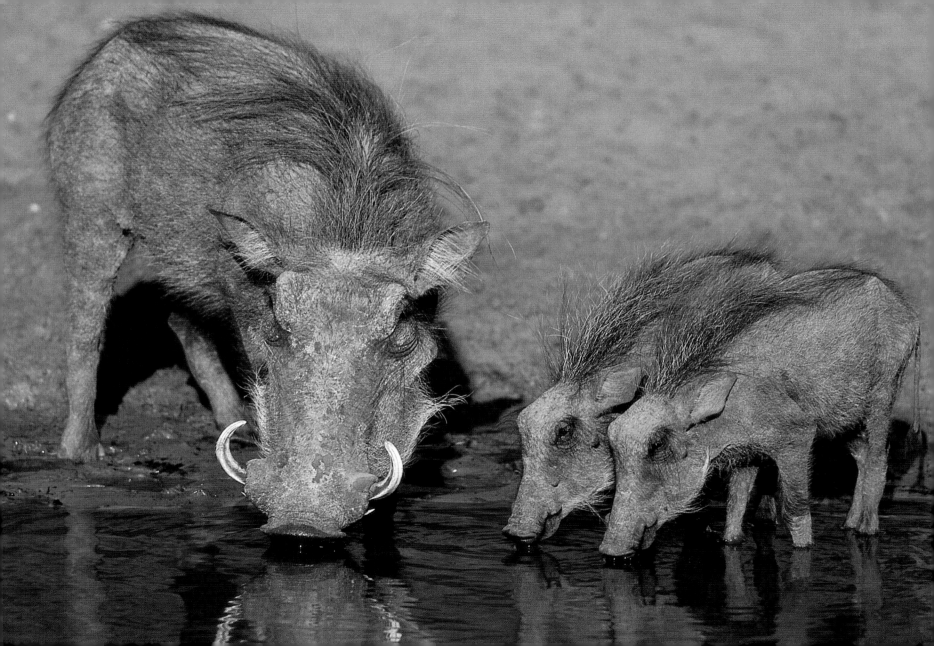

Handholding has now become more feasible on many Canon and Nikon lenses with the advent of image stabilizing (IS) technology from Canon and vibration reduction (VR) from Nikon. These lenses damp small movements and are a real boon if you can afford them, allowing you freedom to move about more and greater scope in low light.

If you are serious about photographing a range of mammal and bird subjects, you will need to invest in lenses over the 300mm mark. Professional-quality fixed lenses with large maximum apertures can produce superb results, but are large and heavy, demanding excellent technique. Canon's 600mm f/4 lens weighs in at a whopping 5.3kg (11½ lbs) and is 45cm (17½in) long, even without the enormous lens hood. We prefer the slightly more manageable 500mm f/4 – a mere 3.9kg (8½lbs) and 38cm (15in) long. Apart from size, weight and general lack of manoeuvrability, these lenses are very expensive – costing the equivalent of a small car.

A more affordable option is one of the new breed of superzooms. Lenses such as Canon's 100–400mm f/4.5/f/5.6 or Sigma's 170–500mm f/5.6/f/6.3 offer long focal lengths combined with the flexibility of a zoom, at affordable prices. The trade-off is less speed and reduced image quality – the wider the focal range of a zoom the greater the optical distortion. Providing you are aware of the limitations and practise good technique when photographing, these lenses are capable of producing good results.

An inexpensive way of extending the reach of medium-length fixed lenses is to use teleconverters. Converters are simple optics which fit between lens and camera body. A 1.4x

converter will turn a 300mm lens into a 420mm, while a 2x converter makes it up to a 600mm. However, a 1.4x converter halves the amount of light reaching the film, while a 2x converter reduces it by 75 per cent. This means lower maximum shutter speeds and increased risk of camera shake.

Converters also reduce image quality and prevent autofocus working on some lenses. We find a 1.4x converter gives acceptable results and is very useful, but we avoid using a 2x converter due to the greater loss of image quality. If you can put up with this, a 2x converter is an inexpensive way of getting bags more focal length. We'd recommend choosing camera manufacturers' own makes, and using them only with good quality lenses.

If you anticipate doing a lot of close-up photography you may also want to invest in a macro lens. Macro lenses are optically designed to give excellent results at close range, and focus much closer than conventional lenses. They have very small minimum lens apertures to give enough depth of field when working at close range. Macro lenses of 50 to 60mm are the easiest to handle but have to be used very close to the subject, so a lens in the range of 90 to 200mm is a better option for general fieldwork, as you are less likely to disturb insects or block your own light working at close range.

The cheapest option for close-up photography is to attach simple supplementary lenses (or 'close-up lenses') to the front of your normal lens. They come in a range of strengths, with +1, +2 and +3 dioptres most useful. You can stack them, but attach the strongest first, and don't exceed a total of +4 dioptres, or image degradation becomes excessive. Supplementary lenses are designed for use on 50mm lenses. As a cheap option, you pay the price in image quality, especially around the edges of the frame, so position your subject centrally.

Extension tubes and bellows

Extension tubes will allow you to focus more closely and magnify your subject, using a conventional lens. Extension tubes are simply hollow tubes that are mounted between lens and camera body, and allow you to meter normally. They usually come in sets of three of around 8mm, 12mm and 25mm.

Warthog family drinking
Working from a permanent hide built out over this waterhole it was possible to get a frame-filling shot with no more than a 300mm lens. Good locations and fieldcraft can compensate for a limited armoury of long telephotos.
Canon EOS-1N with 300mm lens, Fuji Velvia 50 ISO, 1/80 of a second at f/11

A 25mm tube on a 70–200mm zoom makes a good general-purpose macro combination. On longer telephoto lenses extension tubes don't make much difference to the minimum focusing distance, but we've occasionally used them when photographing small birds and mammals at close range. Bellows units have a similar purpose, but are flexible, moving along a rail to give a continuous range of magnification. However, bellows are mainly suited for studio work, rather than fieldwork.

Filters

Used sparingly, filters can be valuable additions to your toolkit. Polarizing filters, warm-up filters and graduated neutral-density filters all come in useful at times for wildlife work. Buy the best quality you can afford in order to reduce image degradation.

Lens hoods

Many amateur photographers don't bother with lens hoods. Professionals do. They physically protect your lens from dust, water and scratches, and reduce lens flare caused by direct sunlight falling on the front element. Using lens hoods is one of the simplest, cheapest and quickest ways to improve the quality of your photographs.

Flash

Modern automatic flashguns have removed the fear factor from flash, making it a very simple tool to use. Nonetheless, we try to avoid using flash unless absolutely necessary, as we prefer the effects of natural light. A moderately powered automatic flashgun offering through the lens (TTL) flash metering is useful for fill-in lighting, back-lit subjects, adding detail to shadows and to help with exposure in contrasty light. An off-camera flash bracket is essential to avoid red-eye – the unnatural colour in eyes often produced by light bouncing straight back from the retinas when you use flash mounted on the camera's hot-shoe. Other useful flash accessories include a diffuser, which snaps onto the flash head to soften the artificial light, and, if you expect to use flash a lot, a teleflash adaptor, which focuses the flash into a tighter more powerful beam, increasing its range.

Tripods and supports

A good quality, sturdy tripod is essential if you are serious about improving your photography – it can make a huge difference to image sharpness, especially when using long lenses. Don't waste money on cheap, flimsy tripods that won't give the necessary support and might cause expensive accidents if they fall over. The bigger and heavier a tripod is, the better it will function. Balance this against the fact that you are also going to need to carry it with you in the field. Carbon fibre tripods are a lighter alternative to traditional metals, but cost more. Decide how much you need the weight saving. Look for a tripod that has strong locking mechanisms, is easy to erect, and can be used down near ground level. Extending central columns merely add an extra element of instability, so it's better to use a tripod without a central column, but which is tall enough to let you look through the lens when you are standing. Generally, using a tripod at minimum leg extension gives you the most stable platform. Tripods come with maximum load specifications, so make sure you buy one which will support your heaviest lens/camera combination. Gitzo and Manfrotto are two reliable makes.

You also need a good-quality tripod head. We use a ball head because it's quick to operate, but they can tilt under the weight of large lenses, so make sure you use one that is strong enough. Some photographers prefer pan and tilt heads. A video fluid head can also work well for heavier lenses. For really large telephotos, the specialist gimbal heads produced by Wimberley make panning on moving subjects simple. Our advice is to try out a few types to see what suits you.

Cape francolin

Big telephoto lenses can produce excellent-quality images, but only with good technique to ensure a rock-steady support. Here, two home-made beanbags filled with a few kilos of dried rice were just as important in producing a sharp image as the expensive 500mm f/4 lens.
Canon EOS-1N with 500mm IS lens, Fuji Velvia 50 ISO, 1/125 of a second at f/8

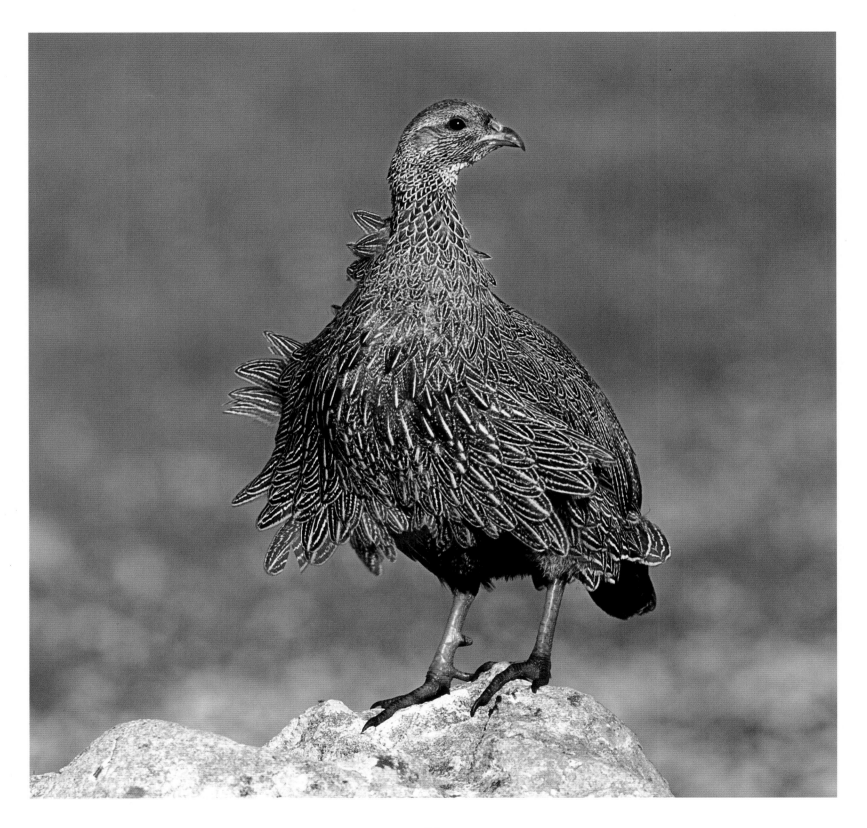

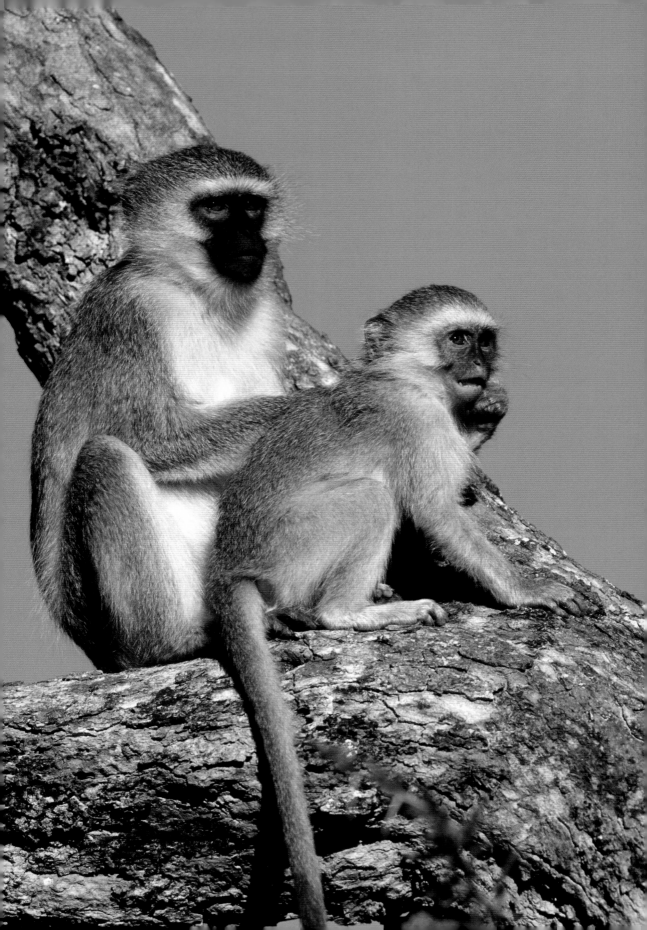

We use a Gitzo 1340 tripod for maximum stability, but also get a lot of use out of a lightweight Benbo Trekker, a cleverly designed, versatile tripod which gets into awkward places and is great for macro work and photographing at low levels with relatively lightweight equipment.

Monopods don't give anything like the stability of a good tripod, but are useful for stalking animals and birds, when carrying a tripod isn't practical. Look for a well-engineered, stout model.

The humble beanbag is another of our most heavily used pieces of kit. It's essential for supporting lenses low on the ground and when working from vehicles and hides. For overseas trips we carry them empty and fill them with rice at our destination – dried beans also work well. It takes 2kg (4½lb) of rice to 80 per cent fill a beanbag measuring 30cm (12in) by 20cm (8in) so that it will mould to the shape of a camera and lens. Used carefully, a couple of beanbags will give you a rock-steady platform, and we've not yet found custom-designed window mounts or brackets to compare.

PRO TIPS

▶ To clean the inside of your camera, remove the lens, set the camera to the slowest available shutter speed (usually 15 seconds or more) on manual, press the shutter release, then open the back. You can now see right through the body and check for dust. Blow gently to remove dust, and definitely do not use canned air, which can damage sensitive shutter blades.

▶ When shopping for lenses, look for those with internal focus mechanisms, which are much easier to use on a beanbag than those with moving external parts.

▶ Look for telephoto lenses with a rotating tripod collar, allowing you to switch quickly between portrait and landscape formats when using a tripod.

BEWARE!

▶ Many SLRs only show about 90–95 per cent of the final image when you look through the viewfinder. Bear this in mind when framing. Some top-of-the-range models show 100 per cent.

▶ Teleconverters magnify imperfections in lenses. Be wary of using them with zoom lenses, as image quality may prove unacceptable. Avoid 3x converters.

▶ If you are tempted to buy a mirror lens (catadioptric lens) of, say, 500mm, as an inexpensive way to get a large focal length, think carefully. Mirror lenses are cheap and compact, using a system of mirrors to reflect light internally, but they have a very small fixed aperture (usually f/8 or f/11), which makes them useless in low light, they give poor image quality, and produce distracting out-of-focus 'doughnut' highlights.

Vervet monkeys
In wildlife reserves visited by large numbers of tourists, animals can become quite tolerant of people. Nothing longer than a 300mm lens was needed to photograph these monkeys in South Africa's Kruger National Park.
Canon EOS-1N with 300mm IS lens, Fuji Sensia 100 ISO, 1/20 of a second at f/11

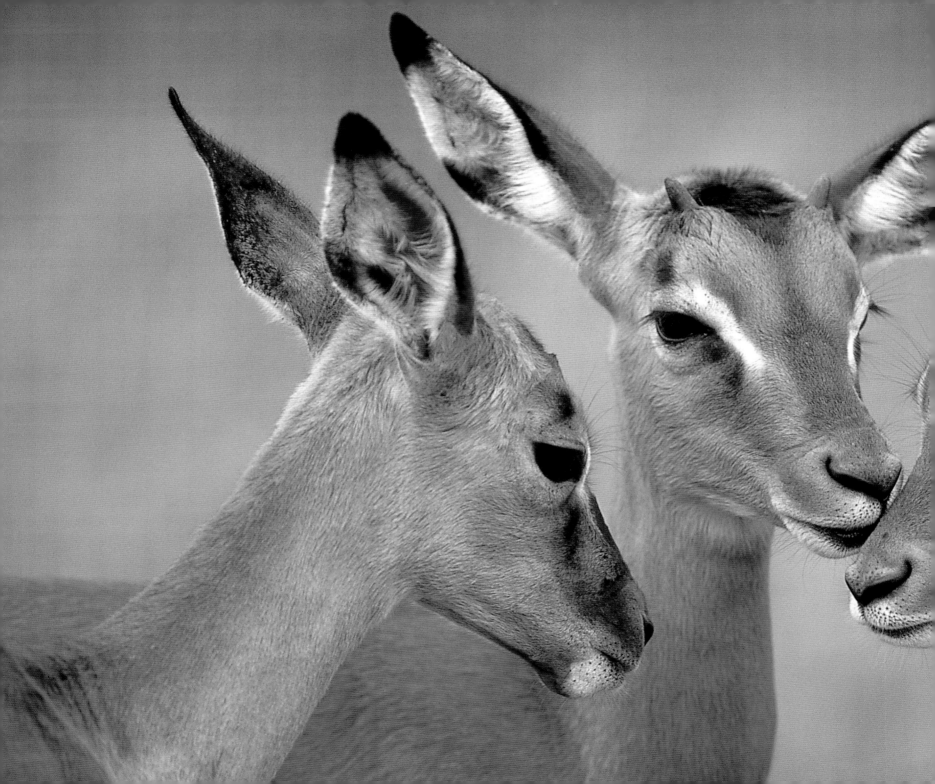

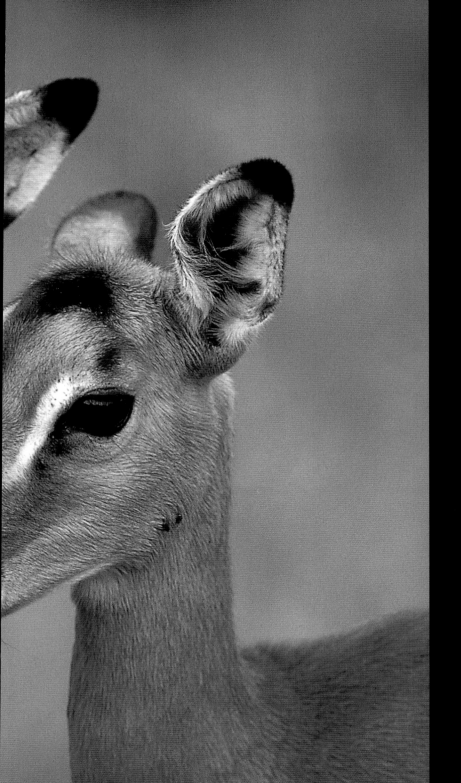

Workshops

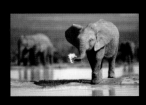
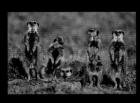
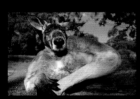
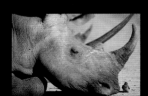

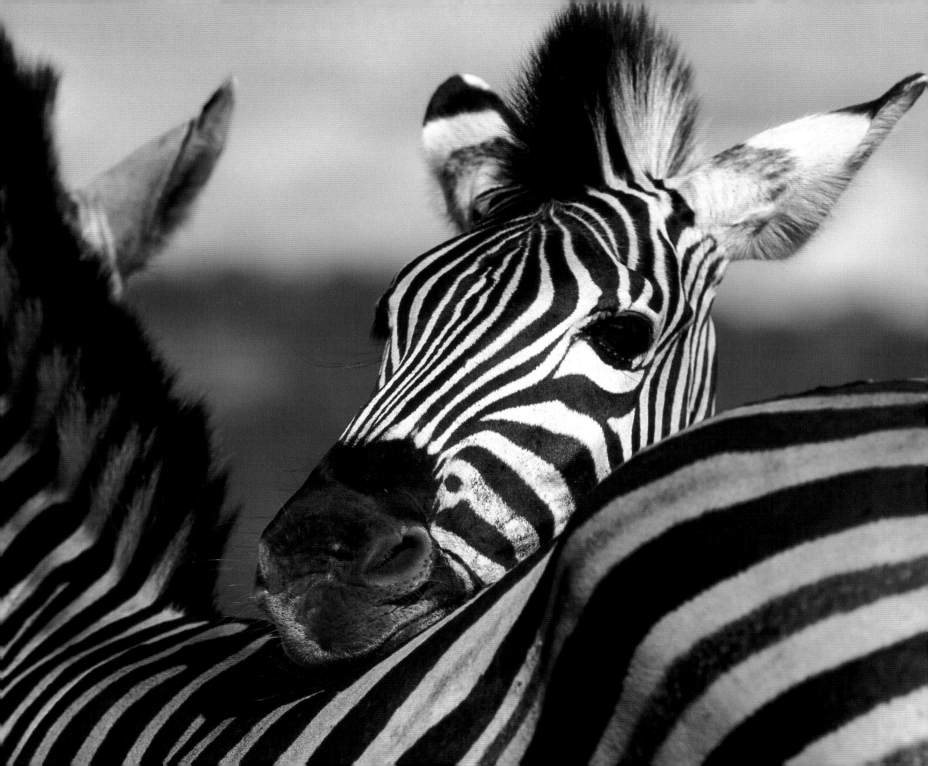

The Basics

Exposure is a confusing subject. Every complicated exposure 'rule' seems to come with innumerable exceptions; so it is hardly surprising many photographers take the easy way out and leave the decision-making to their camera. But that can be a big mistake. Modern cameras, with their sophisticated metering systems, will deliver you a well-exposed image 90 per cent of the time, but the 10 per cent they let you down often represent the most interesting opportunities. Learning to take control of exposure is the surest way to improve your wildlife photography by leaps and bounds.

The key to unlocking the mystery of exposure lies in learning to 'read' the tonality of a scene, so you can produce exactly the effect you want on film. In photographic terms, tone does not refer to colour, but to degrees of brightness. Every scene contains a range of tones, and the aim of making a good exposure is to record these in the way you want without losing important detail in the palest and darkest areas.

Burchell's zebra resting

You might imagine zebra would be a nightmare for exposure calculations, but experience has taught us that the average of off-white and rich brown stripes happily produces the equivalent of a mid-tone. Taking a meter reading from the stripy flank of the animal seems to work perfectly. The mistake with a zebra would be to use spot metering, when the suggested exposure setting could fluctuate by three stops or more, depending on whether you aim the spot at a light or dark stripe.
Canon EOS-1N with 300mm lens, Fuji Velvia 50 ISO, 1/160 of a second at f/8

Aperture size and shutter speed

Your camera controls how light or dark your photograph turns out by modifying the light intensity hitting the film (by changing the aperture size), and by modifying how long the aperture lets in this light (by changing shutter speed). Aperture size is measured in f stops – an aperture of f/2.8 is a large aperture, which will give you very little depth of field in your image and isolate your subject from the background, whereas an aperture of f/16 is small, giving a lot more depth of field. Each step in the sequence f/2, f/2.8, f/4, f/5.6, f/8, f/11, f/16, f/22 represents a halving of the aperture size.

If you think of exposure as the aperture size multiplied by the shutter speed, it becomes clear that various combinations of aperture and shutter speed can produce the same exposure. You will get the same exposure value at f/16 and 1/100 of a second, as you will at f/11 and 1/200 of a second, f/8 and 1/400 of a second, and so on. Choosing the right combination depends on you; for example, do you want lots of depth of field to show an animal in its environment, or lots of speed to freeze its movement?

The meter in your camera measures the light bouncing off your subject and suggests a combination of aperture and shutter speed which will deliver enough light to give the correct exposure for the subject. You can vary the aperture if you want, so long as you adjust the shutter speed accordingly.

So far, so good. But your camera makes one essential assumption, that the subject it is metering is mid-toned. If your subject is actually paler or darker than mid-tone, the camera, in trying to turn it into a mid-tone, will let in the wrong amount of light – underexposing pale subjects, or overexposing dark subjects.

Exposure compensation

There are a number of ways you can correct this. One is to dial in exposure compensation, increasing exposure (overexposing) for light subjects or decreasing it for dark (underexposing). Unfortunately, there are no simple recipes for how much exposure compensation is required for different subjects. It depends on factors such as how much lighter or darker your subject is than mid-tone, how much of the frame it fills, and the direction and quality of light. A frame-filling white swan photographed in bright midday sunshine might need two or more stops of positive exposure compensation, but the same subject in overcast light might only need +1/2 stop.

Mute swan

A simple shot but a tricky exposure. Relying on the camera's meter for this white swan would probably have led to underexposure, as the camera tried to turn it into a muddy mid-tone. In this case a meter reading was taken from some green reeds just beyond the frame but in similar light. This reading was then tweaked, with a slight underexposure of 1/3 stop, to retain detail in the white feathers. Try to avoid photographing swans in very bright light.

Canon EOS-1N with 400mm lens, Fuji Sensia 100 ISO, 1/320 of a second at f/8

Sloth bear (C)

In contrast to the swan, the camera's meter would have overexposed this subject, washing out the rich dark colours of the sloth bear's fur. With no reliable mid-tone to meter from, a reading was taken from the animal's fur, then negative exposure compensation was dialled in, to 'under-expose' against the meter reading. The shot was bracketed with underexposure of -2/3, and -1 stop. It was the -1 stop shot which produced the most accurate result.

Canon EOS-1N with 300mm IS lens and 1.4X converter, Fuji Sensia 100 ISO, 1/250 of a second at f/8

Judging exposure compensation becomes easier with experience, but until you feel confident about it, it may prove more reliable to take an exposure reading off a mid-toned area, within or without the frame, when you are faced with light- or dark-toned subjects. You can then lock this reading into the camera, if you have this facility, or you can dial in the values manually before refocusing on your subject. Blue sky or green grass are typically mid-tone, and, provided they are in the same light as your subject, should give you a reasonably accurate reading.

If you are photographing in bright sunshine and your subject is front-lit, you could use another approach that doesn't even require you to take a meter reading. This is known as the

Little pied cormorants

This scene contained a wide range of tones, with the added complication of water, which is always difficult to meter reliably. The solution was to take a spot meter reading from the nearest bird's pale belly, then overexpose by +2/3 stops to allow for it being lighter than mid-tone. Bracketed shots at +1/3 and +1 stop were also taken, but +2/3 stops proved the best exposure. As it happened, this was exactly the same as the exposure suggested by the camera using evaluative metering!

Canon EOS-1N with 400mm lens, Fuji Velvia 50 ISO, 1/125 of a second at f/8

Blacksmith plover in a puddle

We always try to avoid metering off water, as its reflectivity and tone can vary so much that it often misleads the meter. Here, anything other than a spot meter reading on the bird would have included too much water in the metered area to be reliable. However, a spot meter reading would also have been difficult, as the bird was a mixture of extreme tones. Instead, a reading was taken from green grass in the background and locked in with the exposure lock button.

Canon EOS-1N with 300mm lens, Fuji Velvia 50 ISO, 1/320 of a second at f/5.6

sunny-f/16 rule, which states that the correct shutter speed at an aperture of f/16 is equal to the inverse of the ISO of your film. For example, at f/16 with ISO 100 film you would need a speed of 1/100 of a second, with ISO 200 film 1/200 of a second, and so on. Of course, you don't have to set your aperture to f/16. You can choose any aperture you like, but you have to adjust the shutter speed accordingly to maintain the same exposure. These guidelines work fine in practice, once you grasp the idea, but can only really cover you in fairly conventional lighting conditions.

Modern cameras help you in offering a choice of metering modes. These usually include a honeycomb or matrix mode that meters from a large area of the frame, a partial metering mode weighted towards the central area, and a fine spot metering mode which takes a reading from an area of perhaps 2.5 per cent of the frame. Consult your manual and familiarize yourself with your camera's metering options, because it is important which you use. Programmed matrix modes do not simply average out readings from a large part of the frame, but attempt to evaluate the scene and compensate for complicating factors such as pale, dark or back-lit subjects. Known as evaluative metering, this is one reason why modern cameras have such a high success rate of accurate exposures. This can confuse matters, though, if you wish to manually dial in exposure compensation for a difficult subject, as you don't know how much compensation the camera meter has already introduced. In this case, select a simple spot meter mode to take a baseline reading from your subject and then dial in the amount of compensation you judge necessary.

Bracketing

If you don't have much confidence in your exposure calculations, or believe you have a winning shot, it's also worth bracketing. This simply means taking a series of shots at varying exposure values above and below what you or your meter believes is the best one. Most cameras allow you to bracket in half-stops, while some give you the option of 1/3 stop intervals. As little as 1/3 stop can make a big difference with slide film, but print film is more forgiving when it comes to exposure, and 1/3 stop will barely register – use a full stop above and below instead.

If this seems a lot to consider in the heat of battle, practise thinking through exposure adjustments in more relaxed photographic situations, and you will soon speed up and start applying the same thought processes to fast-changing wildlife opportunities. Try to take control of the exposure process when taking photographs so you know when to go with the camera's meter and when to overrule it. Make decisions about the way you'd like to record the scene only once you've assessed the range of tones in the scene before you. Analyze your results carefully and learn from your successes and failures. This is easiest if you have the self-discipline to make notes of what you are doing at the time of picture-taking and are prepared to use film, making several exposures for tricky situations.

As you gain experience, you can shrug off the straightjacket notion that there is a single 'correct exposure' and get more creative. Mechanistic approaches to exposure are designed to deliver images with tones rendered faithfully and with acceptable detail in highlights and shadows. But exposure is also an opportunity for self expression. With deliberate overexposure you could accentuate the pale, ghostly plumage of swans on a mist-covered wetland. With underexposure you could intensify the brooding intelligence in a portrait of a chimpanzee. If you can view exposure control as your creative ally you will find it much easier to get to grips with. Finally, remember exposure often boils down to educated guesswork, and you will learn fastest from your own successes and failures.

Fighting gemsbok
Bear in mind there isn't always one 'correct' exposure, particularly when photographing back-lit subjects. A range of exposures would have produced different moods in this image. We didn't want the gemsbok to reproduce as true silhouettes, as we wanted a softer effect, complementing the back-lit dust. But nor did we want too much subject detail to detract from the graphic quality of their shapes. Various exposures were tried, but it was a simple meter reading from the foreground grass which worked best.
Canon EOS-1N with 400mm lens, Fuji Sensia 100, 1/640 of a second at f/5.6

PRO TIPS

▶ If in doubt about the correct exposure value, remember underexposed images are often salvageable, but overexposed images are usually only fit for the bin. Err on the side of a darker image. This will also help retain detail in highlights, which, given the choice, is usually more important than retaining shadow detail.

▶ The following little phrase 'add light to white and dark to black' might come in handy if you are struggling to remember the guiding principles about overexposing for pale-toned subjects and underexposing for dark-toned subjects when you start out.

▶ If you take a reading from a nearby mid-tone subject, but your actual subject is white or very pale, underexpose slightly on the mid-tone reading to stop highlights burning out. Conversely, with a very dark subject, overexpose a touch on the mid-tone reading to bring out detail in shadows.

▶ If your frame includes a wide range of tones, decide which element it is most important for you to expose correctly. Overexposing for a white swan is correct if the swan is your main subject, but if your photograph is of a dark lake and the swan is an incidental detail, then expose for the landscape.

▶ For close range subjects it is possible to lower the exposure range of a contrasty scene by using fill-in flash or reflectors to throw light into shadowy areas.

▶ If you cannot lighten the shadows, you can reduce highlights which would otherwise burn out by using a polarizing filter to remove reflections from water or vegetation, or a graduated neutral-density filter to darken a bright white sky.

BEWARE!

► If you dial in exposure compensation, don't forget to reset to zero when you have finished, or you will incorrectly expose subsequent photographs.

► Spot metering is a useful option if you wish to take a reading from a small mid-toned part of your subject. If your subject is a mix of dark, light and mid-tones, do be careful you aim the spot accurately at the mid-tone, as a fine spot will not average out tonal variations.

► Don't assume that because a photograph doesn't look right you have necessarily made a mistake with exposure. In scenes with high contrast, particularly in bright light, the film may simply be unable to cope with the wide range of tones.

► Exposure compensation will affect colour as well as tone. Overexposing tends to wash out colours, while underexposing saturates them. Woodland and fresh grass can benefit from underexposure, but pastel hues of delicate flowers may look better with slight overexposure.

ASSIGNMENT

Once you get to grips with the principles of exposure it is possible to use the effects creatively in your wildlife photographs. In this assignment the objective is to explore how exposure can be controlled, at times, rather like using a dimmer switch, to intensify mood in a picture. The idea behind the exercise is to have a go at taking a 'high key' picture – so-called because light or pale tones predominate, with minimal dark tones, perhaps confined to a subject's eyes, or small areas of shadow. Ideal subjects for this sort of approach might be white swans on pale grey water lit with soft frontal lighting, or an estuarine wader roost. Look for landscapes full of light tones, snowscapes, pale sand-dunes or scenes with large amounts of pale sky, which all lend themselves to high key treatment. Morning mist might be good, or the delicate pale tones of

a large expanse of tidal mudflats. When you have found a promising subject, take an exposure reading using your camera's meter; then take a series of photographs dialling in progressively more 'overexposure'. Ideally overexpose in increments of 1/3 stop, or 1/2 stop if that's all your camera allows. Keep notes of the amounts of exposure compensation for each frame. When you get the results back you may be surprised just how much exposure compensation was needed to produce the best high key effects. Choose the results you like best and consider how much detail is lost by overexposing highlights or lightening shadows. Is this a price worth paying for the mood you have created? If you enjoyed the exercise, try the same experiment with a low key scene, in which most of the tones are dark.

SEE ALSO:

Film, 30–37 Light Direction, 59–64 Quality of Light, 65–69 Filters and Fill-in Flash, 70–75 Weather, 76–81

There's no escaping the fact that to be successful at wildlife photography you need to be able to take a sharp photograph. While this might seem fairly obvious, many keen photographers struggle to produce pin-sharp pictures consistently. Of course, sharpness is not a requirement in all wildlife images – used creatively, blur can produce powerful, impressionistic effects – but there's a huge difference between a deliberately un-sharp picture and one that is down to poor technique. Chances are, if you take a hard, unforgiving look at your own work, you will find one or two that fall into this last category.

It happens to all of us. There are plenty of times it just isn't possible to get a truly sharp image. But there really is no great mystery if you want to see a dramatic improvement in your sharp-shooting success rate. It's simply a matter of taking a little more care, and honing your technique to get the best from your equipment.

You can usually identify where the problems lie by taking a closer look at your pictures. The three main causes of un-sharp images to look out for are camera shake, subject movement and incorrect focusing.

Leopard

A fleeting encounter on a dull, overcast morning produced this subtle image, with soft tones and understated colours. In the low light it was necessary to shoot with the 500mm lens wide open at f/4, and even that only gave a shutter speed of 1/60 of a second. Bracing solidly on a couple of beanbags rested on the vehicle's window frame was the key to acceptable sharpness.

Canon EOS-1N with 500mm IS lens on beanbags in vehicle, Fuji Sensia 100 ISO, 1/60 of a second at f/4

Camera shake

In a photograph affected by camera shake nothing will be entirely sharp. Camera shake usually occurs when you are handholding, or using inadequate support for your camera/lens combination, particularly at slow shutter speeds. It tends to be worse with long lenses, which are inherently more unstable and magnify any small movements.

As a rough rule of thumb, you can handhold your camera and still get a sharp image provided you use a shutter speed at least equal to the reciprocal of the lens's focal length – so you need at least 1/60 of a second for a 50mm lens, 1/300 of a second for a 300mm lens, and so on. But this only applies when focusing at or near infinity. For closer subjects you will need more speed.

Unfortunately, it is not always possible to shoot at high speeds, light conditions may be low or you may have been forced to select a small aperture to give sufficient depth of field. Indeed, even when there is plenty of light you won't find many professionals handholding if they can avoid it. It is much better to make sure your camera is well supported.

We discussed the importance of tripods in the equipment chapter (see pages 10 and 13), but it's worth reiterating that they provide an essential camera support in many situations. You need as sturdy a tripod as you can afford, but one that is comfortable to carry around in the field.

Some photographers say you can't take sharp pictures without a tripod. While this may be true for the landscape or medium-format specialist, you should bear in mind that in wildlife photography a tripod is not always the best option, and that sometimes, when shooting from a vehicle for example, a tripod may be completely impractical.

There are a host of other gadgets available to support your camera, from monopods to window clamps and custom-built brackets. What you use depends largely on where you are working and what works best for you. We find a couple of strong beanbags hard to beat. They make excellent platforms when shooting from a car window, can be placed on rocks, walls, tree stumps, fence posts or the ground, and are very quick and easy to use. The drawbacks are that you won't find a convenient place to put the bag every time, plus it's hard to pan with a moving animal when your camera is resting on a

Wildcat (C)

A similar composition to the leopard picture (see page 23), but this time taken in bright winter sunshine. Using a 300mm lens with image stabilizing meant a shutter speed of 1/160 of a second was more than ample to ensure a sharp image, even handholding the camera. Handholding meant it was possible to follow the wildcat as it prowled around its large, naturalistic enclosure – using a tripod would have meant missed opportunities.

Canon EOS-1N with 300mm IS lens, handheld, Fuji Velvia 50 ISO, 1/160 of a second at f/8

beanbag. In these situations a tripod head on a bracket or tripod is the better option.

The other essential item if you want pin-sharp pictures is an electronic cable release. You can achieve sharp photographs using even the largest lens at speeds down to 1/30 of a second, if you use a cable release rather than pressing the shutter release manually, providing you use a strong tripod or beanbags in addition of course. At slower speeds use mirror lock-up as well, if your camera has this option, to stop any vibration introduced by the mirror flipping up. Mirror slap is worst between 1/15 of a second and 1/4 of a second, but with very long telephotos can be a problem at faster speeds.

Canon's recently developed image stabilizing (IS) lenses and Nikon's vibration reduction (VR) lenses have proved a huge boon to wildlife photographers. These use a floating lens system to damp vibration, and can allow you to handhold at speeds at least two stops slower than with conventional lenses – you can achieve a sharp image at 1/60 of a second or even slower with a 300mm IS lens handheld.

Subject movement

Supporting your camera firmly, or using stabilizing lenses, may resolve the problem of camera shake, but won't deal with the second cause of un-sharp photographs: blur due to subject movement. You can easily diagnose subject movement as the problem in a blurry photograph because static elements in the frame will be sharp (assuming you didn't also suffer from camera shake).

The only way to avoid subject blur is to shoot at a shutter speed fast enough to freeze movement. The necessary shutter speed will depend on how fast the subject is moving, but also on its direction and distance, and the size of your lens. A deer trotting across your field of view at a speed of 30 kph (19 mph), 30m (98ft) in front of you, might need 1/3000 of a second to totally freeze movement using a film speed of ISO 100 and a 300mm lens. The same animal walking directly towards you, at 8 kph (13 mph), might only need 1/200 of a second.

Using a lens with a large maximum aperture can reduce the risk of camera shake and subject movement by allowing you to shoot at higher shutter speeds. An f/2.8 200mm lens

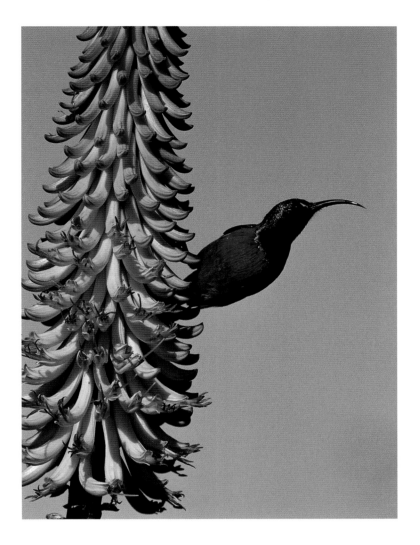

Greater double-collared sunbird on aloe

These sunbirds are constantly on the move as they flit around the aloes gathering nectar, so a fast shutter speed is essential to freeze movement. That means a wide aperture is needed, which gives little depth of field – a problem aggravated by having to photograph them with a longish telephoto at close range. Not only that, but the camera's autofocus was too slow to keep up with the subject. To achieve a sharp, accurately focused image the solution was to mount the camera on a tripod, pre-focus manually on the desired position, and wait for the bird to pose in just that spot before firing the shutter.
Canon EOS-1N with 400mm lens, tripod, Fuji Sensia 100 ISO, 1/800 of a second at f/5.6

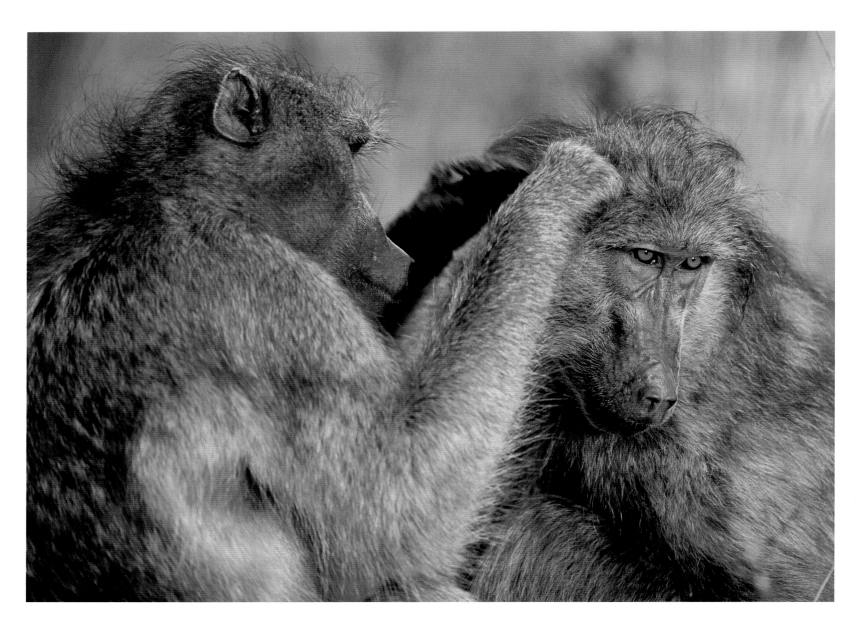

used wide open would give a maximum shutter speed of 1/250 of a second in light conditions where a 200mm f/5.6 lens only allowed 1/60 of a second. However, a 200mm f/2.8 lens is significantly heavier than a 200mm f/5.6 lens and a lot more expensive. The extra weight can help steady the lens when properly supported, but if you have to handhold it your arms will soon become tired and shaky. The other problem is that you will rarely want to shoot wide open at f/2.8, as depth of field is so limited.

Chacma baboons grooming

This appealing anthropomorphic behaviour in beautiful late evening light was begging to be photographed, but the low light level demanded a wide open aperture to avoid blurred subject movement. This gave very little depth of field, so it was absolutely essential to focus accurately on the baboon's eyes, to at least ensure this key part of the picture was pin-sharp.
Canon EOS-1N with 500mm lens, beanbags in vehicle, Fuji Velvia 50 ISO, 1/60 of a second at f/4

Incorrect focusing

If you do have to sacrifice depth of field in order to achieve a higher shutter speed, then it is crucial to focus precisely on the part of the picture that needs to be sharp for the shot to work. For example, suppose you photograph a bird and the tail is soft. The shot may still work, provided crucial elements such as the beak and the eye are sharp. If the tail is sharp and the beak soft, you probably focused on the wrong part of the picture – the third common cause of un-sharp pictures. Modern autofocus lenses may be very accurate, but you still have to point them at the right part of your subject!

Your choice of film will also affect how sharp your pictures look. Used properly, fine-grain films, such as Fuji Velvia ISO 50, produce unsurpassed sharpness. But slow films like these can involve using very slow shutter speeds, increasing the chance of camera shake and subject blur. Loading a faster film may lose you some intrinsic sharpness, but the faster shutter speeds (or the option of greater depth of field at any given shutter speed) that this allows can more than compensate.

Working on your technique to ensure sharper images isn't the most exciting part of wildlife photography, but it can dramatically improve the end results. Assess your photographs rigorously for sharpness. We recommend using a good quality magnifying loupe to edit your pictures. But before you discard the ones that don't work, ask yourself why they weren't sharp and how you might put it right next time.

Gulls calling

Photography often involves a compromise between depth of field and shutter speed. Here a shutter speed of 1/400 of a second was needed to avoid a blurry subject, but this gave an aperture of only f/4 in the 'cloudy bright' conditions. As a result, the second bird is out of focus. However, there is still enough detail to show it echoing the behaviour of the main subject, so the picture works.

Canon EOS-1N with 300mm lens, beanbags in hide, Fuji Velvia 50 ISO, 1/400 of a second at f/4

BEWARE!

▶ Firing off a burst of shots in continuous firing mode can affect sharpness, so if you are using a slow shutter speed and the situation allows, take one frame at a time to allow vibrations to dissipate.

▶ Try not to press the shutter release violently. Learn to squeeze it gently.

▶ If shooting from a vehicle, turn off the engine. You can try coasting up to a subject with the engine off, but many animals and birds associate vehicles with engine noise and are more likely to be frightened by a silently moving vehicle, so it's often better to drive up, then turn off the ignition.

▶ If you must handhold, remember that standing is the least stable position. Try to brace against a tree, wall or vehicle. Sitting or crouching with elbows braced on knees is good; lying prone with elbows on the ground is even better.

▶ Teleconverters may magnify your subject, but even top quality converters reduce image quality. They also reduce the amount of light reaching your film, and hence the maximum shutter speed available to you – by one stop for a 1.4x converter, and by two stops for a 2x converter. In low light or with a moving subject it may be better to shoot without the converter and crop your image later.

▶ Watch out when using multi-point focus systems that may select which part of your subject to focus on simply by its proximity to the camera – you can easily get an animal's nose sharp but its eyes soft. We prefer to use a single focus spot and make the decision as to where to focus ourselves, recomposing after focusing if necessary.

▶ Many lenses produce slightly poorer quality images with more distortion when used at their largest aperture. If you don't need maximum shutter speed, stop down the aperture a couple of stops to get the best out of your lens.

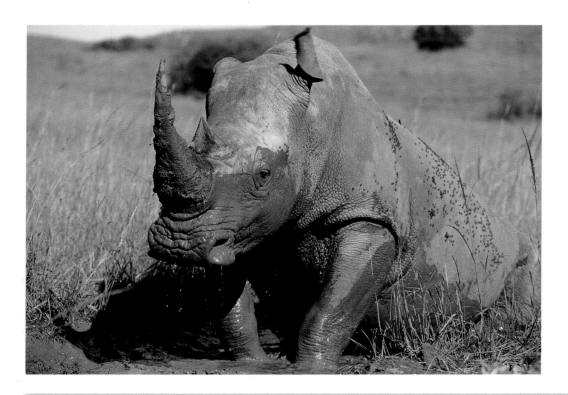

White rhino emerging from wallow

Does everything need to be sharp all the time? Certainly not. Rhinos have long heads, and even with a fairly short focal length lens it's necessary to stop down to ensure the nose and eyes are both sharp. That meant a shutter speed of only 1/200 of a second at f/8, which froze movement in most of the rhino, but left a twitching ear blurred. In the next frame the ear was sharp, but we preferred this shot, as we felt it added a touch of movement and life to the image.

Canon EOS-1N with 70–200mm zoom, beanbags in vehicle, Kodak E100VS 100 ISO, 1/200 of a second at f/8

PRO TIPS

▶ Top-end lenses really do produce sharper, less distorted images, so do buy the best you can afford.

▶ If you don't have a cable release and your subject isn't going anywhere, use the self-timer on your camera. This allows time for the vibrations caused by pressing the shutter button manually to elapse before the picture is taken.

▶ In windy weather remove the lens hood from a long lens to make it more stable. Try to shoot from sheltered positions, in the lee of trees, rocks, vehicles or buildings. Shoot from low down, as wind speeds are slower near the ground.

▶ Always aim to use a tripod at the minimum extension possible, because it is more stable. If you do need height, extend the legs rather than the centre column. Better still, use a tripod without a centre column.

▶ You can increase the stability of your tripod by hanging a weight from it – your camera bag will do.

▶ If you think your chosen shutter speed may not be fast enough to give a sharp image, try shooting at a variety of speeds and adjusting the aperture accordingly.

ASSIGNMENT

Whatever the rules tell you about handholding, the truth is, as individuals, we all vary in how steadily we support our cameras. Knowing your limitations can save you a lot of wasted film. This assignment is a technical exercise in testing your own limitations. Load your camera with a 100 ISO film and find a subject that will stay motionless while you work – it doesn't have to be fauna or flora. Attach a short lens, say around 50mm, and position yourself so that the subject fills at least half the frame. Focus carefully, and take a series of shots at different shutter speeds. Start with a speed around twice the reciprocal of the focal length of lens you are using – so 1/125 of a second for a 50mm lens. Then take shots at 1/60, 1/40, 1/30, and 1/20 of a second (or the nearest equivalents that your own camera allows). Photograph from a standing position, holding the camera as still as possible but not bracing against anything. Repeat the exercise using a medium telephoto length of, say, 200mm, adjusting your position so that the subject still occupies about half the frame. For a 200mm lens, use speeds of 1/400, 1/250, 1/160, 1/80, and 1/60 of a second (or the nearest available). If you are using lenses with IS or VR technology, try taking some shots at even slower speeds. Finally, repeat the exercise with the longest lens you own (but no longer than 400mm – after that you really shouldn't be handholding). Again, use a range of speeds faster and slower than the reciprocal of the focal length. Keep careful notes of the shutter speed used for each frame. Now repeat the whole exercise shooting from a prone position, with your elbows resting on the ground. When you get the film processed, check the sharpness of each frame carefully (with a good loupe if you have one) and be brutally honest. How slow were you able to go with a particular lens and film speed and still get a sharp image? Even with a good bracing technique you may be surprised by how fast a speed you need. Don't forget there are lots of complicating factors in the field – shooting at closer range, or in wind will demand even faster speeds, for example, and that's before you consider the need to freeze subject movement…

SEE ALSO:

Exposure, 17–22 Film, 30–37 Movement, 114–119

WORKSHOP 3: FILM

Film isn't just your canvas: it's your paint as well. Your choice of film will determine the colour palette, sharpness and contrast of your final image, and has a major impact on the range of photographic opportunities available to you in any given situation.

Of course, if you use a digital camera film choice isn't an issue. But for the majority of wildlife photographers, film, at least for the moment, is still the number one choice. Despite the daunting variety of films available, there is no one film that will do everything you want. The quality and amount of available light, the need to freeze subject movement, the maximum speed of your lenses and the mood you are seeking can all affect the film you choose.

Slide or print film?

Your first decision is whether to use slide or print film. Print film is ideal for producing economical enlargements of your pictures for framing. Compared with slide film, print films are more forgiving and do not require such accurate exposure. Minor faults in exposure and colour cast can often be corrected by a decent processing lab. You can be out by as much as two stops in your exposure and still get a decent print.

Slide films produce unmatched sharpness and colour. They are pretty much essential if your aim is to get your work published on a regular basis. Yet slide films are much trickier to use, demanding exposures within no more than half a stop of the optimum to produce acceptable results.

Film emulsion and speed rating

Next you need to decide which film emulsion to use and at what speed rating. Film emulsions come in a bewildering choice. Some are designed to give accurate skin tones, others to produce strong, saturated colours, maximum sharpness and fine grain. It's worth experimenting with a few types to start with, as film preference is subjective. Once you've learned how different films behave in different situations it's good advice to stick to a select few you like and can become familiar with.

The sensitivity or speed of film is expressed by its ISO rating. The lower the rating the slower the film. You can choose film speeds from as low as ISO 25 to as high as ISO 3200. Slower films have finer grain and superior colour saturation and sharpness. Against this you have a trade-off with workability at slow shutter speeds in low light conditions or when animals are moving.

Most professional wildlife photographers use ISO 50 and 100 films for the bulk of their work, for their sharpness and richer colours. The benchmark film for pro and serious amateurs alike is Fuji Velvia ISO 50, which is very sharp, has little grain, and produces strong, punchy colours. Velvia is excellent in overcast light, hazy conditions, or rain, when it delivers rich, saturated colours which other films would show as flat and dull. Put Velvia slides taken in these conditions on a light box next to slides taken on other films and the Velvia jumps out at you – great for instant impact.

Unfortunately, photographing in subdued light is precisely the time you need more speed. If you don't have a very fast lens of f/4 or f/2.8, a still subject, and a very well-braced set-up, you can really struggle to avoid camera shake and subject movement. In very warm light, just after sunrise and just before sunset, colours can look overblown and caramelized on Velvia, while in strong directional light results often look contrasty with dense, black shadows.

Black swan at sunset

We are wary of using Fuji Velvia around sunset, as the saturated colours it produces can be simply too startling. But in this case the colour in the sky and water just after the sun had dipped below the horizon were very subtle, so Velvia, with its rich colour palette, was a good choice. Photographing into the light meant that even after sunset it was possible to use a fast enough shutter speed to ensure a sharp silhouette.
Canon EOS-1N with 300mm lens, Fuji Velvia 50 ISO, 1/200 of a second at f/4

Big fans of Velvia for portrait work in cloudy-bright conditions, we switch to ISO 100 when we need more workable speeds for action or the option of an extra stop's worth of depth of field. Recent improvements in film technology mean there is now little to choose from in terms of sharpness and grain. Fuji's Provia 100F, for example, is comparable in sharpness to Velvia. Provia's colours are not quite as vibrant, but, as we've just discussed, this could be a plus when shooting in very warm light. Like Velvia, however, Provia does not like contrasty situations, and, for us, Fuji Sensia 100 is a better choice in the middle of a sunny day and performs very well in sweet light.

Of course, Fuji does not have a monopoly on film, and other brands can also be very good. Kodak's E100VS is a highly saturated film which has an extra stop advantage over Velvia. Like Velvia, it is good in muted hazy or lightly cloudy conditions, but is too saturated for the 'golden hours' and too contrasty in side-lighting. In our trials it had an overly yellowish cast, but some photographers like it. Kodak also offer E100S (S for saturated), a good accurate film for rich, warm sunrises and for subjects that already have warm golden tones, and the warmer toned E100SW.

Burchell's zebra braying
The hard, bright sunshine of late morning in the semi-desert of northern Namibia isn't the time for attractive lighting, but it is the time when zebras trek to waterholes and indulge in interesting social interaction. By loading a less contrasty film, such as Fuji Sensia 100, and by carefully composing to avoid harsh shadows, it's possible to carry on photographing long after the golden light of early morning.
Canon EOS-1N with 400mm lens, Fuji Sensia 100 ISO, 1/400 of a second at f/8

Faster films of ISO 200 and 400 have improved considerably, but are still grainy and produce less pleasing colours. Again, it's worth experimenting to find which suit you. Many professionals, for example, rate Provia 400F highly as a fast film with acceptable grain, sharpness and colour saturation, but are less impressed with Provia 200F.

An alternative to loading faster film is to 'push' film. This simply means overriding the film's recommended ISO rating, and manually setting a faster film speed on your camera. The resulting underexposure is corrected by asking the processing lab to 'push process' the film, giving it extra development to bring out maximum detail. Pushing film means you keep the sharpness and fine grain, but it does increase contrast, can result in colour shifts, and may produce a muddy picture. Nonetheless, modern film emulsions do push very well, and there are plenty of photographers who would rather push an ISO 100 film by one stop than use an ISO 200 film. Not all cameras allow you to alter the film rating, but you can achieve exactly the same effect by exposure compensation. A 100 ISO film pushed to 200 ISO is simply a film in which all frames have been underexposed by one stop. You can also do the opposite of pushing, by down-rating a film. This may be necessary to avoid overexposure or to reduce contrast in a harshly lit scene, and requires that the exposed film be given a reduced development time ('held back'). Slide films respond better to up-rating and down-rating than print films.

Whatever films you use, do look after them. Make sure new film is long-dated, and store it in cool, dry conditions. Don't leave film in the camera for weeks on end, and keep film cool and out of the sun when out in the field.

As we mentioned earlier, there's a lot to be said for finding out which films you like and sticking with them – with practise you will understand how those films work in different lighting conditions. But it can also be fun to experiment and stretch your creative boundaries. Try using very fast films such as ISO 800, 1600 and 3200 under low light or even night conditions. The results will be grainy, but can be unusual and effective.

PRO TIPS

▶ If you must use a high contrast film, such as Velvia, in bright sunshine, try to position yourself with the sun directly behind you to minimize dark shadows in your picture.

▶ Although lower contrast films with less saturation may have less immediate impact on a light box, they can reproduce better when published.

▶ If your images are mainly for web use, bear in mind that high contrast films, such as Velvia, are harder to scan accurately. Given that absolute grain-free sharpness isn't so vital in an image for the web, choose a 100 ISO film with less contrast.

▶ Most modern cameras incorporate DX coding readers, which automatically read the recommended film ISO rating. You can override the DX code on some cameras to push film, for example, but if you want, you can also use this facility to tweak the ISO rating slightly. For example, many photographers prefer Velvia rated at 40 ISO, to reduce colour saturation slightly. Experiment with your favourite films to find out what you like.

▶ We ask for processed slide film to be supplied unmounted in sleeves. We mount our own slides, at the editing stage, using better quality slide mounts than are provided by most processors. As we may only keep a handful of shots from a 36 exposure film, this often works out cheaper.

▶ If you fly abroad to photograph, getting film processed before you return home halves the number of baggage scans it is exposed to, and it can be cheaper in some countries, but do make sure the lab you use is reliable.

▶ If a good shot is spoilt by light scratches, and you can't correct it digitally, try getting a dupe made, as these often don't show the fault. But do get a high quality dupe from a specialist lab, as cheap dupes are of very poor quality.

BEWARE!

▶ Some photographers, who will happily spend a fortune on cameras and lenses, try to save money by using cheap brands of film. Don't! Cheap films often use outdated emulsions, may have poor quality control, and will produce inferior results.

▶ Learn how your film responds to the use of filters. You may need to use filters more judiciously with films that give high colour saturation.

▶ If you push film, bear in mind the whole roll will be affected. Don't forget to tell the processing lab to adjust development accordingly.

▶ Mark pushed films immediately to avoid confusion with un-pushed films. Some photographers carry a sheet of small coloured stickers to mark the canister.

▶ Just as it's important to use a good-quality film, it's also important to use a good-quality processing lab. High street quality can be very inconsistent. Professional labs are good for reliable results and fast turnaround. Some of the processing-by-post operators are very fast, inexpensive and offer excellent and consistent quality. Ask fellow photographers, or look on Internet photo-forums for recommendations.

▶ If you use film straight from a cold fridge, water may condense on it, leaving marks. Allow film to come to room temperature before loading. If you buy film in bulk, you can freeze it, but make sure you thaw it gently and thoroughly before use.

▶ Never let your unexposed film go through an aeroplane's hold, as baggage scanners can ruin it. Slow films will happily stand 12 or more passes through hand-baggage scanners, but we err on the side of caution, and any film which returns unused from an overseas trip is not taken abroad again. Faster films, especially ISO 800 or above, are more sensitive to scanners. Ask politely for them to be hand searched.

▶ If one film out of 50 is scratched you can be sure it will be the one with your best shots. Be very careful when loading film – avoid loading in windy conditions, or in a moving open vehicle. In dusty conditions it's worth carrying a moist cloth in a plastic bag to wipe down the outside of your camera before opening it to reload.

▶ Professional-quality films (for example Fuji Velvia or Provia) are designed to mature to their optimum state fairly quickly, so don't keep these films a year before you use them. Non-professional film stock, like Sensia, has a longer shelf life.

Otter emerging from water (C)

To make sure the greens, browns and blues were as punchy and saturated as possible, we used Velvia for this shot of a captive otter. The danger of using Velvia in fairly bright sunshine was that it would produce an overly contrasty image. However, working with a captive otter enabled us to observe the animal's favourite exit points from the water and select a viewpoint that was front-lit to reduce the problem.

Canon EOS-1N with 400mm lens, Fuji Velvia 50 ISO, 1/200 of a second at f/8

ASSIGNMENT

It's important to understand how your film responds to different lighting conditions. For this exercise, choose a good-quality film with a speed rating significantly different from your usual stock. If you shoot a lot of Fuji Velvia, try a Provia 400F ISO film, for example, or if you normally shoot Kodak Supra 100 ISO, try the 400 ISO. If, on the other hand, you normally shoot with a fast film, try a slow one instead. The aim of the exercise is to expose a roll of film on a subject of your choice, in various lighting conditions. Any reasonably large subject will do, but avoid very dark or very pale subjects. You will need to photograph it at different times of day, so a captive animal or a tree study would be a sensible choice. You should photograph in at least three types of light: bright sunlight in the middle part of the day; softer, warmer direct light around dawn or dusk; and in soft diffuse light, either in overcast conditions or in light shadow. For the first two types of direct light take shots of the subject with the sun directly behind you (front-lit subject), with the sun to one side (side-lit), and, if possible, with the sun behind the subject (back-lit). Rely on your camera's meter for the first shot in each lighting situation, but then bracket your exposures, taking one shot underexposed and one overexposed. If you are using slide film, bracket by 1/3 stop, or 1/2 stop if that is all your camera will allow. With print film, bracket by a full stop both ways. It's vital that you keep detailed notes of every shot. When you get the results, analyze them carefully to see how the film responded to the different lighting situations. Was it overly contrasty in bright sunshine? Did it hold detail in shadows or highlights? Did it give good colour rendition in soft light? Did the colours wash out in bright sunshine? How did graininess, contrast, and colour rendition compare with your normal film? Shooting a single roll won't give you a complete feel for how a film responds to the infinite variety of lighting conditions you will encounter in the field, but this systematic approach is a good starting point. For example, do you know how your favourite film responds in similar conditions, or is it worth repeating the exercise with this film too?

SEE ALSO:

Peregrine (C)

Working with a falconer's bird that was at ease with people meant it was possible to use a slow, fine-grained film, even in dull light. The peregrine was still and the camera could be firmly supported on beanbags, so a sharp image was possible even at a shutter speed as slow as 1/60 of a second. The benefit of using Velvia in these lighting conditions is reflected in its excellent reproduction of the rich chocolate brown plumage and the attractive green of the background.
Canon EOS-1N with 300mm lens and 25mm extension tube, Fuji Velvia 50 ISO, 1/60 of a second at f/8

Perspective

WORKSHOP 1: CHOICE OF LENS

It's time to explode one of wildlife photography's big myths: that your success rate in nailing good wildlife images is equal to the size of your lens. While there are many occasions when a telephoto lens is a necessity in nature work and your choice of lens will be dictated purely by the practical consideration of getting close, it's not true that telephotos are the wildlife photographer's sole weapon of choice. There are many occasions when you can produce stronger, more dynamic or just plain different wildlife images by selecting some of the other lenses in your bag. The skill is learning what to use when and appreciating that, ultimately, your choice of lens is as much to do with composition and creativity as it is to do with image size and accessibility.

A good grasp of what lenses do and how they behave is fundamental, allowing you to select a lens because it will produce the effect you want, as opposed to simply getting you closer to your subject every time. We've seen how some photographers get superglued to their 600mm telephotos in their excitement on safari, and neglect to vary their shots by switching lenses, so this is a point worth stressing. It's very

easily done. The first time we went out with big telephotos our results were one-paced and we quickly tired of editing endless, frame-busting head-shots of animals.

Bull elephant dusted in red earth
Working in a reserve where the elephant population is accustomed to vehicles and a very close approach is sometimes possible, we chose to photograph this massive bull using a standard zoom. The wide angle of view helps emphasize his looming presence and the bulk and power of the world's biggest land mammal.
Canon EOS-1N with 35–80mm zoom lens, Fuji Velvia 50 ISO, 1/200 of a second at f/8

Robin on plantpot
Robins can be bold in winter, especially if there's a meal in the offing, and you don't require a hide to photograph them, but a telephoto lens affords a comfortable working distance to record natural behaviour without stressing the birds or scaring them away. The pot was placed in position to leave space for the robin within the frame, and baited with birdseed.
Canon EOS-IN with 300mm IS lens, Fuji Velvia 50 ISO, 1/100 of a second at f/5.6

Variety is the spice of every photographer's portfolio. Even if you never intend to sell any of your pictures, utilizing a range of lenses will add a breadth and depth that your intended audience will welcome – even if you only take pictures for yourself.

There are a number of factors you need to consider before you reach into your bag for a lens: how close you can approach the subject; what size you want your subject to appear in the frame; the angle of view and depth of field you need; your choice of viewpoint and composition; and what you want the background of your shot to look like. Each has a bearing on your selection. And, as is often the case in photography, all are interrelated and involve a series of trade-offs.

There isn't always one correct lens for a given situation, but a range of options. Try experimenting with different lenses the next time you have a willing subject. A fresh take on a much-photographed animal will often have more impact than a 'me-too' shot that's become a cliché. Mix things up a bit. Photograph large mammals from a distance with a short lens, or go in really tight for an extreme close-up where exaggerated facial features are slightly blurred.

Short versus long

Before we go any further, let's clarify what we mean when we talk about short and long lenses. As a benchmark, a 50mm lens records the image in the viewfinder pretty much as the eye would record it. Anything longer than 50mm and the image in the viewfinder is magnified. If you look at a red squirrel through a 400mm lens it will appear eight times bigger in the frame than it would through a 50mm lens. Anything longer than 50mm is, strictly speaking, a telephoto lens, but, for the purposes of this book, when we refer to telephoto lenses we usually mean lenses with a focal length above the 200mm mark. Short lenses are anything around 50mm or less, including the short zooms of 35–80mm or thereabouts, which come as standard with many new cameras.

Lenses shorter than 50mm are referred to as wide-angle lenses, because they broaden the angle of view, as well as decreasing image size. The opposite happens with telephoto lenses – look at that squirrel first with the 50mm lens and then with the 400mm and the angle of view narrows significantly.

Cape vulture on cliff-top
Purely in practical terms there's no choice but a long telephoto lens for an image like this, taken from a cliff-top hide. The long lens renders the distant mountain completely out of focus, setting off the bird to good effect against the complementary colours of the uncluttered backdrop.
Canon EOS-1N with 500mm lens plus 1.4x converter, Fuji Sensia 100 ISO, 1/500 of a second at f/5.6

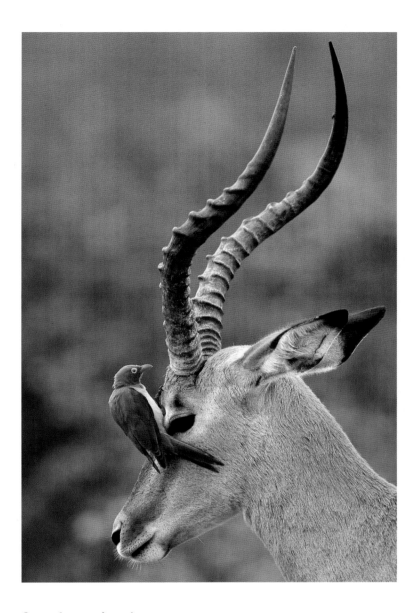

Lioness hiding in long grass

Working close to a subject with a telephoto lens gives a shallow depth of field, which helps convey a sense of the danger lurking in the undergrowth. The surrounding vegetation is out of focus, drawing attention to the focal point of the picture, the lioness's bright, predatory eye.

Canon EOS-IN with 400mm lens, Fuji Velvia 50 ISO, 1/160 of a second at f/5.6

Oxpecker on impala ram

With two shy subjects like this it's better to hang back and use a longer lens to secure the shot before trying a closer approach where you run the risk of alerting the bird and alarming the antelope. Depth of field was not too much of an issue here because both the bird and the impala's head and horns were in much the same plane, so a wide aperture was selected to keep the background nicely out of focus.

Canon EOS-1N with 400mm lens, Fuji Sensia 100 ISO, 1/125 of a second at f/5.6

There are similar trade-offs when it comes to depth of field – depth of field being the zone of acceptable sharpness from front to back in a picture. From any given range, the longer the lens you use the less depth of field you'll have to play with. And no matter what focal length lens you use, the closer you get to your subject the less the depth of field.

It's important to understand these technicalities because you can utilize their effects to enhance your pictures, or avoid them where they threaten to wreck your image. If you want to photograph a single bloom in a wildflower meadow, a longer lens used quite close would produce a narrow angle of view and limited depth of field, allowing you to successfully isolate that single bloom from the rest. A short lens might ruin the effect you're after, because the wider angle of view would make it difficult to exclude other distracting flower heads from the frame.

Long lenses combined with a distant viewpoint can be used to compress perspective in a shot – those wildflowers in the meadow would appear more densely bunched, herds of plains game would seem more massed together. Wide-angle lenses combined with a close viewpoint, on the other hand, can be used to expand perspective – the meadow's colourful blooms stretch into the distance, while the savannah appears scattered with antelope from the camera to the horizon. You can go further by combining choice of lens with choice of viewpoint to exaggerate and even distort perspective to good effect in a picture.

PRO TIPS

▶ We've said it before, but it's worth reiterating – when you purchase new lenses, spend as much as you can afford, as the quality of your lens will directly affect the quality of your pictures.

▶ Don't mothball the standard 35–80mm zoom that came with your camera body when you acquire longer telephotos and shorter wide-angle lenses. A standard lens is a useful lens for wildlife work and will probably be a lens you are comfortable using. It is extremely portable, has good optics for the price, and is very easy to handhold. Some of our favourite images were shot with a 35–80mm zoom!

▶ When you feel you've exhausted all the possibilities of a subject with the first lens you thought of, attach a different lens and experiment to see what else you can get out of the situation. Very often the shots that work best are not the obvious ones, but those you took when exploring a subject's potential more fully.

▶ Zoom lenses give you the advantage of precise framing and creative control. Where you need to be mobile and when stalking wild animals, one zoom lens can do the job of several fixed-length lenses.

▶ Use a shorter lens, set a small aperture and move away from a subject if you want to increase depth of field in your picture. Use a longer lens with the aperture wide open and move in close if you want less depth of field.

BEWARE!

▶ Although zoom lenses are flexible to work with, this can come at the expense of image quality and shutter speed when compared to fixed focal length lenses. Read reports in photo-journals and equipment reviews by other photographers to find the best-quality option in your price bracket.

▶ Attention all gear freaks – don't get so fixated on the size of your lenses that you forget your fieldcraft. Size isn't everything. If you lack the focal length you need to reach a subject, the answer might be to move closer. Not always possible, but often overlooked as a solution.

ASSIGNMENT

There are many situations in wildlife photography when your choice of lens will not be driven solely by your physical distance from the subject and the size you want it in the frame. Choice of lens requires you to make creative decisions too. This assignment is rooted in the plant kingdom, pardon the pun, as it will be easier for you in this exercise to photograph subjects that are fixed to the spot. It involves taking a series of shots of flora at one site working with short and long lenses (shoot at least one roll for each lens). Select one of the following subject areas: flowers, foliage, fruit, seeds, weeds or grasses. Now pick a location with clearly defined boundaries that enclose plenty of your chosen subjects – it could be a meadow, a roadside verge, garden flower bed, shrubbery, orchard or plot of overgrown waste ground. The only constraints on how you interpret the subject are that you stay within the location boundaries, use both long and short lenses, and that you illustrate the subject in each of the following ways:

- In profusion
- In isolation
- As one of the crowd

How did you get on? Did you feel you were able to exploit all the potential within your site with the equipment available to you? Which lenses – long or short – proved most useful for which parts of the exercise? What problems did you experience in terms of framing, depth of field and shutter speed for each of the three areas? Which picture do you like best? Did you learn anything new about your own approach to a) your equipment and b) the subject matter?

Spring flowers in South Africa

Short lenses are an essential part of your wildlife toolkit for documenting habitats and eco-systems in the natural world, but also come into their own when you need to step back and simply convey the sheer profusion of animals, birds or flowers in a scene. This shot was carefully framed to include enough colourful foreground interest to arrest attention, but also a view through the boulders on the left giving a hint of yet more purple blooms in the distance.

Canon EOS-1N with 35–80mm zoom lens and polarizing filter, Fuji Velvia 50 ISO, 1/60 of a second at f/16

Spring flowers in South Africa

Same scene, same lens – different image. This time the short zoom was used from a very low angle, close to the subject, to emphasize one plant as a specimen while preserving the wider view. This allowed us to show the plant's habitat at the same time as focusing on the plant itself. A narrow depth of field stopped the background detail from overpowering the flowers singled out as a focal point.

Canon EOS-1N with 35–80mm zoom lens and polarizing filter, Fuji Velvia 50 ISO, 1/250 of a second at f/6.3

SEE ALSO:

WORKSHOP 2: SHORT LENSES

Short lenses play more of a lead role in today's wildlife photography. In the past, these lenses were often relegated to B-list status in the equipment bag, with a cameo role when it came to focusing closer than a telephoto could on small subjects, or the odd walk-on part when shooting landscapes or habitats. Both are still very valid and worthwhile reasons for owning such lenses, but their use has been extended in recent years to provide a fresh perspective on the natural world.

Saturation coverage of popular species shot in conventional formats and the constant demand for new images has intensified picture researchers' quest for something different, more dynamic and more 'real'. Longer lenses, with their narrow angle of view and tendency to foreshorten a scene, produce a two-dimensional image that can distance the viewer from the subject. It's as if we're gazing into another world, but are not invited to be a part of it. This is where short lenses have stepped into the limelight.

Curious white rhino with calf
We try to exploit the wide angle of view of short lenses whenever possible. When this short-sighted but curious white rhino and her calf approached close to our vehicle one afternoon we were able to take advantage of their slightly elevated position to make the rhinos look even more dynamic and dominant in the picture.
Canon EOS-1N with 18–35mm lens, Fuji Velvia 50 ISO, 1/125 of a second at f/8

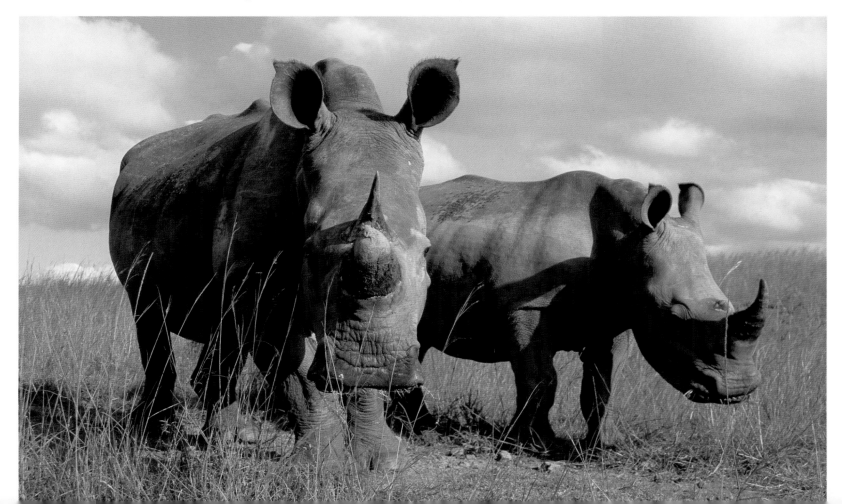

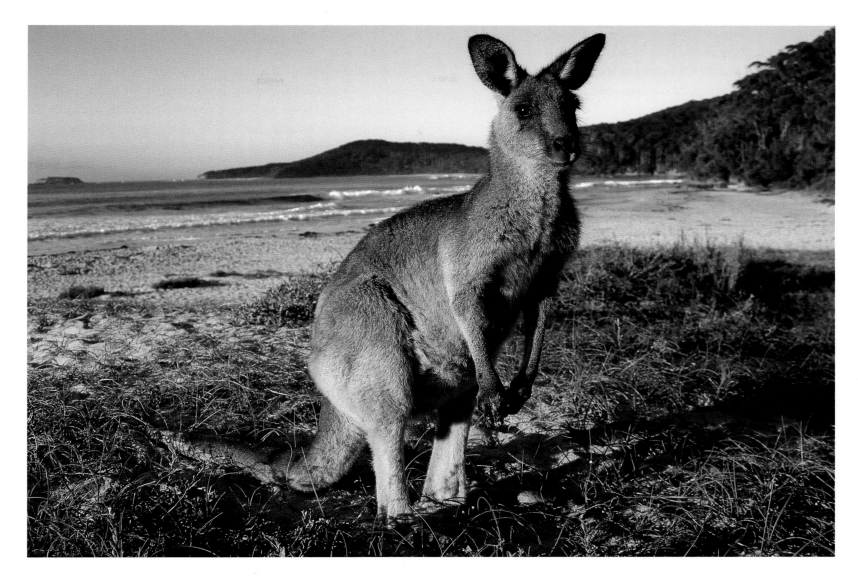

Images taken with short or wide-angle lenses have more of a three-dimensional quality and their broad perspective draws the viewer into the heart of the scene. Consider how photojournalists use short lenses combined with low viewpoints, not only to give us more information, but to grab our attention and make us feel we're actually there. It's a style of photography that's strong on immediacy and impact. And while it might seem like a million miles from wildlife photography, short lenses are increasingly being used in this way to make powerful and arresting images of much-photographed animals, helping us see them in new and dynamic ways.

Beach-living eastern grey kangaroo

Working with a wide-angle lens used close to the subject is an effective way to get frame-filling shots of your subject, while also documenting their habitat. When we photographed a mob of kangaroos living by the sea in New South Wales it was imperative to include clear landscape detail in our pictures. In this case the background is as crucial a part of the image as the animal.

Canon EOS-1N with 18–35mm lens, Fuji Velvia 50 ISO, 1/80 of a second at f/11

With a short lens you can exploit the wide angle of view to document the bigger picture. We instinctively reach for a shorter lens if we simply need to fit more into the frame, but the effect works best when used in a more considered way to show a subject's habitat or convey clues about its natural history. For instance, a frame-filling image of a fox taken with a long lens may work extremely well as an intimate portrait of the animal, but, however well executed and appealing, may tell us little about the fox other than its physical attributes. Is it a wild creature or a captive one? Does it live in a remote rural area or on the edge of a busy town? You can often say much more about your subject and add context to a picture simply by using a shorter lens.

Framing

There's a lot more to pulling off wildlife pictures with short lenses than simply cramming in as much information as you can, however. Careful framing is crucial. It's very easy for the additional background detail to make a picture messy or overwhelm the subject, particularly when you are working at a distance and the subject is small in the frame. Principles of good composition will help you get the right balance between your subject and its surroundings, and this is particularly important when using short lenses.

It can help to study the work of your favourite landscape photographers – just to get some idea of how they weight items

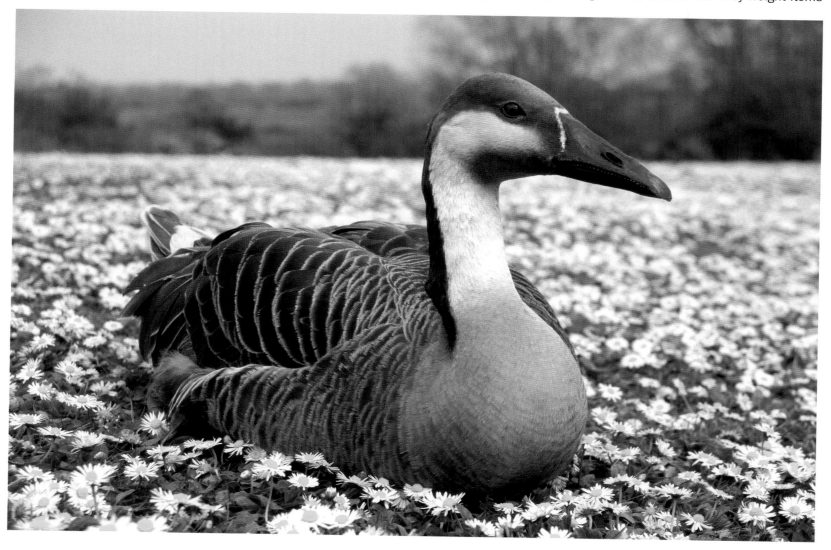

when framing a picture. Look particularly at how they deal with the important foreground area, using the lens at close range to focus attention on something prominent, such as an interesting boulder or rock-pool, to engage our interest and lead the eye in to the picture.

This approach can be just as effective in wildlife work. You can fill a large part of the frame with a prominent subject, while at the same time showing lots of background context. The effect is pleasingly three-dimensional. Unlike telephotos, where the need for a fast shutter speed often means working at large apertures with little depth of field, you can achieve greater depth of field working with short lenses from the same range. You can also focus more closely on your subject with a short lens and can handhold lenses at much slower speeds without camera shake, allowing you the freedom to explore different viewpoints.

Viewpoint

The three-dimensional effect is dramatically enhanced when combined with a low viewpoint. Getting in really close to a subject and tilting the camera upwards from a prone position distorts perspective, making your subject appear to loom out of the frame. The technique works well with powerful, characterful, comical or expressive animals. It's a popular style of animal photography, but there's a catch. You need to get extremely close to your quarry, so generally you need to work with habituated or controlled subjects to be safe. You should back off immediately if you sense an animal is being stressed by your presence.

Goose in daisies (C)

This simple shot of a swan goose taken in a wildfowl sanctuary on an overcast day illustrates how short lenses can be used to make the most of a straightforward subject. As the goose was quite accustomed to visitors it was possible to lie-down right next to the bird and exploit the wide angle of view to include the mass of daisies in the frame, checking first for any unwanted clutter or people.
Canon EOS-1N with 35–80mm lens, Fuji Sensia 100 ISO, 1/200 of a second at f/8

Exmoor pony grazing

A short lens used very close to a subject and from a very low viewpoint (in this case lying prone) gives you a fresh angle on fairly common subjects we're used to seeing photographed in quite conventional ways. Here we exploited a natural slope in the terrain to further exaggerate the effect.
Canon EOS-1N with 35–80mm lens, Fuji Sensia 100 ISO, 1/32 of a second at f/8

PRO TIPS

▶ Try tilting your camera sometimes when using a short lens up close and from a low angle. Although the subject looks decidedly off-kilter, the effects can be quite striking. It doesn't work with all subjects, so have fun experimenting.

▶ Point a short lens skywards next time you are photographing in woodland and explore how effects of distortion can be used to create a dynamic image of life under the canopy. Notice how the converging verticals of tree tops create a tension in the picture, appearing to make the trees loom large as if they are about to fall on your head.

▶ Use a polarizing filter to get that appealing postcard blue in your skies when photographing with short lenses on a bright day. But check how things look before pressing the shutter release so you don't overdo the effect – the beefed-up blue can sometimes come out a nasty black around the corners of your image.

▶ To get rid of potentially distracting or messy backgrounds, use a short lens from a low viewpoint and simply frame your subject against the sky. This can be a useful technique when photographing captive subjects.

▶ The key to success when using wide-angle lenses is to make sure your picture has strong foreground interest that leads your eye into and through the picture.

▶ It's easier to handhold short lenses, so move around a subject as much as possible, exploring as many different viewpoints as you can. Don't forget there are joints in your knees – you can dramatically alter the impact of a picture simply by adjusting your height in relation to your subject, as well as moving closer or to the left or right.

▶ If you want to photograph a camera-shy subject with a short lens from a low angle, try using a remote release so you can move away to a safe distance.

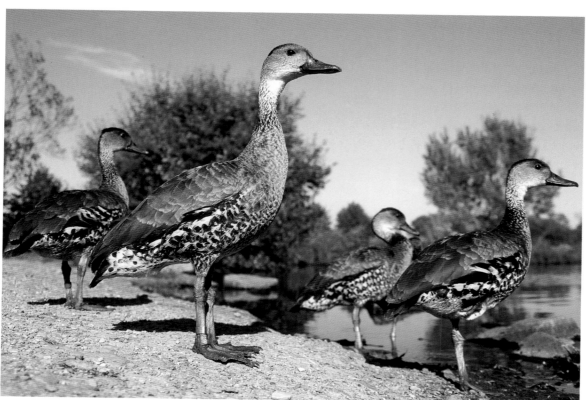

Whistling ducks by the water (C)
Play around with perspective and explore different viewpoints to present wildlife subjects in a novel way. Here's our worm's eye view of whistling ducks at a local wetland sanctuary. The shot is taken by lying on the path very close to a group of ducks that were happy enough to tolerate the presence of an odd-looking photographer shuffling towards them on her stomach.
Canon EOS-1N with 35–80mm lens, Fuji Sensia 100 ISO, 1/250 of a second at f/8

Feral camels in the Outback

'Up and under' shots, using a short lens tilted upward from a low viewpoint, exaggerate perspective and are a great way to bring out the character of your subjects in wildlife photography. The technique is particularly suitable for long-necked subjects like giraffes, ostrich and camels, or anything characterful, comical or expressive. It's also an excellent way to convey a large or dominant animal's power.
Canon EOS-1N with 35–80mm lens, Fuji Sensia 100 ISO, 1/320 of a second at f/8

BEWARE!

▶ When working with very wide lenses check round the edges of your frame to make sure the lens hood can't be seen in the shot. Badly designed or incorrectly attached lens hoods can show as out-of-focus dark areas around the edges, known as vignetting.

▶ Make sure your shadow doesn't appear in the foreground of your frame when using short lenses up close and from low angles. The simplest way to avoid this is to reframe or adjust your position slightly.

▶ When photographing with short lenses it's often quite hard to avoid including sky in your shot. Dramatic skies or, at least, strong blue skies, ideally with a few soft white clouds, work well. If you have to photograph when the sky is very pale, a graduated neutral-density filter will help reduce excessive contrast.

▶ With a wide angle of view it's especially important to check the background carefully for any unwanted highlights or clutter that may not have been immediately apparent to you – telegraph wires, vapour trails, bits of buildings etc.

Assignment

Short lenses enable you to convey lots of information about your subject's environment. They lend work a three-dimensional quality that's difficult to achieve with telephotos due to their narrow field of view. The theme of this assignment is 'habitat'. The challenge is to photograph a wildlife subject using only short or wide-angle lenses, showing as much of the natural habitat, but keeping the subject as the main focal point. The choice of subject is up to you, but you should include in the picture as many clues as possible about where and how your subject lives. Make sure you take a series of shots with a range of focal lengths and viewpoints, and vary the aperture so the habitat is rendered sharp throughout in some shots but less sharp in others. At the end of the exercise select the one image that most successfully documents the habitat and features your subject prominently within it. What it is about your other attempts that prompted you to reject them in favour of the image you chose? How big a practical issue was depth of field? What effect has this had on your final results? How big an issue was perspective and point of view?

SEE ALSO:

Ostriches (C)
We've often photographed ostriches in the wild, but to get this close with a short lens we had to visit an ostrich farm.
Canon EOS-1N with 28–70mm lens, Fuji Velvia 50 ISO, 1/60 of a second at f/11

WORKSHOP 3: LONG LENSES

The natural world is one place at least where the cult of celebrity thankfully does not reach. Animals are camera-shy creatures in the main and in our experience don't go out of their way in the wild to get their pictures taken. To get good wildlife shots, photographers often have to make like paparazzi (but with impeccable ethics) and stalk their publicity-shy quarry from a distance using long telephoto lenses so as not to disturb, distract or alert their subjects.

Joey in pouch (C)

Long lenses are useful for isolating part of a subject that you want to make the main focal point, as in this close-up of a swamp wallaby joey peeping from its mother's pouch. Not only is a shot like this appealing, it also conveys important information about marsupial behaviour and reproduction.
Canon EOS-1N with 400mm lens, Fuji Sensia 100 ISO, 1/250 of a second at f/8

In addition to getting you close enough to record images of timid or skulking wildlife, telephoto lenses provide a safe working distance, allowing you to operate without stressing a subject or triggering its fright or flight defence mechanisms. You are much more likely to achieve naturalistic shots and capture interesting behaviour if an animal is able to carry on its routine oblivious – at least that's the aim – to your presence.

You can get closer to your subjects with good fieldcraft techniques, but there's usually a price to pay for the ground you gain. Startled or self-conscious expressions with animals looking straight at the camera signal to anyone viewing a picture that the animal was supremely aware of the photographer. Most of the time what we're aiming for is a sense of wildlife undisturbed and at ease – although there are occasions when we do want to hold a subject's gaze momentarily towards the lens if we're looking for strong eye contact in a picture, or seeking to illustrate a particular concept, such as aggression or fear.

The downside

The downside with long lenses is that their weight and bulk makes them difficult to handhold and keep steady enough to avoid camera shake, although if you are lucky enough to own lenses with image stabilizing technology life gets easier. Unless you are happy to ditch most of your shots because they're just not sharp, always support the weight of a long lens adequately using beanbags or a sturdy tripod and develop and use good bracing techniques at all times.

Apart from the very big and obvious plus of getting you access to a whole heap of subjects that would be impossible or extremely time-consuming to even contemplate photographing without long lenses, you could be forgiven for thinking that the problems outweigh the benefits when it comes to using telephotos. They're expensive, cumbersome and unsteady, they don't focus close to and they give a narrow angle of view with scant information about a subject's habitat. They compress or foreshorten perspective, making images appear unnaturally flat, they offer less depth of field than a short lens used at the same range and it gets even worse if you move in close or light levels are low.

The benefits

With the exception of cost, it's quite possible to turn most of the above minuses into pluses when it comes to working creatively with long lenses in the field. Their limited depth of field, particularly when photographing with the aperture wide open, makes them especially useful for making subjects really stand out because detail beyond the subject is conveniently thrown out of focus. Backgrounds appear as an un-distracting, pleasing colour wash or tint when you use long lenses, throwing a subject into clear relief. The effect is simple, images look clean and punchy, and it works particularly well where you're able to position yourself so the subject is picked out against an overall backdrop of a single, complementary hue. Try to isolate a background section

Young rock hyrax peeping over rocks

If you want to draw immediate attention to your subject, you can exploit the narrow angle of view of a long lens and shoot at wide apertures to create a soft focus frame around the main focal point of your picture, as in this shot of a curious young rock hyrax. Adopting a low viewpoint and focusing on the head of the subject renders the foreground and distant background out of focus.

Canon EOS-1N with 300mm lens, Fuji Velvia 50 ISO, 1/200 of a second at f/5.6

with shades that reflect the colours of the relevant habitat, eco-zone or season in which you're shooting.

You can further exploit this shallow depth of field when it comes to composing your shots a bit more creatively. One trick is to compose your subject viewed through a surrounding frame of foreground vegetation, such as bushes, grass, reeds or tree foliage. Setting a large aperture throws the vegetation out of focus, softly framing your sharply focused subject like a cameo in the centre of a picture frame. This is a good device to use when you want to give your images a soft, natural and intimate mood. Once again, this has the effect of drawing the eye in.

You can also use out-of-focus foreground material to frame a subject by shooting from a prone position with a wide aperture. This technique can be very effective for photographing subjects such as birds in grass or rabbits and hares in a meadow, and turns the surrounding grasses, in front of and beyond your subject, into a soft blur of colour that delicately frames the subject in a pleasing way.

The narrow angle of view of a long telephoto can be turned to your advantage too. Because longer lenses zero in on your subject and cut out information from the broader scene, you can effectively concentrate the viewer's attention where you want it – on your subject and away from any distracting clutter. This is very useful in portrait work when you want to reveal as much as possible about the animal itself but are less interested in the context of its surrounding habitat. Indeed, you may want to exploit shallow depth of field and a narrow angle of view to deliberately hide context in a picture. In captive conditions, such as zoos, or even when photographing the wildlife in your own garden, telephotos are extremely useful to help throw any tell-tale or unsightly man-made structures completely out of focus.

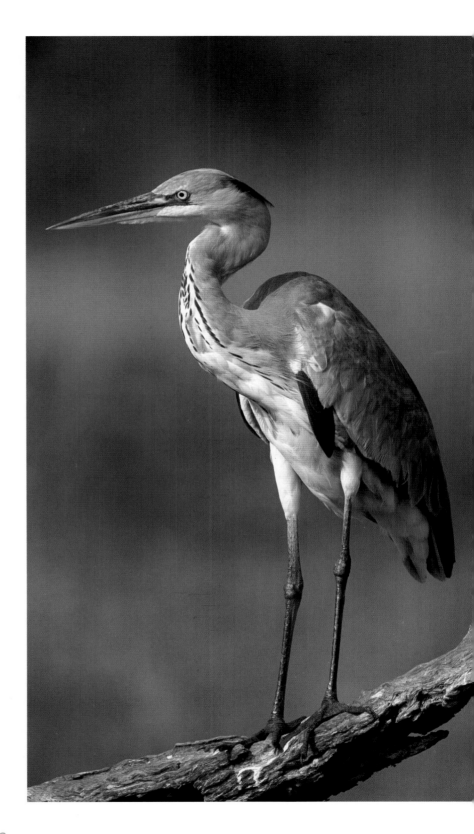

Grey heron perching

By photographing an animal standing proud of its background it is often possible to get the depth of field required for your subject to be sharp throughout without bringing the background into sharper focus.
Canon EOS-1N with 500mm lens plus 1.4x converter, Fuji Velvia 50 ISO, 1/160 of a second at f/6.3

Red fox portrait (C)

When photographing long-snouted animals at close range with long lenses ensure you have enough depth of field to get the head sharp from the tip of the nose to the tip of the ears. Focus on the eyes, then stop down, using your depth of field preview button to check. With experience you will learn to judge how much you need to close down the aperture.
Canon EOS-1N with 300mm IS lens, Fuji Velvia 50 ISO, 1/160 of a second at f/6.3

PRO TIPS

▶ To get sufficient depth of field in your subject when photographing at close range with big lenses it is often necessary to stop down to at least f/8 or f/11. Try to choose a viewpoint that maximizes the distance between your subject and the background, so the background remains out of focus.

▶ Use your depth of field preview button to check you have stopped down sufficiently. Try to achieve a pleasing balance between subject sharpness and background fall-off.

▶ Some animals, such as foxes, have long snouts, making it difficult to achieve sharpness from the eyes to the tip of the nose. Try shooting portraits in three-quarter profile as well as face to face, as the necessary depth of field is often less.

▶ Remember to focus on the critical part of the subject that you most want to be sharp – usually the eye or eyes of an animal. If the eyes are sharp a portrait may be acceptable even if the rest of the features fall off a little. If you don't get the eyes sharp because you've focused on another part of the head the shot is probably destined for your bin.

▶ For pin-sharp pictures when using big lenses at slow shutter speeds use an electronic cable release. If your camera has a mirror lock-up facility, this will further reduce vibrations at very slow speeds.

▶ Long telephoto lenses often won't focus at close range, which can be a problem when photographing small subjects such as birds. You can get round this by using extension tubes, or attaching a teleconverter and working from range – adding a teleconverter doesn't increase the minimum focus distance of a lens.

▶ Extension tubes don't reduce the close focus distance of large telephotos by very much, but if your subject is just a fraction too close to focus they can solve the problem.

▶ Longer lenses can extend useful shooting times on an overcast day because the narrow angle of view allows you to exclude dull and uninteresting skies from your picture.

Painted snipe reflection

To photograph a shy bird in the wild requires a long lens and a hide (in this case a vehicle), plus great care not to disturb the subject. Don't forget to exploit a good reflection – here it adds compositional interest but also helps fill the frame.

Canon EOS-1N with 500mm IS lens plus 1.4x converter, Fuji Sensia 100 ISO, 1/320 of a second at f/5.6

BEWARE!

▶ Never use a telephoto lens without the lens hood. Hoods reduce flare and provide some protection to the front lens element in the event of an accident.

▶ Remove camera straps when working with big lenses in confined spaces such as a hide or a vehicle, as they invariably get caught up on other equipment, the hand brake, steering wheel etc, slowing you down and restricting movement.

▶ If you stop down to increase depth of field in your subject, be careful you don't overdo it and allow the background to become intrusive. Use your depth of field preview button to check.

Assignment

We use long lenses when we have to work at a distance from our subjects and need to magnify them in the frame. But they are also used creatively – exploiting their shallow depth of field to differentiate between different parts of the picture, highlighting a key portion of the frame you want to draw attention to by ensuring everything else in the shot is thrown out of sharp focus. This assignment is designed to explore ways in which this 'differential focus' can be used creatively to convey mood, emotions or even conceptual ideas when photographing a wildlife subject. The challenge is to produce a set of three pictures of animals, plants or insects using long lenses, where only a small part of the picture is sharp in each. In each case you will need a clear idea of what feeling or idea you are trying to convey, which part of your subject you want to highlight and how you might use the camera and lens combined with different viewpoints to achieve your aims. Below is a list of suggested themes you might want to illustrate – interpret them how you wish or choose a different concept of your own if you prefer:

• Concealed
• Emerging
• Intimate
• Stealthy
• Delicate

Spread the three pictures you like best on your light box and get a fellow photographer to tell you what the pictures say to them about each subject, which they like best and why. What makes the best one work? How could you have improved the shots to make your point? Was differential focus the best technique to communicate the idea or mood you wanted to illustrate?

SEE ALSO:

White rhino and calf in Zululand hills

Using long lenses doesn't mean you always have to fill the frame with your subject and exclude an interesting background. This picture works precisely because the main subjects, lit by warm afternoon sun, are being dwarfed by the distant, but impressive hills. The telephoto lens flattens perspective, bringing the background closer to the rhinos.

Canon EOS-1N with 300mm lens, Fuji Velvia 50 ISO, 1/250 of a second at f/5.6

Painting with Light

WORKSHOP 1: LIGHT DIRECTION

You don't need us to spell out the make-or-break importance of light in good wildlife photography. Yet how often do we snap away excitedly when a photogenic animal strolls into range only to end up disappointed and crestfallen when we see the results? Recognize this syndrome? An everyday subject in great light can produce a great photograph, but a thrilling subject taken in poor light can only result in a mundane shot. Learning to 'see' the impact of light on our subject and its environment, to anticipate how the film we use will record that light, and understanding how to manipulate lighting to dramatic effect are crucial in developing your skills as a wildlife photographer.

For the purpose of this book we are going to look separately at two key aspects of light: 'direction' and 'quality'. Bear in mind the two are actually inextricably linked. Both quality and direction of light can enhance or diminish the definition of shapes and textures in the frame and influence the sense of perspective and mood.

Front-lighting

Light direction is most simply described in terms of front-, back- and side-lighting. Front-lighting is sometimes referred to as 'beginner's lighting' because it is the easiest form of lighting to

Wildcat snarling (C)

This wildcat was being encouraged to snarl by the offer of food from its handler. With the cat moving position constantly, it was necessary to use a handheld camera in order to adjust composition frequently, keep the background clean, and stay focused on the eyes. With all that to think about, it was helpful we could work with simple front-lighting, the safest option, ensuring exposure could be left to the camera's meter, and there was enough light to freeze movement. If your subject is interesting, it doesn't always matter that you choose the least inspiring lighting option.
Canon EOS-1N with 70–200mm zoom, Fuji Velvia 50 ISO, 1/320 of a second at f/5.6

Lappetfaced vulture

This vulture was photographed about half an hour after sunrise as it warmed itself on a cold morning. The viewpoint was carefully selected to ensure a clean silhouette (slightly closer and the beak would have been lost behind the shoulder) and to exclude the sun from the background. A meter reading was taken from the sky, and 1/3 stop underexposure dialled in to ensure the bird itself was black and the sky's colour was beefed up.
Canon EOS-1N with 500mm lens plus 1.4x converter, Fuji Sensia 100 ISO, 1/250 of a second at f/5.6

work with. Your camera will meter most reliably off front-lit subjects, it's reasonably easy to get catch-lights in the eyes, and reveal detail in fur and feathers. If the sun isn't too high in the sky, front-lighting also allows you to flatten unwanted and distracting shadows. This is often the best sort of light for plain, illustrative photography.

On the downside, front-lighting tends to flatten perspective because the absence of shadows produces a limited tonal range and a two-dimensional feel. Hard front-lighting also tends to wash out colours and conceal texture.

Side-lighting

Side-lighting, on the other hand, is more difficult to work with, since it is trickier to get correct exposures, but it can be very rewarding in terms of results. Side-lighting emphasizes depth, dimension and form, creating a sense of perspective, with shadows that accentuate textures and provide tonal contrast. Direct side-lighting can be an unflattering way to photograph people – it brings out every line and blemish – but is excellent for wrinkly skinned creatures such as elephant, rhino, or reptiles. It is also very effective for emphasizing musculature in powerful animals such as big cats, great apes, large deer and antelope.

Side-lighting is particularly effective when the sun is low. Rich lighting and elongated shadows really enhance the three-dimensional effect. You can use it effectively to isolate a single animal against a clean background. It's also the easiest light for getting catch-lights in the eyes.

The biggest problem with it is that it can produce excessive contrast between the dark shadows and the brightly lit side of your subject. In hard light the contrast range may well

White rhino close up

The heavy shadow produced by strong side-lighting doesn't suit every subject, but with a powerful heavyweight like this rhino it really emphasizes the animal's physique and the drama of a close-up, eyeball-to-eyeball confrontation. Side-lighting also adds an attractive glisten to the wet mud on the rhino's nose and legs.
Canon EOS-1N with 70–200mm zoom, Fuji Velvia 50 ISO, 1/200 of a second at f/8

exceed the exposure latitude of your film. It's best to use spot metering, and take readings from the illuminated side of the animal, making any necessary exposure compensation if the subject is darker or lighter than mid-toned. You will also find that contrasty film emulsions, such as Fuji Velvia, exaggerate the problem, so load a film with lower contrast unless you are deliberately looking for this effect.

If you are photographing relatively small, static subjects, such as fungi or flowers, you can always reduce the contrast problem by bouncing light back into the shadows using purpose-designed reflectors, or improvize with a sheet of paper, white card or aluminium foil.

Back-lighting

Shooting into the sun is perhaps hardest to handle, but back-lighting can produce some of the most eye-catching results in wildlife photography. Most effective in the early morning or before sunset, the technique works to good effect when used to enhance the translucence of back-lit dust, grasses, mist, dew, flower petals or leaves. It produces an attractive halo of rim-lighting around some subjects, outlining fur, the tiny hairs on plants or soft feathers, and works well with translucent subjects such as leaves and petals. Back-lighting can also suggest perspective by throwing long shadows towards your camera.

You need to watch out for lens flare when shooting into the sun, as this reduces contrast and colour richness. Use a lens hood or something to shield your lens from direct light. Alternatively, you could try shooting from the shade of a tree, building or vehicle, or even use your own shadow, firing the shutter with a cable release if necessary.

Accurately exposing a back-lit subject can be tricky – you have to be careful to meter off the subject. Try using spot metering, though you may need to dial in some positive exposure compensation to bring out detail. You can also try bouncing light back into the subject with a reflector, or use a touch of fill-in flash, set to underexpose by about one stop.

One occasion you don't want to meter off a back-lit subject is when photographing silhouettes. Silhouettes work best when kept simple and uncluttered, with your subject placed against a clean background of sky or bright water. Here you need to meter from

Steppe buzzard on a termite mound

A low evening sun cast a strongly directional side-light on this buzzard, emphasizing its three-dimensional form and that of the termite mound on which it was perched. Front-lighting would have produced a standard 'fieldguide' shot, with more information on colour and plumage, but a flatter, less interesting sense of perspective.

Canon EOS-1N with 400mm lens, Fuji Velvia 50 ISO, 1/125 of a second at f/5.6

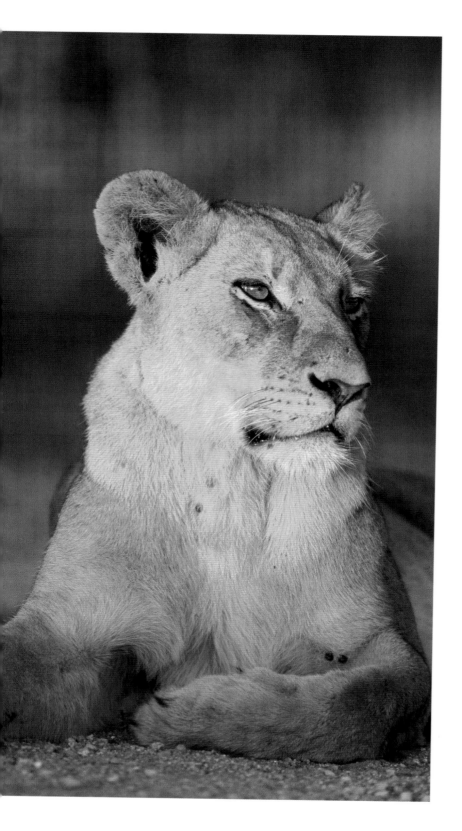

Lioness at sunrise

Soft, warm light made for a simple, flattering portrait of this lioness as she soaked up the first warm rays of the early morning sun. But with the sun directly behind the camera the picture was a little flat. Adjusting our viewpoint slightly added a touch of side-lighting, which gave more depth, and a strong catch-light in the eye.

Canon EOS-1N with 500mm lens, Fuji Sensia 100 ISO, 1/60 of a second at f/5.6

Springbok in the Kalahari

Strong back-lighting was the key to this moody early morning image. The antelope themselves are thrown into silhouette, paring back the information content to just the bare essentials of form and shadow. Dust thrown up by the springboks' activity catches the sunlight, bathing the scene in gold.

Canon EOS-1N with 400mm lens, Fuji Velvia 50 ISO, 1/400 of a second at f/4

the bright background, ensuring the animal will be underexposed to produce a crisp, dark shape. Make sure you focus on the animal not the background, though, and try to catch your subject in a characteristic pose, as the shape alone must identify the animal in your picture. Silhouettes against sunset skies can look stunning, but bracketing your exposures is a good idea, as a range of different exposures can all work in their own way.

We've majored on front-, side- and back-lighting, but of course there are many occasions in wildlife photography when you'll be photographing in diffuse light, which is apparently non-directional. Even on a cloudy day, however, the quality of light falling on an animal will show subtle variations, depending on the relative position of the obscured sun, which you will need to consider when searching for the ideal viewpoint. In overcast conditions we usually try to position ourselves so that the sun, were it shining, would be behind us, as this gives a slightly more pleasing light. We will look in more detail at diffuse light in the next chapter.

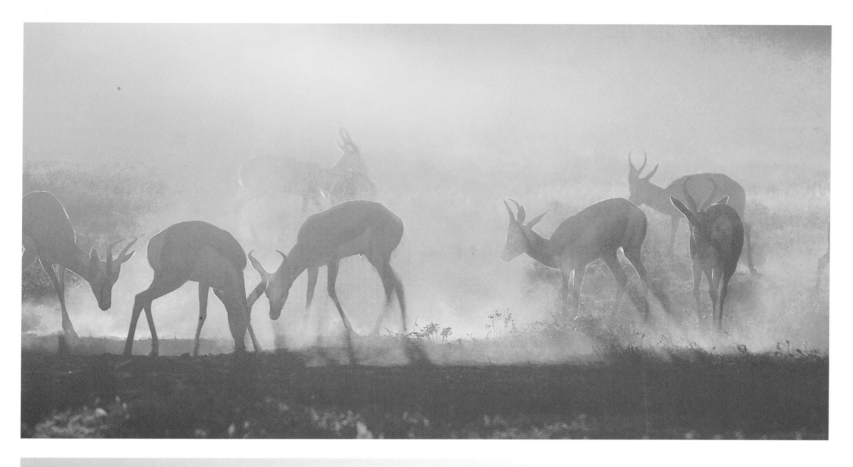

PRO TIPS

▶ If a front-lit subject looks flat and two-dimensional, try altering your position to introduce a touch of side-lighting, which will bring out modelling.

▶ Front-lighting mutes the colours of many subjects, but the iridescent hues of birds such as kingfishers and starlings are often seen at their best in front-lighting.

▶ To avoid flare when shooting into the sun from a vehicle, position yourself on the 'wrong' side from the subject and shoot through the vehicle, using its roof as a lens hood to shield your lens from the sun. Similarly in a hide, pull back your lens as far into the hide as you can.

▶ You can use lens flare deliberately to reduce contrast and give a misty, ethereal effect to a scene, but this is a hit and miss technique.

▶ Back-lit and side-lit subjects look particularly dramatic if you can frame them against a dark background – adjust your viewpoint if necessary.

▶ Very dark shadows produced by strong side-lighting can add drama to shots of powerful animals – a looming bull elephant, for example.

▶ Colour can be a very important aspect of animal behaviour, such as courtship or threat displays. If you want to document this behaviour in your photograph, position yourself so that the light best brings out the colour.

BEWARE!

▶ Try to ensure front-lit subjects are evenly illuminated. It's very hard to get good results and expose satisfactorily if your subject is in dappled shade.

▶ When shooting silhouettes against a sunset sky, don't give up once the sun has dipped below the horizon. Some of the most beautiful, subtle colours occur in the 15 minutes after sunset.

▶ Make sure your shutter speed is fast enough to freeze subject movement when shooting silhouettes in low light, such as just after sunset. Consider using a faster film and make sure your camera is rock-steady.

▶ Contrast problems in hard side-lighting can be exacerbated by the type of film you use. High contrast films, such as Fuji Velvia or Kodak E100VS, will make dark shadows appear even darker, whereas films such as Fuji Astia or Kodak E100S can reduce excessive contrast.

▶ Don't get carried away with overuse of fill-in flash in tricky conditions, such as shooting into the light or when the light is very low, as your pictures can become repetitive. Watch out for an unnatural extra catch-light in your subject's eyes when using fill-in flash.

ASSIGNMENT

There is rarely a single best direction of light in which to photograph any given subject, and different characteristics of a subject are best photographed in different light. The aim of this assignment is to make a photographic essay of a single tree, using light from different directions to portray the whole tree to best effect and to complement individual elements of the tree as well. Pick a tree that stands in isolation, so you can view it from all sides. Start by photographing the whole tree – you might use a telephoto from long range, framing it in strong back-lighting against a dark background, then choose a wide-angle, close-up viewpoint in front-lighting to reveal more detail. Next, look at individual bits of the tree. The leafless branches of a deciduous tree in mid-winter might be photographed against a bright sky, throwing them into bold, stark silhouettes which emphasize their overall form. You could move in tight for a close-up, near abstract shot of bark, side-lit to emphasize texture. If the tree is in leaf or blossom, experiment by photographing a small section of foliage in both front- and back-lighting. Leaves could be shot in close-up to show delicate colour and texture, or as a frame-filling wallpaper shot of blazing autumn colour. The object is to find the light direction most suited to each frame. Ideally, you can revisit the tree and photograph at different times of day and in different weather. What would be the best light to portray the delicate traces of snow or frost on the branches, or catch the mood of a misty day? How does strong back-lighting compare when used to create a halo of green foliage in springtime, or throw dramatic shadows towards the camera in winter? Review your results and analyze how light direction affects the depiction of form, texture and colour. What have you learned? Consider how you would use this knowledge next time you photograph in less controlled situations, with wild animals for example.

SEE ALSO:
Quality of Light, 65–69 Filters and Fill-in Flash, 70–75 Weather, 76–81 A Sense of Time, 133–139

It's amazing how often we don't really notice what's right in front of our eyes. Take sunshine, for example. We become so conditioned to believing colours are brighter on a sunny day, we fail to notice how much direct sun washes out colour. If you really want to enjoy the rich greens of woodland foliage, the jewel colours of a pheasant's plumage, or the vivid palette of your garden in summer, try taking a closer look at them on an overcast, rainy day.

Learning to see, not merely to look, is fundamental to appreciating the subtle influences of light quality on the scenes we photograph. Light changes not merely from season to season, or day to day, but from moment to moment.

We've already considered the direction of light and its importance in the representation of perspective, form, and texture. But light has other qualities, too – notably colour, intensity and whether it is hard or soft. Quality of light not only affects the tones and hues in your picture, but its mood and even its message.

Technical considerations

The aim is to find the quality of light that best complements your subject. How you deal with light quality, however, is dictated as much by key technical considerations as it is by aesthetic or creative ones. The amount of light actually falling on your subject may be the least interesting element of light quality, from an aesthetic viewpoint, yet is vitally important in determining the

Eastern grey kangaroo I and II

These two eastern grey kangaroos were photographed within a few metres of one another, using the same film stock. The two pictures were taken in the late afternoon only a few minutes apart, yet the light quality is completely different in the two images. In the first (top right) the sun was behind a cloud, and the overcast light is soft but fairly cool. Moments later the sun came out from behind the cloud and lit the second 'roo (right) with a warm, golden light. Both images work, but evoke quite different moods.
Canon EOS-1N with 300mm lens, Fuji Velvia 50 ISO (I)
1/60 of a second at f/5.6 (II) 1/125 of a second at f/8

65

Blackbacked jackals

The sun was only half-risen when this photograph was taken, producing a beautiful, soft, delicate warmth, and the subtlest of colours. It's a lovely effect, but means using a very slow shutter speed even at maximum aperture, so bracing firmly (in this case on beanbags) is essential. The second jackal is a little soft, but more depth of field would have meant an even slower shutter speed.

Canon EOS-1N with 300mm lens, Fuji Provia 100 ISO, 1/15 of a second at f/4

Whooper swan aggression

Bright winter sunshine and a front-lit subject don't make a particularly exciting combination, but work well when you require enough shutter speed to freeze the moment, as with this whooper swan 'honking' aggressively. The other compensation was the attractive blue colour of the water – much more appealing than the muddy colours on most winter days.

Canon EOS-1N with 400mm lens, Fuji Sensia 100 ISO, 1/320 of a second at f/8

techniques you'll need to ensure a sharp image. This is particularly significant when photographing in low light levels, where you need to avoid camera shake and subject movement at the same time as achieving adequate depth of field.

Technical considerations may also dictate your response when faced with hard light or soft light. Will your film's reaction to the tonal range in a picture affect the degree of contrast in the end result when the light is hard, for example? But since hard or soft lighting can have a powerful impact on the mood or message of an image, and can be particularly helpful when you wish to convey a subject's character, this is where you can start to get more creative in your handling of light. Direct sunlight is hard, producing strong shadows, great for portraying a belligerent large mammal with strong physical features. The softer, more forgiving qualities of skylight, on the other hand,

can be used to good effect when you want to create a gentler mood. A good way to add emphasis to your pictures is to match light qualities to the characteristics that, for you, define a subject. As a rough rule, however, bear in mind that when photographing animals on a bright day, the soft light of open shade will generally be more flattering than hard sunlight.

Season and time of day

Next is the question of how you will use the overall colour of the light. This can influence our emotional response to an image quite significantly. Think of the rainbow: red is hot and assertive, oranges and yellows are warm and inviting, greens and blues, cool and restful, while indigo and violet are sombre and withdrawn. Bright, saturated colours make us feel good, muted pastel tones relax us. The colour of light can vary with

weather, season and time of day. Think of the blue cast of a snowy landscape or the golden hues of sunset. Often, we don't notice the true colours in a scene, or we come to it with preconceived ideas. Try looking more closely at the effects of light on colour the next time you look through your viewfinder.

The most productive time for wildlife photography in fine weather is the first hour or two after dawn and the final hour or two of daylight, when the quality of light is soft, warm and golden. This is also the time when side-lighting and back-lighting are most effective. The problem is, we can't always photograph at these times for a number of reasons. Some wildflowers only open their petals during bright sunshine, while elephants, notoriously late risers, are unlikely to be seen splashing around playfully in waterholes until the middle of the day. The solution, when you to need to photograph in bright midday sun, is to manipulate the light quality by using filters – a polarizing filter to stop colours looking washed out or a warm-up to counter the blue cast you can get on these occasions.

It's much easier to photograph at these times when the sun is obscured by cloud. Cloudy-bright light, when cloud cover diffuses sunlight, is one of our favourite working conditions. The shadowless light on an overcast day is excellent for holding detail in fur and feathers, produces natural colours and eliminates the problem of high contrast, making it a lot easier to achieve successful exposures. We find this light gives the best effects in shots where the subject is fairly large in the frame and you are able to keep the sky out of your shot – making it perfect for animal portraiture.

In more heavily overcast 'cloudy dull' light conditions, however, your headaches really start. Colours fade and shutter speeds can be too low to freeze movement. But you don't need to give up entirely if you have a strong subject. The results can turn out better than they appear to the naked eye, if you can overcome the speed problem in order to use a film with rich saturation, like Fuji Velvia, to bring up the colour. Adding light by using fill-in flash is another option if your subject is close enough. Dull light is particularly good when photographing white or very pale wildlife subjects, as shadowless, low contrast light helps to prevent whites from burning out.

Impala

Overcast but bright weather is perfect for photographing delicate close-ups of fur or feathers, especially with a film that boosts colour saturation. These three impala, a little nervous at our presence, were seeking mutual reassurance.
Canon EOS-1N with 300mm lens, Fuji Velvia 50 ISO, 1/60 of a second at f/11

There will still be plenty of occasions when you simply won't have time to worry much about the aesthetic quality of light. Photographing animal action or behaviour often means relying on instinct and fast reactions to capture the decisive moment. It's all you can do to check basic technical details like shutter speed and aperture – light is an issue only in terms of whether there is enough of it. But when you do have time to analyze and exploit the aesthetic qualities of light, go for it!

Elephants in waterhole
Sometimes as a photographer you have no choice but to photograph in less than ideal light. These elephants only came down to water to cool off at the hottest, brightest time of day. The harsh, contrasty light is unavoidable, but the appeal of the subjects saves the picture.
Canon EOS-1N with 500mm IS lens plus 1.4x converter, Fuji Sensia 100 ISO, 1/320 of a second at f/8

PRO TIPS

- ▶ If you want to show how an animal blends into the surroundings – perhaps a moth camouflaged against a tree trunk – diffuse light, which gives soft, muted colours can work best. Avoid using flash, which produces tell-tale shadows.
- ▶ Try using very fast films (ISO 800 or above) when you are looking to increase mood in very low light shots. This can give an attractive, grainy effect not widely exploited in wildlife photography.
- ▶ In very dry, arid environments, which can look particularly washed out under a high sun, we've found it can sometimes help to underexpose slide film a little, although we don't tend to do this with Velvia. Alternatively, using a warm-up filter can sometimes rescue a picture.
- ▶ To photograph forests, woodlands or green foliage pick an overcast day for the best results, but frame shots carefully so there is no sky in your shot.

BEWARE!

- ▶ The magic hours of early morning and evening light may produce appealing colours, but actual light levels can be very low. Be very careful about camera shake and subject movement.
- ▶ Heavily saturated films, such as Fuji Velvia, can produce spectacular effects when shooting in the golden hours after dawn and before dusk, but the punchy colours can look overdone. A faster, less saturated film (100 ISO) is often better for this, and has the advantage of giving you more speed. Experience and experiment will teach you when to switch films.
- ▶ When photographing in overcast conditions, compose your picture without any white sky in the frame. White or pale grey sky makes accurate exposure difficult, and looks very unattractive in photographs. Alternatively, use a grey graduate filter to darken the sky and reduce problems with contrast.

ASSIGNMENT

Sunsets may be something of a photographic cliché, but the constantly changing light quality before and after sundown is well worth exploiting in wildlife photography. Check local sunset times (your local newspaper should tell you) and find a subject you can photograph at dusk, with the setting sun behind you – a deer park, waders feeding on a shoreline, geese settling to roost in a field, whatever inspires you. You will need to work with your camera well supported, either with a sturdy tripod or beanbags, and use a film of at least 100 ISO. Take photographs during the half hour before sunset, then continue for another half an hour afterwards. As the light diminishes you will need to work at maximum aperture if you want sharp images, so choose your point of focus carefully. In addition, try some slow shutter speed exposures on moving subjects, as the combination of motion blur and soft light can be very effective. Review your results and assess how the changing light quality has altered the colour, definition and mood of your images. Which effects best suit your chosen subject? Which shot conveys the mood most successfully? You can repeat the exercise shooting into the light, using a sunset sky as a backdrop to your subjects. Again, you should see dramatic changes in light quality and mood in the space of just a few minutes.

Leopard on log

As the sun sank behind our hide, it cast a warm, orange light, which perfectly complemented the cat's golden coat. At this time of day, in low light with an active subject, we had to use a 100 ISO film, but Velvia 50 ISO may have overcooked the already vibrant colours, so a less saturated film was perfect.
Canon EOS-1N with 300mm lens, Fuji Provia 100 ISO, 1/60 of a second at f/8

SEE ALSO:

Exposure, 17–22 Light Direction, 59–64 Filters and Fill-in Flash, 70–75 Weather, 76–81 A Sense of Time, 133–139

WORKSHOP 3: FILTERS AND FILL-IN FLASH

We prefer to photograph in natural light whenever possible, but there are times when nature needs a helping hand. Filters and flash are the two easiest ways to give that help, allowing you to manipulate or add to available light levels where necessary, or correct the way colours are recorded. The secret to using both is moderation.

Filters

Compared to landscape photographers, wildlife specialists tend to use filters very sparingly. When photographing a fast-changing situation or shy, difficult subjects, fitting a filter can cost precious seconds of time. When trying to freeze an animal's expression, movement or behaviour, speed is of the essence, and since most filters cut down the amount of light reaching your film, by up to two stops of light in some cases, their use isn't going to prove that helpful to you.

That said; there are times in wildlife photography when filters do come in very useful. Used judiciously, they can enhance and improve a wildlife image; used inexpertly, they can overwhelm it, make it appear artificial-looking, or even ruin it. The effects of using filters may be very subtle, for example where a filter is used to reduce the contrast between the light and dark areas in your picture, but this isn't a requirement. Filter use doesn't have to be undetectable. Nothing is subtle about a heavily polarized wildlife shot, and you don't need to be

a skilled picture researcher to know when a polarizer has been used, yet most of us respond positively when the colours in a photograph, particularly blue skies, are enriched in this way. As ever, the creative choice rests with you.

Two filters we wouldn't be without are a circular polarizer and a warm-up filter. Even though we generally use film with

Quartet of little corellas

This shot of corellas in Australia's Kakadu National Park was heavily polarized to produce an inky blue background and prevent the birds' pale plumage from looking washed out against the powder blue of a mid-morning sky. The birds were fairly still and the sunlight was very bright, but a tripod was essential to ensure a sharp image.

Canon EOS-1N with 400mm lens plus 1.4x converter, polarizing filter, Fuji Velvia 50 ISO, 1/50 of a second at f/8

quite saturated colours there are occasions when the end result doesn't quite match up to the vividness of the original scene. Both these filters can spice up colours in a pleasing way, providing you don't overdo it, and, on occasion, both will allow you to keep on photographing when natural lighting conditions might dictate otherwise. On overseas trips we can extend our shooting times considerably in the middle of the day when the sun is harsh simply by using a polarizing filter, and when it's overcast, or we're shooting in shade, a warm-up serves the same purpose. For us this makes sense commercially as well as creatively!

Polarizers

Polarizers work by cutting glare and reflections from water, shiny surfaces and particles in the atmosphere to enhance the colours in a scene and make them look darker. You get the strongest effect when the filter is used at right angles to the sun, and by rotating the filter you can both check and control the level of its effect. As well as its conventional use

for deepening blue skies and making white clouds stand out more, a polarizer can sometimes help define reflections in water and, by removing surface glare, can allow you to photograph wildlife just under the surface. You can also use a polarizer to damp down reflections on a reptile's skin, or reduce the sheen on damp woodland foliage to bring out the natural colour. A polarizer at full effect costs you up to two stops of speed, so think carefully about camera shake and subject movement when using one.

Warm-up filters

For warming-up images we use an 81 series amber filter. These colour-correcting filters get progressively stronger from 81 to 81EF. We prefer the weak 81A, as we don't want the effect to look obvious, and because we regularly use fine-grain film that already provides us with rich colour rendition. For the most part, warm-ups are useful to enrich light on duller days, or to alter the cool cast when photographing in shade, but we also occasionally use this filter in bright sunlight to counter a bluish cast.

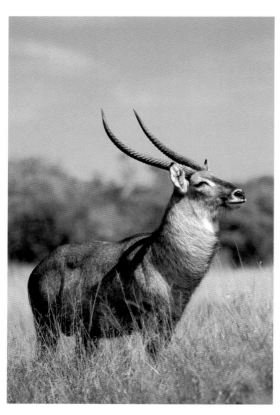

Waterbuck without filter (I) and Waterbuck with warm-up filter (II)

Bright midday sunlight can produce a cool blue cast in your pictures. You can pack up and wait for better light or try using a warm-up filter to counter this effect. The first shot of the waterbuck (far left) was taken without a filter, in the second (left) an 81A warm-up filter was used.
**(I) Canon EOS-1N with 300mm IS lens, Fuji Velvia 50 ISO, 1/350 of a second at f/5.6
(II) Canon EOS-1N with 300mm IS lens, 81A warm-up, Fuji Velvia 50 ISO, 1/300 of a second at f/5.6**

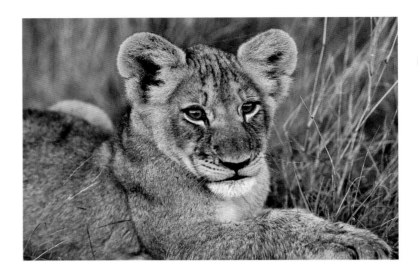

Thrush gathering grubs

Some photographers routinely use a warm-up filter in most of their work. We find they work best in dull conditions, to enhance subjects with similar or complementary colours such as earth tones, yellows or soft browns, as in this shot of a thrush.
Canon EOS-1N with 300mm IS lens plus 1.4x converter, 81A warm-up filter, Fuji Sensia 100 ISO, 1/160 of a second at f/5.6

Lion cub

We were following a pride of lions with small cubs on a dull day in persistent drizzle when they decided to rest next to our vehicle. There was scant light to work with, but we didn't want to miss the opportunity to get some close-ups of the cubs. Fill-in flash was essential to bring the shots to life. Although it's very slow, Velvia helps to intensify colours in these low light conditions.
Canon EOS-1N with 300mm lens, Fuji Velvia 50 ISO, TTL fill-in flash set to -1.3 EV

Neutral-density filters

If you're going to do a lot of wildlife habitat shots then a graduated neutral-density filter is handy to combat the problem of high contrast between very pale sky and darker land. This filter will darken the sky without adding an artificial colour cast. An ungraduated neutral-density filter has occasional value, reducing the amount of light entering your camera in bright conditions and thereby allowing you to shoot using slow shutter speeds, if, for example, you want to show motion blur.

Skylight filters

One filter we don't generally bother with is a skylight filter. Some photographers use them all the time as transparent lens caps to protect the front of their lenses, but we're of the school that says there's little point spending hard-earned cash

on good-quality lenses and then sticking a cheap bit of glass in front that's going to degrade the quality of the image. Lens hoods provide better protection anyway.

Fill-in flash

Flash is a scary subject to many photographers, but modern automatic flashguns have really made it much easier. Using flash for photographing nocturnal wildlife is still a fairly technical, specialized area, requiring multiple units for reliable results, but fill-in flash for daylight use is simple and effective to use. Even the small pop-up flashes built into many cameras can help lift a close-range picture, but a reasonably powerful, dedicated flashgun designed to work automatically with your camera is a worthwhile investment. Use it on an L-shaped bracket, rather than on the camera's hot-shoe, as this will reduce red-eye.

Fill-in flash is flash used to complement natural light, rather than overwhelm it. If you photograph in strong, contrasty light, particularly with slide film, then your images can lack detail in the shadows. A small burst of fill-in flash lifts these areas and reduces overall contrast. It can add sparkle to eyes and remove colour casts on subjects photographed in shadow, and on heavily overcast days can boost colour rendition and add punch to your pictures. To ensure the flash remains subsidiary to the ambient light in the picture, set negative flash exposure compensation on your camera. Around -1.6 EV is about right for a mid-toned subject, but for dark subjects use around -2.0 or -2.3 EV to avoid over-lighting them, while light subjects may need -1.0 EV to ensure they get enough illumination.

Even the most powerful flashguns have a limited range out of doors, where they don't have the benefit of light bouncing from ceiling and walls, though you can use a specially designed Flash X-tender to focus the flash beam and increase its range. At very close range, with static subjects, it's better to use reflectors to bounce light into dark areas, as the result is more natural. When we do use fill-in flash we also take a shot without flash whenever possible.

Kurrichane thrush
This thrush was perched in heavy shade. Fill-in flash gave the extra illumination necessary to prevent the bird from recording on film as a dull silhouette.
Canon EOS-1N with 70–200mm lens, Fuji Velvia 50 ISO, TTL fill-in flash set to -1.6 EV

PRO TIPS

▶ Buy the best-quality filters you can afford, as more expensive filters will degrade your images less.

▶ A UV filter will reduce the bluish cast you sometimes get when photographing in mountains as a result of the increased ultra-violet radiation at high altitude.

▶ A warm-up filter can enhance the effect when photographing at sunset.

▶ When using short lenses plus a polarizer to shoot animals in a wider scene, a blue sky broken up by fluffy white clouds can look more effective and interesting than a purely blue sky. Conversely, a close-up portrait of an animal set against a blue sky often works best on a cloudless day, giving you a simple, all-blue backdrop with no distracting clouds.

▶ Amber warm-up filters work best when used with complementary colours, such as yellows, reds and earth colours. They can be used effectively to enhance the colours of autumnal foliage.

▶ Sometimes, filters are used to correct colours; for example, to render blue flowers accurately on film. However, opinions differ as to whether using a blue filter is the best approach for this. Some photographers advocate using tungsten-balanced film, others pick a blue sky day but wait for the sun to sink low in the sky. We use Fuji Velvia for blue flowers in cloudy-bright conditions, but it's worth experimenting to find what looks right to you.

Plains-grazing white rhino
Polarizing filters should be used in a controlled way. Here we wanted to enrich the bold colours without overdoing the sky. Fluffy white clouds in a blue sky often look better than a plain blue sky.
Canon EOS-1N with 35–80mm lens, polarizing filter, Fuji Velvia 50 ISO, 1/60 of a second at f/8

BEWARE!

▶ Sea-spray and cameras don't mix. UV or skylight filters come in handy when used in conjunction with a lens hood to protect your lens against the damaging effects of salt water.

▶ Watch out for vignetting when using polarizing filters with wide-angle lenses. Polarizers are most effective when used at right angles to the sun. Don't get carried away – polarizing often works best when kept subtle.

▶ The amount of lighting reaching your film can be greatly reduced when using filters, which can sometimes mean photographing at slower speeds than would be ideal, thus increasing the risk of camera shake or subject movement. Be confident that a filter will improve your shot before fitting one to your lens.

▶ Fine-grain films often produce very saturated colours. Get to know how your films respond to filters in different lighting, as sometimes the effects can be over-the-top.

▶ Be careful when using a graduated neutral-density filter that you align the filter correctly on your horizon and use a large aperture, or you'll end up with tell-tale stripes above or below it that will spoil your picture.

▶ Warm-ups won't look good where the scene is supposed to look cool. Avoid their use when photographing snow, and white subjects generally, although they can help when photographing frost in shade.

ASSIGNMENT

Think of filters for wildlife photography less as the special effects department in your equipment bag and more as helpful colour and light correctors. Remember that while they can sometimes improve the final result, you may have to trade speed for any benefits they bring. The best way to understand just what these tools can offer you is to practise using them in the field. It's really only by experimenting that you will be able to assess how well you like their effects and when they work best for you. For this assignment you will need a polarizing filter, a blue-sky day, a scenic stretch of water lined with trees, and your lunch hour. Expose a roll of film by making a series of images of the scene with or without any available wildlife. For each image you compose, take one frame without the filter and two more with it. Rotate the filter and take one shot where the polarizing effect appears quite subtle and another where it is more intense. Take a range of photographs, with and without water, sky and trees, altering your position so that the sun is at different angles to the scene. Look at the results to identify which shots stand out. In which shots is the colour of the sky closest to what you saw on the day? Can you detect differences in the appearance of the water and foliage in the shots where you used the filter? Has the polarizer removed surface glare and enriched colours? Do the images that were most heavily polarized look natural? Do they look pleasing? Try repeating the exercise on an overcast day, exploring the pros and cons of using a warm-up filter with a 'live' subject or a still-life from nature. Experiment with polarizing and warm-up filters, using different films to familiarize yourself with their effects.

SEE ALSO:

Exposure, 17–22

Sharpness, 23–29

WORKSHOP 4: WEATHER

'The weather's good today, I think I'll go out with my camera.' Before you head out the door with camera straps swinging, ask yourself what really is good weather for wildlife photography.

The sunny days and pleasant temperatures that generally tempt us into the great outdoors certainly don't always provide the best conditions for stalking animals. It's often easier to get close to wild animals on a windy day, for example, when the sounds of your approach are lost among the other noises created by the wind. More importantly, 'good' weather tends to mean conventional lighting conditions. By contrast, challenging weather at the edges of available light can often increase opportunities for the more unusual, exciting shots all wildlife photographers strive for.

Wind-blown desert lion
Strong winds can really whip up on occasion in the Kalahari. The sun was getting high in the sky when this lion appeared, but seeing him battling through the elements of his harsh, barren habitat was an irresistible opportunity.
Canon EOS-1N with 400mm lens, Fuji Provia 100 ISO, 1/400 of a second at f/6.3

Although often tricky to handle, soft rain, snow, frost, mist and storms can all be great mood enhancers in wildlife photography. When the natural light is subtly dimmed or dramatically heightened as a result of changing weather conditions it's possible to crank up the emotional impact of your images. If you still need convincing, just take a look at the intensity of colour produced when the rays of a low sun fall directly on brooding storm clouds.

To fully exploit the opportunities on offer it helps to become more than a little obsessive about checking the

Barn owl in summer storm (C)
Heavy cloud building up before a storm can make for a dramatic backdrop. Bright light illuminating your subject against that ominous slate grey makes the bird or animal you're photographing really stand out. We spent an afternoon photographing the barn owl in a range of settings, but the shots with most impact were those taken from a low viewpoint against the looming storm.
Canon EOS-1N with 70–200mm lens, Fuji Velvia 50 ISO, 1/160 of a second at f/6.3

weather forecast so you are prepared. Depending on where you live, snow or frost may not hang around for long, so you need to act quickly to make the most of its potential. You might even want to draw up a 'wish-list' of images you'd like to photograph in extreme weather conditions, so you're not stuck for what to shoot when there's only a small window of opportunity.

Whatever the weather conditions, hot or cold, extreme temperatures can damage your equipment and compromise your safety. Your main concern is to ensure you and your camera gear can function effectively at all times. Once you're confident you've got both of these covered it's easier to concentrate 100 per cent on your photography. Wear appropriate clothing for the job and don't take risks with your camera – particularly if you don't have a spare camera body as back-up in the event of a malfunction. In heavy rain or snow, avoid getting your camera too wet by using a protective covering – a simple plastic bag can do the job – or work with a clear umbrella over your equipment.

Rain

Rain can be one of the most miserable conditions in which to photograph wildlife, as it usually means juggling with the

frustrations of shooting in low light at slow speeds while getting a soaking. In very low light conditions you may need faster film, and a firm camera support is essential. Yet rain offers a wide range of photographic bonuses, including images with soft pastel colours or the instant sparkle of shooting into the light.

Rain drops are great for providing added visual interest to close-ups, whether they are dripping off wet fur and feathers or hanging delicately from a flower-petal or leaf. Be alert to the way subjects behave when it's raining, too. Is rain welcome, bringing the promise of a much-needed drink, or is it a threat? Photograph groups of animals huddled miserably in the wet, or splashing about enjoying an end to a long, dry spell. And be ready for the magical moment when an animal shakes excess water droplets from its hair or hide. Select a slow shutter speed of about 1/30 of a second to enhance the feeling of movement, or go as fast as you can to freeze every last drop. To capture falling rain as a backdrop to your shot, position your subject against a dark background so the streaks of rain stand out. Underexpose the shot a little to keep the background dark and use a slow shutter speed of 1/15 or 1/30 of a second.

Young baboon after rain
During a particularly heavy African downpour we came across this young Chacma baboon quietly sitting out the storm. We waited for the storm to pass and for him to shake his fur, but when the sun came out he seemed content to just sit, dashing our hopes of an action shot. Instead we were able to shoot into the light which made the raindrops in the grass around him sparkle, while outlining his soggy fur with rim-lighting.
Canon EOS-1N with 400mm lens, Fuji Velvia 50 ISO, 1/320 of a second at f/5.6

Snow

Wildlife plus snow is always an attractive combination. A fresh blanket of snow transforms and simplifies a scene which can work to your advantage as a photographer. The headaches start when it comes to getting the exposure right. Snow can be frustratingly chameleon-like, changing its appearance according to the direction and brightness of the light, so you may need to experiment with exposure, and bracket widely to be on the safe side. In general, follow the same guidelines you'd use when metering for any light-toned subject, overexposing your picture according to how much snow is in the scene. More snow, more light is the rule of thumb, but how much can easily vary from +1/3 stop to +2 stops or more. It's never simple. For example, what do you do when you want to photograph a dark-toned wildlife subject at the heart of a light-toned snowscape? The easiest solution is to spot-meter from what you reckon to be a mid-toned part of the animal, or something else in the scene that's mid-toned and in the same light as your subject. Exposing for snow is easier if conditions are overcast, as this substantially reduces the high contrast often seen in snow-covered scenes.

Unpredictable or lousy weather ranks high on a wildlife photographer's list of bugbears, but providing you can keep warm and fairly dry it's often possible to turn many 'bad' weather conditions into excellent photo-opportunities. You'll still have plenty of time indoors to view, edit and file your results on those dark, dull days when the wind is howling and the downpours are torrential!

Teal 'skating' on ice (C)

Extreme weather conditions, such as ice and snow, can give your pictures a seasonal feel and provide an opportunity to observe how subjects react when their natural habitat is temporarily transformed. It helps to keep a list of places close to home where you can find ready subjects when there's a big freeze. We photographed this sharp-winged teal at a nearby wildfowl sanctuary.
Canon EOS-1N with 300mm lens, Fuji Sensia 100 ISO, 1/250 of a second at f/8

PRO TIPS

▶ It can be easier to photograph birds in flight when it's windy – their progress is slowed down, giving you more time to compose your picture while they hover or hang on the wind.

▶ Keep an atomizer spray filled with water in the back of your car so you can create raindrops or dew to order on a dry day.

▶ When photographing a frosty scene, overexpose your shots as you would for a snowscape, assessing the tonal range within the image.

▶ To retain detail in back-lit frost or ice, try underexposing a little.

▶ Stuck on how to expose for shots with mist or fog? Unless you're photographing mist made golden by a low sun at dawn, treat mist and fog as you would any other pale-toned subjects that could fool your camera's meter. Overexpose by as much as a stop to compensate.

▶ To bring out the colours of a rainbow try underexposing the shot by a 1/2 stop.

▶ In difficult weather it always pays to bracket your shots, taking a series of frames at slightly different readings to increase your chances of getting the image you want.

BEWARE!

▶ When photographing close-ups of ice or subjects outlined by frost, tones may vary considerably within the scene. You may need to adjust exposure for the dominant tones, or the way you want the picture to look.

▶ Don't overexpose by too much when photographing snow with the sun directly behind you, or you will lose all sense of its texture in your picture.

▶ In hot weather keep your film cool. We use small cooler bags to carry your film for each day when working in hot climates. Keep cameras and film out of direct sunlight.

▶ In hot and humid conditions there's a chance your equipment could get damaged if fungal growth develops inside camera bodies. Keep a sachet of silica gel crystals in your camera pack.

▶ Carry extra supplies of batteries in cold weather, as you'll get through them quicker. Keep batteries warm in a pocket close to your body, and insulate cameras under your clothes.

Fallow deer

Wildlife often congregates at food or watering points in harsh weather – in this case the stags were gathering around fodder put down by the deer park manager.
Canon EOS-1N with 400mm lens, Fuji Velvia 50 ISO, 1/120 of a second at f/8

ASSIGNMENT

Taking wildlife photographs in challenging weather conditions can produce quite stunning results, and will help to lift your pictures out of the ordinary. Learn to recognize the quality of light that different weather patterns offer you, and try venturing out to photograph from time to time in the sort of weather that would normally keep you at home. You'll need to keep an eye on the weather forecast for this exercise. Your assignment is to visit a favourite location for wildlife photography on a wet day instead of a fine one and take as many shots as you can, in light rain and immediately afterwards. Have a selection of slow and faster film in your pocket – if it's not too damp you might want to experiment using different ISO ratings (from slow to fast) to assess the effects on your pictures. Try a few shots at slow shutter speeds. Challenge yourself to see how many different shots you can take illustrating the impact of rain on the environment and wildlife around you. How does the rain change the way the place looks? Are the colours different, for example? Observe how the wildlife behaves and consider ways to record this on film. Have a go photographing the concept of 'shelter', for example. What happens when the rain stops? Is there potential for portraying how raindrops have transformed the scene? Can you find birds drinking or bathing in newly created puddles? Are there any reflections in these? And how has the rain altered the textures and surfaces in the natural environment around you? Critique your results, selecting two good points about each picture and two bad points. Look at the images that nearly worked and consider how to get them right next time.

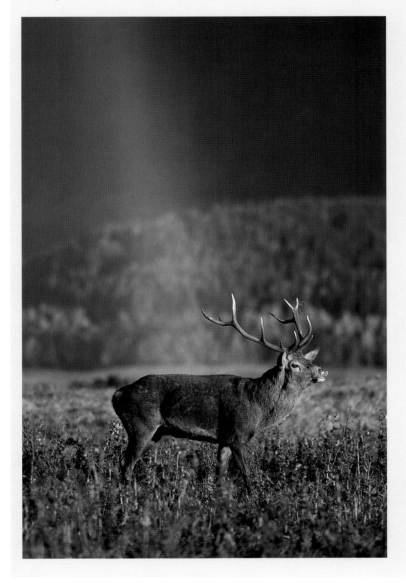

Red deer stag and rainbow (C)

After persevering in dull conditions and rain showers for most of the day in this deer park, we were relieved to see the sun break through and add drama to the distant storm clouds. A bright rainbow was an added bonus – by shifting the position of our vehicle and using a long telephoto lens we were able to foreshorten the perspective and maximize the unusual effect.
Canon EOS-1N with 500mm IS lens, Fuji Velvia 50 ISO, 1/160 of a second at f/5.6

SEE ALSO:

Exposure, 17–22 Quality of Light, 65–69 Filters and Fill-in Flash, 70–75 Behaviour, 120–126

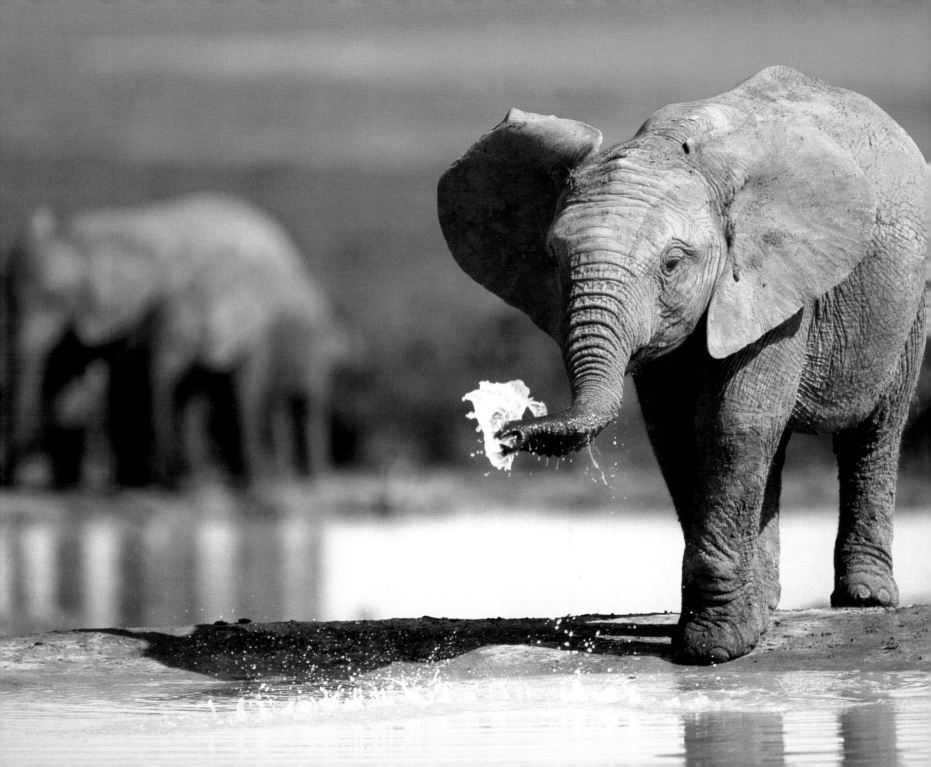

Composition

You might be forgiven for thinking landscape photographers have it easy. For a start their main subject isn't going to fly off or run away. And since they can usually move around freely, sampling possible shots through the camera from a range of viewpoints, they can usually afford a more considered approach than wildlife photographers when it comes to composition. Try this next time you're stalking an elusive subject through woodland with a weighty telephoto. It's not easy. The need to work rapidly can make creative composition feel like a luxury. With some subjects the best you can hope for is a fairly standard documentary shot that's sharp throughout.

There's nothing intrinsically wrong with this approach – one function of wildlife photography is to produce an accurate record of the subject. But it can get pretty boring. If you want to lift your wildlife work above the purely documentary, there are some basic 'rules' for making strong photographic compositions that will help you produce more visually appealing images. And the more you practise using them, the more instinctive and quickfire the act of composing wildlife pictures will become.

Young elephant blowing bubbles
Subsidiary elements in a picture can be complementary or distracting. By adjusting our position we were able to use the background elephants to balance the composition. We could have closed in on the young elephant, but would have lost any sense of place and depth.
Canon EOS-1N with 500mm IS lens, Fuji Sensia 100 ISO, 1/300 of a second at f/8

Composition is a personal statement. It's the way you choose to present the elements within the frame to your viewer. For this reason, it can be liberating to think of the 'rules' for good composition more as guidelines or conventions. There's no obligation to adhere to them, but they can provide you with a framework within which to develop your own creative style.

Before we look at them in detail, it's time for a brief word about choice of viewpoints when composing wildlife pictures. In our experience, the most naturalistic and appealing viewpoint for wildlife is to photograph at eye-level with your subject – even if this does mean lying flat on the ground to eye-ball the little critters.

Focal point and framing

Having established this, the first rule of good composition is that your picture needs a focal point. In wildlife photography this will usually be the subject itself or that part of it you have pre-selected to highlight. Be clear in your mind about it. The remaining decisions you make about framing the shot will be based around bringing this out.

Consider whether the image will work best in landscape or portrait format. In many cases, the shape and position of your subject will dictate this, but it's worth noting that a viewer's response to your picture may vary according to which you select. Portrait format tends to make subjects appear more imposing, while landscape conveys a sense of stability and appears more natural to the eye. Subjects appear less confined when framed in landscape format, making this the more obvious choice when photographing flocks or herds, a running animal or a flying bird.

Galahs on a gum tree

Faced with a large, confused group of subjects, such as this flock of galahs, it pays to look for structure and design within the image; in this case the repeated shapes of the branches with birds strung out along them. The strong lines fill the frame in a dynamic way and serve to direct the eye up and down the picture area.

Canon EOS-1N with 400mm lens, Fuji Velvia 50 ISO, 1/250 of a second at f/5.6

Immature mute swan

Try to keep the viewer's eye moving around within your picture rather than leading it out. In this shot, the eye is first drawn to the head of the bird and then the water droplet suspended beneath its beak which creates a brief moment of tension. Following the predictable path of the drip to the surface of the water, our eye then moves back up the curving diagonal of the swan's neck and the process starts over again.

Canon EOS-1N with 300mm lens, Fuji Sensia 100 ISO, 1/500 of a second at f/5.6

Subject position

Next is the more complex question of where to position your main subject within the frame. As a rule, it's best to avoid the bang-in-the-middle approach, which looks formal and static. Providing your subject is photographed looking into the picture, helping direct the way our eyes move over the image, a composition is often stronger when the main subject is positioned to the left or right of centre in the frame. Because we scan images from left to right, a subject placed on the left, but looking to the right, arrests our attention and leads us in. Conversely, an animal placed on the right of centre looking left stops our gaze from wandering out of the frame and leads it back in again. This principle is particularly useful when photographing moving animals, which tend to look better moving into the frame.

Just as it's not generally a good idea to position subjects centrally, a central dividing line that cuts a picture into two equal halves, like the horizon or the surface of a pond, can detract from the content in a picture. Too much symmetry is not visually stimulating and tends to take the attention away from your focal point.

The rule of thirds

This is where the much-quoted rule of thirds, that you've no doubt already come across in books and photographic magazines, can help. We make no apologies for quoting it again here – like a lot of things that have been around for ages, it works and is simple to use. All you need to do is to think of the picture area as a blank sheet of paper divided into thirds lengthways and widthways. Effectively this divides the frame into a simple grid.

You can use the lines of this imaginary grid to help you position subjects on dividing lines, like the horizon or pond surface, to better effect in the picture. Placing the pond surface along the lower or higher dividing line generally looks better than crudely cutting the frame in two. Which you choose depends on which part of your image you want to emphasize – if you want to make the foreground more prominent opt for the higher dividing line, if you want to show an expanse of sky select the lower one.

The four points on this imaginary grid where the lines intersect, often referred to as the 'junctions of the thirds', act as visual hotspots in the frame. By placing your subject, or the main focal point of your picture, on one of these hotspots, the overall affect can appear harmonious and pleasing. It's a design device particularly suited to wildlife photography where you often want to locate your subject within its surrounding habitat and don't always want to go in really tight.

If all this is starting to sound too formulaic, bear in mind that once you've grasped the basic rules, using them soon becomes second nature. And the fun part is you can always go ahead and break them whenever you want.

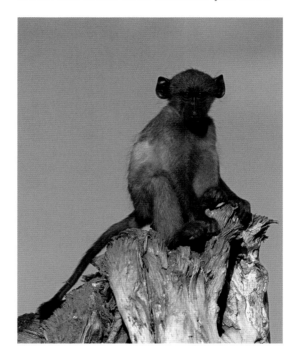

Young baboon on tree stump

Simplicity is the key to many successful wildlife photographs – don't work harder at the composition than you need to! This portrait of a young baboon playing 'king of the castle' on an uprooted tree stump takes a fairly classic approach. The stump and baboon together have been cropped to make a strong triangle in the frame. The converging lines of the triangle lead the eye directly to the focal point of the picture – the baboon's brown, button eyes, placed on the intersection of thirds.
Canon EOS-1N with 300mm IS lens, Fuji Velvia 50 ISO, 1/360 of a second at f/4

PRO TIPS

▶ You can learn an awful lot about composition just by looking at other people's pictures. Study the work of your favourite photographers and analyze what it is about the compositions that appeals to you.

▶ Keep compositions simple. It's a bit like constructing a sentence. The best contain only one idea. The same goes for pictures. Pare things down and concentrate attention on just one point of emphasis.

▶ Exploit internal frames within the picture area to add emphasis. For example, photograph a subject through surrounding foliage, under arching branches or in the gap in a stand of trees.

▶ Draw the viewer's eye to the focal point of a picture by exploiting any natural lines that lead into or converge on it, such as a curving row of fence posts, stones in a braided river, or an overgrown track.

▶ Try to use snaking 'S' shapes, circles, zigzags and triangles in your pictures to lead the viewer's eye round the frame. The shapes might be implied by the way a small number of animals or birds are grouped together, for example, or the way a stream meanders round a habitat zone.

▶ It can help to 'see' potential compositions if you can remove the labels from animals, insects, flowers or birds and think of them instead as a series of shapes. How do these shapes relate to others in the frame. Are they complementary or do they conflict, are there repeated shapes that echo each other?

▶ Colour, light, texture, tone and even sharpness are all elements you can use to structure an image and to create areas of emphasis within the picture frame.

▶ Finally, trust your judgement. If you feel the picture looks 'right', go ahead – press the shutter.

BEWARE!

▶ Be careful not to frame all your compositions in the same way, or your shots will look boring overall. Photograph subjects in portrait as well as landscape format, and try to exploit a variety of designs when framing.

▶ Run your eye over background areas carefully to make sure there are no visual gaffs like twigs poking out of your subject's head or a distant person or car – it's easy to overlook these things in the heat of the moment. Check for nasty highlights too, like pale areas of sky between branches, and any other discordant notes that could look distracting when you get your results back.

▶ To compose frame-filling images successfully leave some breathing space around your subject, or crop in so tight it's clear you actually want the animal busting out of the frame. Nothing looks worse than when the edges of your subject butt up to or just break the edges of the picture area.

▶ Don't hit yourself over the head if you can't find a way to frame a shot. Sometimes there just isn't a picture to be had, no matter how hard you try.

▶ Know the rules about good composition but don't follow them slavishly. And don't be afraid to try something different.

Nyala drinking with reflections

Here's a picture full of diagonals, triangles and repeated shapes that keeps the eye busy within the frame. The reflections of the thirsty antelope help to reinforce the effect, and the position of the water's edge bisecting the shot is slightly off-centre, so the overall effect is not too symmetrical.
Canon EOS-1N with 400mm lens, Fuji Velvia 50 ISO, 1/250 of a second at f/5.6

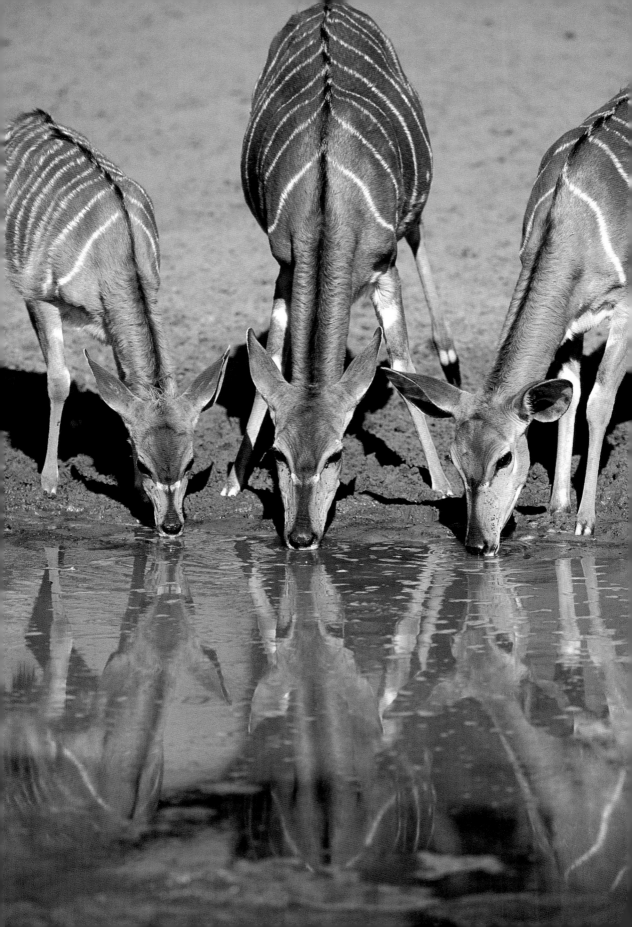

ASSIGNMENT

Good composition is essentially about arranging the various elements of your picture in the frame to get the overall effect you want. It's a personal statement that describes to your viewer the precise way you see your chosen subject. This assignment should help you explore some of the different ways you can use composition to reinforce what you want to say about a subject. Select just one of the broad themes from the list below. You can make the assignment even more challenging by getting a friend to select a category for you, or you could simply shake a dice and let fate decide!

- Isolation
- Connections
- Face to face
- Danger or defence
- Beginnings
- Ebb and flow

Once you have settled on a theme, the aim is to take a series of wildlife or nature images in which you consciously arrange the elements of the picture to help illustrate the selected theme. For example, if you pick 'Isolation' an obvious approach might be to keep the subject quite small in the frame and place it on the junction of thirds within a huge expanse of empty space. 'Connections' and 'Face to face' suggest relationships, so you may want to make a focal point out of the link between two subjects, perhaps making an extreme close-up of locked horns or a pair of mammals nuzzling to reinforce bonds. Consider the shapes your subjects make in the frame, as you or they move around, and use the conventions discussed in the chapter to help you pinpoint the strongest composition. Try several compositions and assess which works best. Which images are the most direct or compelling? Did you find the conventions helpful or constraining when composing your

pictures? Show the images to a friend without explaining the purpose of your project and ask them what they think the shots suggest and which composition they like best and why.

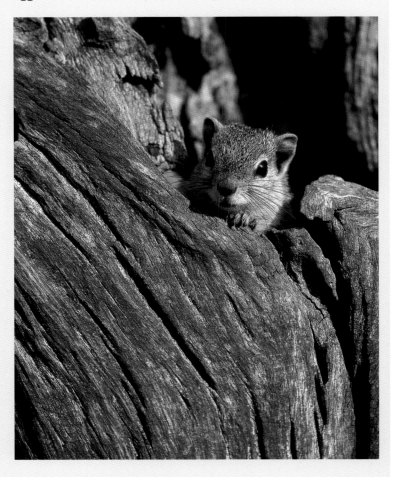

Tree squirrel peeking

A simple picture. The squirrel peeps out at us from the safety of its bolthole in a dead tree. Notice how the focal point is strengthened when placed on the junction of the thirds.
Canon EOS-1N with 500mm IS lens plus 1.4x converter, Fuji Velvia 50 ISO, 1/200 of a second at f/5.6

SEE ALSO:

WORKSHOP 2: BREAKING THE RULES

There are times when your pictures can be greatly improved simply by breaking free from the conventions that normally dictate how you arrange the elements of an image within the frame. You may want a picture to defeat the expectations of your audience, to create a note of surprise or tension, or you may simply decide that the only way your picture works is if you break the rules of traditional composition.

Much of the existing theory about composition has its origin in painting and the past, so there's every reason why photography, as a more modern medium, should push at the boundaries sometimes. The problem in wildlife photography is that we are loath to break free from the conditioning that decrees it has to be about the faithful representation of our subject matter. We tend to get a bit nervous or apologetic when challenging our audience with anything unorthodox.

There's not much point breaking the rules simply because they exist, of course. If you chop off part of an animal on the edge of the frame just for the hell of it, it will probably look like a mistake. On the other hand, if there are many animals massing in a scene, cutting them off deliberately at the edge can help strengthen the impression that their numbers extend well beyond the confines of the picture area. You need to be confident about why you're breaking the rules and what you hope to gain by it. Often the effect is not earth-shattering or wildly innovative, it's simply a better way of getting your message across.

Seeing the whole subject

There's an old-fashioned school of thought in wildlife photography that you should portray the whole animal, or at least a bust of your subject, and that it's not really acceptable if your main subject is partly obscured by a strand or two of grass or an ear is chopped off. Thankfully, this very literal view of how we interpret the natural world is changing. Some of the most powerful pictures portray wildlife as you experience it in the field: a glinting eye glimpsed fleetingly through the foliage;

a partial view of a concealed predator; a suggestion of danger lurking; or the emotion of an intimate, but momentary, encounter in the wild.

Such shots appear realistic rather than contrived. Unless you've been commissioned to compile a species ID guide, dismiss the rules that say you have to feature the whole animal. Try closing in tight on an eye, beak, tooth, claw or horn to highlight the defining characteristics of a species. Photograph subjects peering through the undergrowth or bursting through it

Seven giraffes silhouetted at dawn
This shot, taken in the Kalahari early one morning, was inspired by bushman rock paintings. Washed out colours, the tiny silhouettes and their unconventional position within the picture were designed to reflect the way we experience rock art: faded, naive, yet fascinating.
Canon EOS-1N with 400mm lens plus 1.4x converter, Fuji Sensia 100, 1/125 of a second at f/8

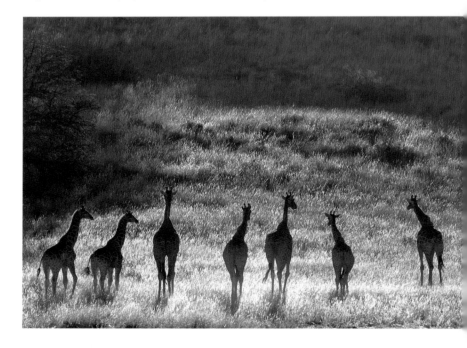

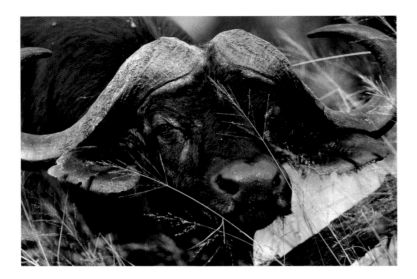

Cape buffalo in undergrowth

The buffalo's horns bust the edges of the frame, there's grass in the way of the main focal point, and overall it's rather a messy composition. Yet this is precisely the way we encounter these impressive animals in the wild. The framing adds to the power of the shot and conveys immediacy, helped by the strong eye contact.

Canon EOS-1N with 400mm lens, Fuji Velvia 50 ISO, 1/320 of a second at f/5.6

Rock hyrax on rock

By placing the hyrax in the extreme corner of the frame, rather than on an obvious intersection of thirds, the shot becomes more intriguing and challenging. We wanted to suggest the way this diminutive creature spends its days sunbathing high on the rocks, keeping a watchful eye on the sky for the majestic black eagle that hunts it.

Canon EOS-1N with 300mm lens, Fuji Velvia 50 ISO, 1/400 of a second at f/5.6

covered with bits of leaf or grass. Be spontaneous rather than considered when cropping your shots and create the effect of immediacy, a sense of your own pleasure, excitement, fear or panic on coming face to face with a wild animal or bird. It helps your audience to feel they are at the scene too.

The rule of thirds revisited

And don't let the famous rule of thirds rule you. It doesn't hurt occasionally to ignore the key points in the frame where the division of the thirds meet up. Deliberately resist placing subjects on these hot-spots. Instead, experiment by placing your subject close to the corners of the frame or on a very low horizon. Not only will this diminish the scale of your subject, it will convey an animal's isolation or vulnerability, without detracting from its strong emphasis in the frame.

An off-centre focal point and horizon

What of the theory that it's not a good idea to position your subjects centrally? The fact this position in the frame is said not to challenge the viewer because it looks too orderly, static and formal doesn't mean it's against the law. When you want to make classic

Lion shaking mane

Lions are a much-photographed animal, and tend to be fairly inactive for large parts of the day, making it quite difficult to get a new take on them. When this proud old male started shaking his mane just a few feet from our vehicle there was only time for a few frames, firing the shutter instinctively. We liked the freshness and spontaneity that captured bags of character.

Canon EOS-1N with 300mm lens, Fuji Velvia 50 ISO, 1/15 of a second at f/16

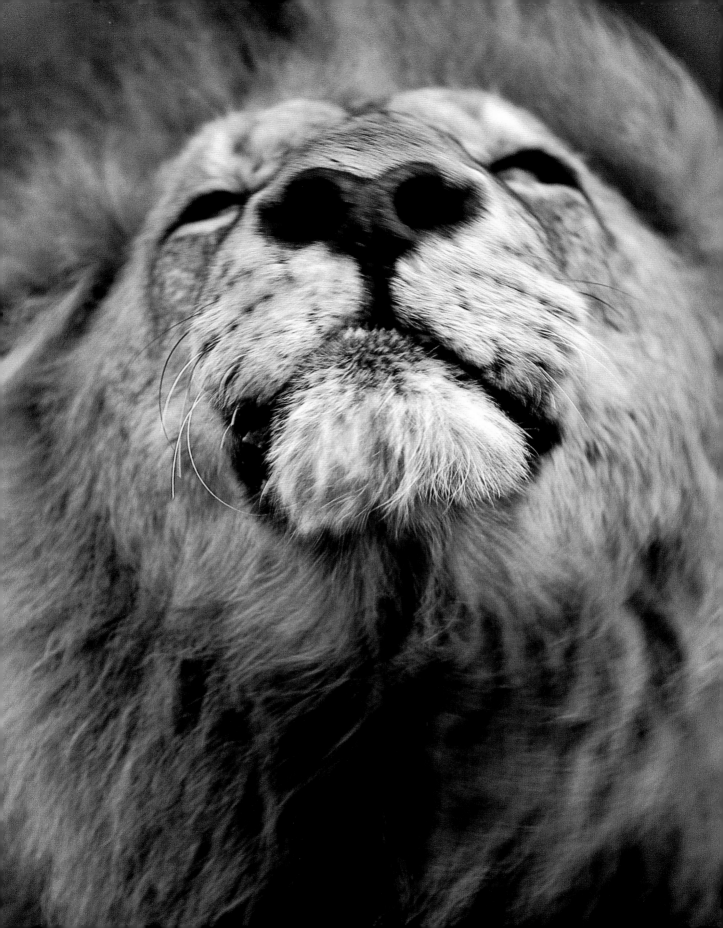

portraits of animals or birds, where you require a very obvious point of emphasis and where your aim is to keep things simple, a central focal point can be a plus. There will be plenty of occasions in wildlife photography when this will be your only option.

Then there's the received wisdom about not splitting an image in two halves by placing the horizon across the centre. The symmetry ends up distracting your eye from the picture content, doesn't it? But what if the thing you most want to emphasize and draw the viewer's attention to is precisely that symmetry? Say you are photographing a bird and it's reflection, for example, but are less preoccupied with the subject matter itself than you are fascinated by the symmetry and shapes created temporarily by this natural mirror effect. Your picture might not work unless you stress this effect by selecting a central horizon.

African elephants bonding

The obvious choice here would have been to use a portrait format to include all of the trunks. We would usually avoid lopping off so defining a feature as an elephant's trunk, but doing so can make the image more arresting, and in this case the tight cropping helps draw attention to the intimacy of social interaction.

Canon EOS-1N with 400mm lens, Fuji Velvia 50 ISO, 1/300 of a second at f/6.3

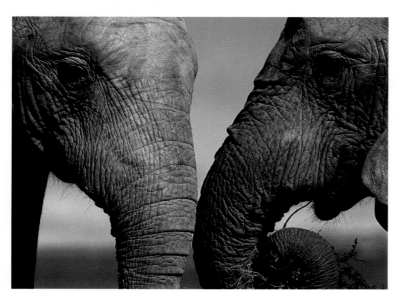

It's all about having the confidence and readiness to break the rules as and when you feel the situation demands. In the end there's really only one rule that matters: knowing the conventions and knowing you don't have to be a slave to them.

PRO TIPS

▶ When framing 'realistic' wildlife shots with spontaneous, tight-in crops, or where the subject is partially concealed by grass, reeds or undergrowth, your pictures will work better if you can capture strong, direct eye contact from your subject as a clear point of reference for the viewer.

▶ Unconventional framing can add impact to your pictures and redirect the viewer's attention to that part of the subject you want to stress. Photograph the trunks of tall trees in a woodland using landscape rather than portrait format, for example. Cutting off the top of the trees concentrates the eye on the picture as it travels up one trunk and down the next and effectively conveys the density of the woodland.

▶ Pictures such as abstracts do not always require a single focal point. Occasionally you may want to include more than one point of emphasis, to juxtapose one against another and create a tension between them.

BEWARE!

▶ Resist the temptation to make all your compositions orderly and harmonious. Balanced images can look bland. It's sometimes more interesting for your audience if you create a discordant note.

▶ The existing conventions about composition have been around for many years for a reason. They work. Understand them before you flout them.

▶ Always edit results carefully and objectively when you are being creative with the rules. If you don't quite pull it off it can look like a mistake. Be honest about your efforts – particularly the ones that don't work.

ASSIGNMENT

This assignment is all about composing pictures instinctively, working quickly, and generally ignoring that mental checklist, like looking round the edges of the frame or depressing the depth of field preview button, normally advocated as good practice before firing the shutter. It will help to work in a location where you have reasonable access to a range of possible animals for characterful close-ups, such as a zoo, rare breeds farm or wildlife sanctuary. However, if you know a good location where you can readily photograph truly wild subjects you will be able to experiment composing shots that aim to convey the feelings of excitement, elation, panic or trepidation when encountering these creatures in the wild. Make images illustrating one or more of the following themes:

- Aggression
- Humour
- Fear

Spend as long as it takes to get within range of suitable subjects, but in terms of actual photographic time you should work at quickfire pace so your responses are instant rather than considered. Aim to shoot one roll of film in 20 minutes or so, depending on the co-operation of your subjects. Be liberal with film and work as spontaneously as you can, exploring unusual angles, unorthodox picture formats and unconventional crops. Don't worry too much about tidy compositions or correct techniques – just go with the flow. When you have completed the project, pick the shots you're most pleased with. What is it about their composition that stands out above the rest? Do they meet the brief? Did you enjoy this approach to photographing wildlife? How could you take the idea further?

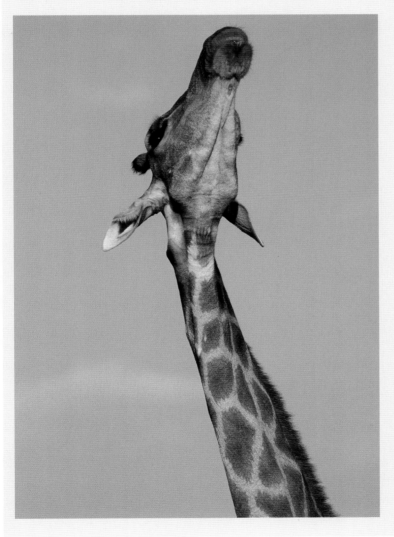

Giraffe stretching

Exploiting the strong diagonal of the giraffe's curving neck to give a picture impact may well be copybook composition, but the odd perspective afforded by our low viewpoint right under the subject, coupled with a rather unconventional pose, is definitely not a classical approach. It works by underlining just how bizarre and amazing the giraffe's design really is.
Canon EO-S1N with 70–200mm lens, Fuji Velvia 50 ISO, 1/250 of a second at f/6.3

SEE ALSO:

Choice of Lens, 39–43 The Rules, 83–88 Portraits, 103–108 A Sense of Place, 127–132

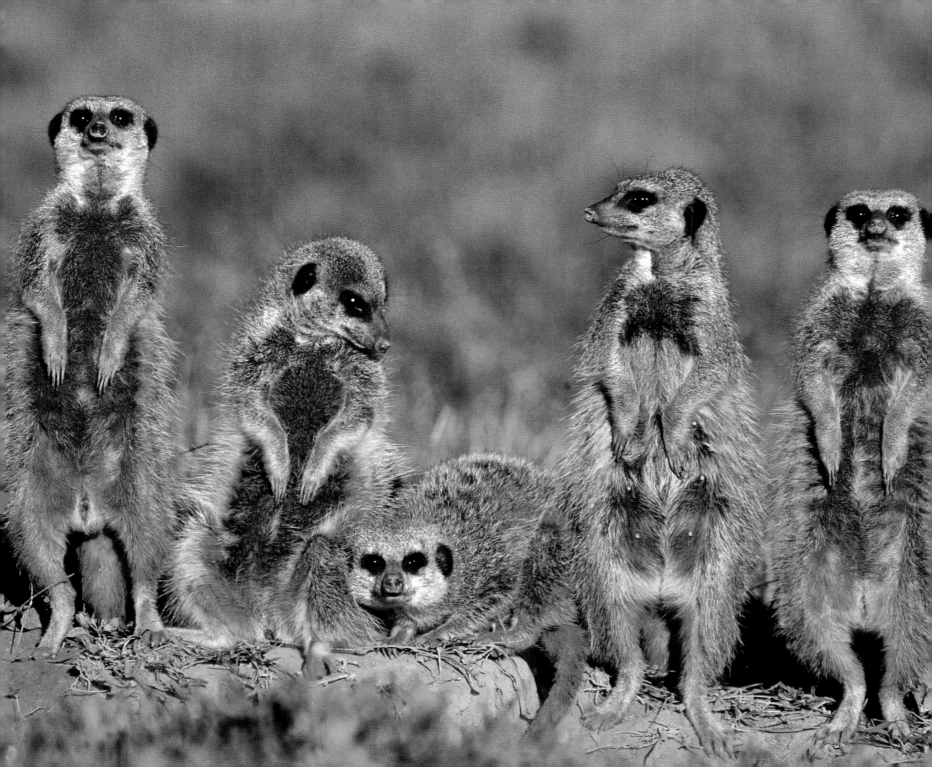

Fieldcraft

Good fieldcraft starts before you put your toe out the front door. You can't find subjects to photograph if you don't know where to look. There are no shortcuts to doing your homework. You need to know as much as you can about preferred habitats and the tracks and signs that provide vital clues to pinpointing animals in the wild. Establish what your subjects will be doing where and when and understand why. Nine times out of ten, when you a see a special image it's not because the photographer got lucky, it's because they got smart.

Don't overlook the obvious and don't overcomplicate matters. You could camouflage yourself to the eye-balls and stalk for miles in a remote spot for a single shot of a distant deer. Or you could visit a local deer park where the animals are accustomed to humans and get through several rolls of film in half a day.

Use the resources immediately available to you. If you have a garden, plant it to encourage wildlife. Erect bird-feeders and nest-boxes, provide a regular supply of clean water and put up one or two attractive, natural-looking perches. Set up a permanent hide, conceal yourself in convenient shrubbery or photograph from a potting shed or the window of a house.

Meerkat group photo

As soon as we located a meerkat den in active use we knew from experience that the animals would spend time warming themselves in the early morning sun before setting off to forage. Spending time each day watching quietly, we were able to habituate the animals to our presence until they completely ignored us and the noise of our cameras.

Canon EOS-1N with 300mm IS lens plus 1.4x converter, Fuji Velvia 50 ISO, 1/160 of a second at f/6.3

Create a pond – even if it's only a small bowl sunk into the ground with a few stones for the wildlife to climb in and out.

Encourage wildlife to come to you by luring subjects with appropriate bait. Learn about animals' food preferences before you begin. Decide whether you want to photograph your subject in the act of feeding, or if the free meal is simply an invitation to join in your photo-session. If it's the latter it may not be necessary to

Red deer stag roaring (C)

We visited this deer park during the autumn rut, using our vehicle as a hide. Operating as a couple helps when working from a vehicle, as driving into the right position and manoueuvring in response to a moving subject is as important as actually using the camera.

Canon EOS-1N with 500mm IS lens, Fuji Velvia 50 ISO, 1/160 of a second at f/5.6

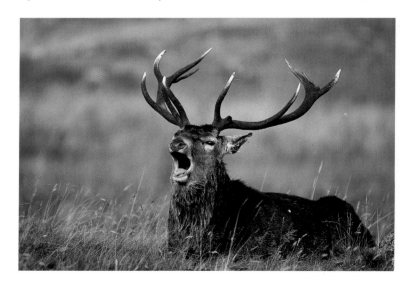

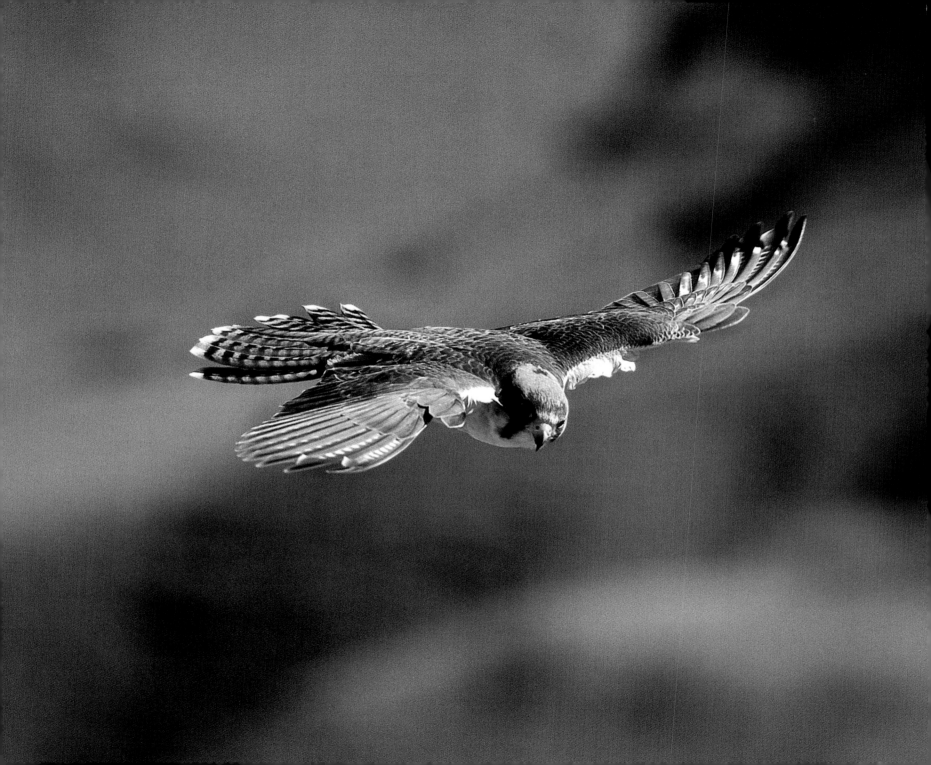

provide naturally occurring foods, but you should make sure food not found in the wild is hidden from view in your shots.

Get to know the rhythms and residents of one or two local reserves really well. If you live in a town or city, focus your attention on parks or promising patches of vacant land. The advantage of working close to home is that you can access good locations at the best times – usually dawn and dusk. Familiarize yourself with commonly used animal tracks or potential nesting sites, and be on the lookout for fresh activity around any earths, burrows or dens. Let people know you enjoy photographing wildlife – they will often tell you things they've heard about or seen that may provide good photo opportunities.

Hides

It's easier to locate good habitats for wildlife than it is to get close enough to get a good photograph. Ideally you need to make yourself invisible. The most effective way is to use a hide. The simple way is to cover yourself, your equipment and a small seat with a camouflage sheet or cape. If you want to set up a more permanent structure make sure you get permission from the landowner or relevant authority first. Don't go to the trouble of constructing a hide until you're convinced subjects will be active in the area. Simple, dome-shaped hides that are light to carry and easy to erect are readily available and reasonably priced. Alternatively, use the frame of an old tent covered with a waterproof fabric in camouflage or neutral colours, or design a custom-made hide adapted to the way you like to work.

Lanner falcon hovering
We photographed this lanner falcon from a cliff-top hide in South Africa's Drakensberg Mountains. Conservationists have set up a 'vulture restaurant', putting out carcasses to feed the local raptor population. Without the benefit of the baited site and the established hide it would be extremely difficult to get such intimate flight shots of a wild bird.
Canon EOS-1N with 300 IS lens plus 1.4x converter, Fuji Sensia 100 ISO, 1/400 of a second at f/5.6

Once again, avoid the temptation to make things more difficult than you need to. Take advantage of any purpose-built hides that are more comfortable to spend time in. Although many public hides haven't been constructed with photographers in mind, make a note of the good ones you do find, as repeat visits will reap dividends. Look for hides that are well-orientated for the light when you need it, where individual subjects come close enough for your lenses, or where there are at least sufficient numbers of birds or animals to allow you to photograph them in groups or flocks.

Your vehicle doubles up as a very effective mobile hide. Many animals may be wary of people, but they don't readily associate people with cars, and there are a remarkable number of occasions when you can get close to them this way. Nature reserve car parks and picnic sites make good places for a spot of in-car surveillance, or you can simply cruise up and down quiet country lanes scanning hedgerows, crisscrossing remote moors, or skirting along estuaries and coastlines. A smooth approach is essential. We've found it's better to drive past, turn round and make another approach, than risk reversing up to an animal, which usually just scares them off. Always use beanbags or a suitable window mount to support your lens and turn the engine off to prevent camera shake.

Stalking on foot

The hardest challenge of all is stalking subjects on foot. Don't be disappointed if your returns are poor when taking this approach – particularly at first. Dress to blend in with your surroundings (that includes the shiny bits of your camera equipment), stay downwind of your subject and stay quiet. Different animals demand different stalking techniques, but, in general, a slow, steady approach keeping as low to the ground as possible while exploiting natural cover works best. Keep absolutely still if you feel you've been rumbled and be careful not to let your outline appear to your subject as a looming, upright, human-shaped silhouette.

Try honing your technique in places where the animals are more used to people before putting your skills to the test out in the field. It helps if you don't mind looking or feeling ridiculous while crawling through the leaf litter dressed like a tramp.

Red Grouse in burnt heather

Using your vehicle as a hide can be as much hard work as stalking on foot. Driving slowly back and forth along a short stretch of moorland road proved a more effective way to photograph red grouse than simply parking up in a likely spot and hoping a subject would walk into view.

Canon EOS-1N with 500mm IS lens, Fuji Velvia 50 ISO, 1/100 of a second at f/8

Straw-necked ibis striding out

Stalking this Australian straw-necked ibis involved a slow, indirect and uncomfortable belly crawl to the edge of the lagoon. Such undignified approaches often end in total frustration. It's a good idea to take shots from range as you edge closer, rather than risk coming away empty-handed.

Canon EOS-1N with 400mm lens, Fuji Velvia 50 ISO, 1/250 of a second at f/5.6

PRO TIPS

▶ It pays to invest in good-quality field and identification guides.

▶ Keep a folder where you can file information you pick up, such as magazine clippings about potential or favourite wildlife locations. Record the techniques you found particularly successful for getting close to different species.

▶ Consider joining a local natural history society or wildlife group to find out more about local flora and fauna and what there is of interest to photograph on your patch.

▶ Keep a supply of bait (including wild bird seed, peanuts and raisins) in your vehicle for unexpected opportunities.

▶ Make sure camera equipment and beanbags are in the passenger area of your vehicle if you are using it as a hide. You don't want to have to get out to retrieve things from the luggage compartment when you have a sensitive subject in range.

▶ Organize your equipment carefully when you're on foot. Carry the minimum and keep everything in the same pockets each time you go out so you know instantly where to put your hands on a fresh film or a filter speedily and quietly.

▶ If you need to cover a stretch of open space to get close to your subjects try an oblique approach rather than a direct and obvious route which might instantly alarm your quarry. Make yourself small and don't exaggerate your movements, as this will simply attract the attention of everything for miles around.

Spotted hyena at waterhole

In African game reserves, waiting quietly at a waterhole where the light is right for photography can be more productive than driving around for hours. Animals will often ignore a parked vehicle, whereas driving up to them may frighten them off and even jeopardize their welfare – such as by preventing them from drinking.

Canon EOS-1N with 400mm lens plus 1.4x converter, Fuji Velvia 50 ISO, 1/250 of a second at f/5.6

BEWARE!

▶ Ethical behaviour is the golden rule of good fieldcraft – the welfare of your subjects should be uppermost in your mind. Know and respect current laws on photographing protected species or at nest sites, but use your own judgement, too. Just because something is legal doesn't make it ethical.

▶ If your presence appears to cause your subject stress, move further away, or leave in search of another opportunity.

▶ If you have been putting out food as bait on a regular basis, consider whether continued feeding will be necessary once you've got your shots.

▶ Be careful to enter a hide when your subject is absent from the site, or get a friend to accompany you and then leave, to fool your subject into thinking the coast is clear (arithmetic isn't a strongpoint for most animals).

▶ Make bait look natural, even if it isn't. When photographing squirrels in pine plantations, we smear peanut butter under the scales of fallen pine cones, for example, rather than use whole peanuts. Honey is also a versatile bait that can easily be disguised – and it's hard for animals to run off with it.

▶ When you're attempting to get close to an animal don't wear any clothing that is going to rustle or crackle when you move – some man-made waterproof fibres are very noisy, while zips and Velcro fastenings are instant giveaways.

▶ Don't forget to consider the light direction in relation to your subject when erecting a hide, and don't be tempted to site it too close to your subject for comfort – even when you're using a hide you may still need to photograph with long lenses to avoid alerting your subject.

ASSIGNMENT

Learning fieldcraft techniques takes lots of practise, and often demands a big investment of your time. It helps to do your homework first and to take a stepwise approach, discovering what works best on a project-by-project basis. Here's a simple assignment looking at the basic elements involved in baiting a subject to get it where you want. To keep life simple we suggest you start out in your own or a friend's garden, so you can get regular access to photograph fairly close to home. There are no time constraints – think of it more as an ongoing project. Choose a subject you most want to photograph – a squirrel perhaps, a hedgehog or a garden bird. Read up about your species, paying particular attention to feeding preferences, the times of day it's most active, and any seasonal behaviour you can expect. Don't forget to research how other photographers tackled similar subjects – there's no need to reinvent the wheel. Work out how best to conceal yourself if necessary, then establish a regular food supply at the site. If you use anything man-made, such as bird-feeders, consider how to get a more natural shot. Position feeders close to a photogenic perch, or introduce one that's ideally placed for the best light and composition. Conceal a food treat or smear the perch with something appropriate, such as peanut butter or suet, to encourage the subject to the exact spot you want. Make a photographic study of your chosen subject at the feeding site and don't forget to continue feeding when you've finished if necessary. As you assess your ongoing results, work out how you can refine the set-up. Identify where your photographs can be improved – is it in photographic technique or fieldcraft? Could you use different bait? Do you need to be better concealed? Which fieldcraft skills were you best at? How could you further develop these?

SEE ALSO:

Sharpness, 23–29 Choice of Lens, 39–43
Movement, 114–119 Behaviour, 120–126

The Subject

If you want to know the wrong way to approach animal portraits, get a passport picture taken in a photo booth. An accurate, frame-filling, sharply focused representation of your face it may be, but with a rigid expression, starkly lit and against an ugly background. And is it you? A good portrait is not just a record of form and function, but gives an insight into the character of the subject, using light, composition and perspective.

Good wildlife images go beyond a subject's physical characteristics, emphasizing qualities such as strength or vulnerability, and moods such as aggression, anger, or fear. The best shots are more than just a faithful representation of the subject, the kind you might see published in an identification guide, and can reveal something of the lifestyle of that subject, placing it in a clear environmental context.

Capturing character

To capture character you need to react quickly to changing expressions and moods, but perhaps more importantly, where the situation allows, you need to spend time with your subject. Don't just take a shot and move on. Wild animals in the presence of a photographer may look alert, curious, nervous or angry, but give them time to relax and you may see other moods. And don't get too obsessed with facial expression alone – look for characteristic body language, such as raised hackles or a crouching posture. One of the simplest ways to make your animal portraits more intimate and direct is to shoot at your subject's eye level. It gives a much more natural perspective.

Decide what it is about an animal's intrinsic qualities you want to capture on film. We find it helps to think of a single adjective that sums up our subject. With lions it might be 'strength', with cheetahs 'speed', with leopards 'stealth'.

Leopard stalking

Portraits can sometimes be quite powerful when you don't show the whole face or body. We like this shot of the leopard peering over the rock because it portrays him as a stealthy hunter. In fact, the animal wasn't hunting but was coming to bait and was wary of our hide.
Canon EOS-1N with 400mm lens, Fuji Sensia 100 ISO, 1/200 of a second at f/8

Red kangaroo

Photographing habituated animals opens up all sorts of possibilities in portraiture. In this case, it allowed a very close-up, low-angle shot with a wide-angle lens emphasizing the kangaroo's laid-back, seen-it-all-before attitude, and deliberately exaggerating his muscular physique.
Canon EOS-1N with 28–80mm lens, Fuji Velvia 50 ISO, 1/160 of a second at f/8

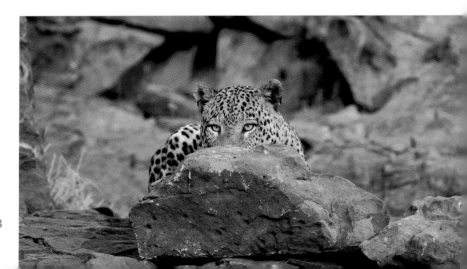

103

Lens and viewpoint

Choice of lens and viewpoint is critical here. If you want to portray the strength and power of a bull elephant at the zoo, then a close-up wide-angle shot taken from a low angle can be very effective. If, on the other hand, you want to suggest the vulnerability of a baby elephant, you might move back and keep the animal small in the frame, juxtaposed against the bulk of a full-grown adult.

With many wild animals long telephoto lenses are the only realistic way to take portraits. Longer lenses have a flattening effect on the subject. This isn't necessarily a bad thing – a frontal shot of a lion's face, for example, may be flattered by a foreshortened perspective. But when you're photographing in zoos or with habituated animals, take advantage of the chance to get closer and try using wide-angle lenses as well to produce powerful, three-dimensional images that ooze character.

Wedgetailed eagle

This magnificent eagle, photographed in a remote national park in New South Wales, amazingly tolerated our approach on foot, with no cover, to within 10m (34ft). Because the camera had to be handheld it was necessary to shoot wide open to avoid camera shake. Waiting for the bird to stand side-on meant the shallow depth of field at f/4 didn't matter, and, by crouching down, the background was thrown nicely out of focus.
Canon EOS-1N with 300mm lens, Fuji Sensia 100 ISO, 1/800 of a second at f/4

Chacma baboon with young

Primates make excellent subjects for portraits, not least because of their anthropomorphic behaviour. In this case we opted for a close crop of the mother cradling her infant because we felt an intimate shot demanded an intimate close-up using a 500mm lens.

Canon EOS-1N with 500mm lens, Fuji Sensia 100 ISO, 1/400 of a second at f/8

Using a telephoto means depth of field can be very limited, so accurate focusing is critical. Unless you are going for something deliberately unusual, always focus on the eyes. Many people make the mistake of using the widest possible aperture for animal portraits, because they want to throw the background out of focus. But an aperture of, say, f/4 with a 300mm lens used for a close-up of an animal's face gives such a shallow depth of field that while the eyes are sharp the animal's nose or beak may be way out of focus. This can give you real problems when photographing long-snouted animals like badgers or deer. Stopping down to f/8 or even f/11 will usually give you acceptable depth of field and keep the background unobtrusive, but use your depth of field preview button to check. Look for viewpoints that position your subject standing proud from the background – on a raised mound, wall, post or perch with clear blue sky or distant hills behind.

If you want to focus all attention on your subject, then an unobtrusive, clean background like this certainly helps. Try to choose a viewpoint that avoids distracting highlights, such as speckles of light breaking through foliage. Think too about the colour of your background. This may be complementary to your subject, implying its natural setting, or quite different and dramatic. Greens and blues can make attractive, vibrant background colours, while a dark, almost black, backdrop can be very dramatic.

Beginners to photography invariably make the mistake of not getting close enough to their subjects, producing pictures with a tiny subject bang in the middle of an empty frame. Conversely, it's easy to go too far the other way in pursuit of the Holy Grail of a 'frame-filling portrait'. Frame-filling is fine, but do allow your subjects room to breathe – that way you won't chop off ears or antlers by mistake.

Remember you need to vary the pace of your pictures, so try ultra-close-up detail shots of an animal's eyes, or pull back to show the animal's habitat. And don't forget that while it may be natural to shoot many tight-in animal portraits in portrait format, don't neglect to take landscape shots. Experiment a bit and explore what results you get by cropping in really close. A deliberate tight crop, which cuts off part of the subject, can be very effective in emphasizing the size of a large animal and for real 'in-yer-face' animal portraiture.

PRO TIPS

- ▶ Always try to get a catch-light in the eye of your subject. This is easiest with front- or side-lighting. With back-lit subjects or animals with deepset or dark eyes surrounded by dark fur or feathers, a tiny touch of off-camera flash can help.
- ▶ If you're not sure how much depth of field you need to keep the subject sharp throughout but suppress the background, use your depth of field preview button.
- ▶ Bright, overcast days with soft diffuse light are especially good for portraits showing fur or feather detail.
- ▶ When photographing the head of an animal think about including some shoulder or chest to create a 'bust', especially if the subject has an upright stance, such as a perched eagle. Don't just photograph a disembodied head.

- ▶ A three-quarter view can be more dynamic than a full frontal or profile.
- ▶ Direct eye contact can make for a striking portrait, but you might prefer to maintain the myth that the photographer isn't there.
- ▶ Look for natural frames such as foliage, branches or rock formations. If the picture looks a bit flat through your viewfinder, try lying flat on your belly and include some out-of-focus foreground grass to add a sense of depth.

BEWARE!

- ▶ Watch out for unwanted distractions or highlights around the edge of your frame. Adjust your viewpoint or change lenses if necessary to avoid them.
- ▶ A bored animal makes a boring subject. Try photographing zoo animals just before feeding time, when they are alert and interested.
- ▶ Watch out for parts of your subject touching the edge of the frame. If it breaks the frame, make sure it looks intentional – not just the tip of a horn or tail.

- ▶ With very tight-in portraits, be especially careful about exposure.
- ▶ Close-up wide-angle portraits can distort the subject. This can emphasize qualities of the animal, but be aware that there is a fine line between character and caricature.

Tawny owl (C)

Simplicity is the key in this classic portrait of a young tawny owl, which stands out well against the dark background of the woods behind. Try to find a viewpoint which excludes distracting highlights. Because the background was a long way behind the owl it was possible to use an aperture of f/11, ensuring the subject was sharp while the trees were out of focus.

Canon EOS-1N with 300mm lens, Fuji Velvia 50 ISO, 1/60 of a second at f/11

ASSIGNMENT

The best wildlife portraits are those that capture the very essence of the subject. In this exercise, your objective is to make two animal portraits, each illustrating a different 'concept' or defining characteristic.

Firstly, think of an animal that you can photograph to suggest the concept of 'grace'. You might select a swan, a deer hind, a horse or something entirely different. Consider the

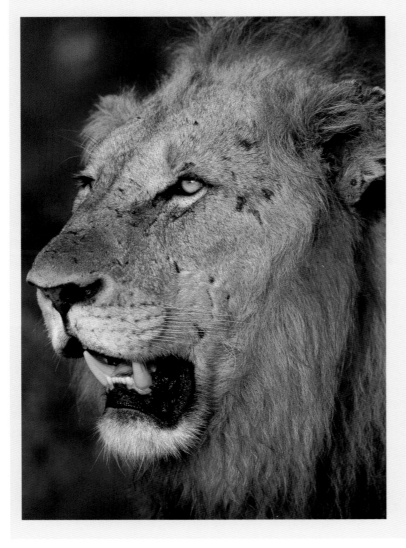

best approach and treatment to bring out the gracefulness of your chosen subject. For example, if you pick a swan you might want to emphasize the curves of its neck, picture it serenely floating on a still pond or photograph it at rest in the gentle, warm light of early morning.

For the second part of your assignment, take an animal portrait that sums up the concept of 'nobility'. Think carefully about the pose of your subject – you want to capture a majestic air. You could try photographing a stag using side-lighting to underline the muscularity of its physique, or go in tight on the regal bust of a perched raptor.

Try to ensure your pictures are technically strong in terms of sharpness, exposure and so on, but don't become a slave to technique. You will have fulfilled the assignment if you can produce two contrasting shots that sum up the concepts outlined above.

Review your results. Pick your best shot for each concept. Is your best 'concept' image also the best photograph technically? If not, think about how you can improve future attempts. Your goal is to find the perfect balance between technical merit and characterful content.

Lion

Warm, early morning light really draws attention to the steely and alert expression on the face of this majestic lion. Shooting from a range of only 3m (10ft), there isn't much depth of field with a 300mm lens. It was necessary to stop down to f/11, which meant a shutter speed of only 1/60 second in the low light. The camera was securely braced on beanbags over our vehicle's window frame to avoid camera shake.

Canon EOS-1N with 300mm lens, Fuji Sensia 100 ISO, 1/60 of a second at f/11

SEE ALSO:

Sharpness, 23–29 Choice of Lens, 39–43 Light Direction, 59–64 Quality of Light, 65–69 Fieldcraft, 95–101

Photographing groups of animals is like being a wedding photographer at a ceremony where the guests are from another planet. You can't even use sign language to pose a herd of deer the way you want. It goes without saying that at least one will have its back to the camera and a bunch of others will be looking the wrong way. But if all wildlife photographers did was photograph single subjects in isolation their pictures would soon become dull and repetitive.

Pulling off successful pictures of large groups of birds and animals is an essential part of documenting the natural world. Many animals are social creatures, defined by their group behaviour. The herding instinct and the notion of safety in numbers underline just how much life in the crowd is an important survival mechanism for many species. Mass gatherings of great numbers of animals are some of the most thrilling spectacles in nature. We've all marvelled at scenes of wildebeest migrating across the Serengeti, for example. Closer to home, anyone who's visited a seabird colony in summer, or witnessed migratory geese at a winter roost site, will know the excitement of seeing so many birds crowded together and will probably have felt a strong emotional response to record the scene on film.

Getting that shot to work, however, is a lot easier said than done. The first piece of advice is not to get too hung up waiting for perfection because it probably won't happen. It's like taking family portraits when everyone's fidgeting for you to be finished. You've got to work decisively and you need to be realistic about what you can achieve, given you're not in a studio photographing models. Aim for an overall effect that's pleasing, getting as many elements right as you can, and be prepared to waste film in the process. That's not to say it's simply a question of 'hit and hope' – there are several things that you can do to get some creative control when the arrangement of subjects in the scene before you appears haphazard or chaotic.

Subgroups

It often helps to isolate a smaller group within the larger scene. It's a lot easier to get five heads turning the way you want than 55. And it's certainly easier for you to impose some sort of artistic 'order' on your image if you break the group down into more manageable 'bite-size' chunks. Scan the scene repeatedly to see if there are subgroups within it that catch your eye. It could be an appealing family group of adults with their young, or a small group of animals engaged in some sort of unusual or interesting behaviour. Perhaps there's a crèche

Common wildebeest drinking

We wanted to document the herds of wildebeest coming down to drink at this popular waterhole, but the animals were either too jumbled to make a decent composition or formed a single line which looked boring however we tried to frame it. When some of the bolder animals got into the water the group took on a more interesting dynamic shape, which we were able to emphasize from our raised viewpoint with a short lens.
Canon EOS-1N with 28–80mm zoom, Fuji Velvia 50 ISO, 1/160 of a second at f/8

where lots of immature animals are gathered, a bachelor party of young males or a breeding group of females – try to exploit such relationships between group members in your shot.

Springbok reflections

When we came across a large herd of springbok milling around a waterhole in the Kalahari one morning we were immediately drawn by the reflected shapes of one small group. Although it's generally not a good idea to cut the frame in half, we felt this underlined the symmetry of the image.

Canon EOS-1N with 400mm lens, Fuji Sensia 100 ISO, 1/400 of a second at f/8

Searching for patterns

It also helps to hunt out any patterns in the scene that can give an element of design to your picture. This may be simpler to do if you can try to forget the nature of the animals you are photographing, 'seeing' them more as a series of interrelated shapes within a space.

Look for strong, simple shapes that will help to anchor your photograph. Diagonal lines, zigzags, a sweeping curve, triangles and diamond shapes work well. The behaviour of one herd animal is often echoed by others and the repeated shapes can help convey how individuals within a group are interconnected. A useful tip with small groups is to frame an

odd, rather than even, number of animals, as it's generally more aesthetically pleasing – so look for images with three or five subjects, rather than four or six.

Even if you choose to photograph a large group of animals as a jumbled, chaotic mass, perhaps to highlight their sheer numbers, you still have to make some creative decisions. Do you want to wallpaper the whole frame with animals, or document the group in some context by including background

Puffin parade

It's hard not to view puffins as comical and clownish, and they certainly make appealing subjects. We isolated this discreet group of birds, which formed a simple curve, making it appear as though they were marching over the rock. The sea behind provides a simple, colourful backdrop.

Canon EOS-1N with 400mm lens, Fuji Sensia 100 ISO, 1/400 of a second at f/6.3

habitat in the shot? Do you want lots of depth of field so that as many of the group as possible are shown in detail, or do you want the depth of field to be quite shallow so that dominant members stand out while the rest of the group is merely hinted at?

Depth of field

Depth of field is one of the trickiest problems to solve when photographing groups of animals. Often you will want as much depth of field as possible, but if you stop down to achieve this you will sacrifice speed. It's a delicate juggling act – will you still have sufficient speed to freeze any movement among your subjects?

Focusing on a point some way into the group will make the most of whatever depth of field you have, but do make sure the foremost animals are in focus. Unless you are deliberately seeking a shallow focus effect to highlight one individual in the middle of a group, it's generally best with a limited depth of field to ensure that the closest subjects are pin-sharp and let focus fall off behind them.

PRO TIPS

▶ Photograph animals congregating near water, as there is often plenty of scope for repeated shapes, and their reflections can be used to good effect in compositions.

▶ Using a telephoto lens to photograph large groups of animals emphasizes their numbers by foreshortening the perspective.

▶ A wide-angle lens used from a raised viewpoint is effective in documenting 'carpets' of large numbers of birds, such as puffin or gannet colonies, or other animals, allowing you to show the whole sweep of activity within a clearly identified habitat zone.

▶ To get all eyes looking towards the camera, try clearing your throat gently or firing the shutter release once. Only do this with tolerant animals and avoid causing stress.

▶ Read up about the social behaviour of your subjects, so that you know what to look for in the field. Some species may be more gregarious at certain times of year, such as during their breeding season.

Gannet colony (I)

These two images demonstrate different approaches to photographing this spectacular gannet colony. Here, a telephoto lens was used to compress the scene. The foreshortening effect helps emphasize the number of birds in a relatively small area of the colony.
Canon EOS-1N with 300mm lens, Fuji Sensia 100 ISO, 1/500 of a second at f/5.6

Gannet colony (II)

A wide-angle lens and a more elevated viewpoint (in this case a public observation tower) produced a completely different shot. We were able to show the crowd of gannets while at the same time revealing more about the location and the birds' habitat. The wide-angle shot gives a more three-dimensional feel.
Canon EOS-1N with 35–80mm zoom, polarizer, Fuji Velvia 50 ISO, 1/30 of a second at f/11

BEWARE!

- ▶ Watch out for unwanted shadows cast by one or two animals on the rest of the group when shooting in strong directional lighting.
- ▶ Check regularly around the edges of your viewfinder to avoid ears, tails, legs and so on breaking out of the frame.
- ▶ Where possible, leave a margin of breathing space around the edges of your shot.

- ▶ Try to compose your shot so that the arrangement of subjects within the frame helps lead the eye around the picture.
- ▶ Avoid having dominant individuals within the group looking out of the frame, as this will direct the viewer's eye out of the picture.

ASSIGNMENT

The aim of this assignment is to take a range of shots of a group of animals. The goal is not simply to illustrate a shapeless scattering of subjects, but to find some order and cohesion within the group. Look in particular for patterns, shapes, and strong graphic lines. Try to suggest relationships between group members and use repetitive shapes to demonstrate uniform behaviour within the group. You could visit a deer park or a summer seabird colony or photograph groups of roosting waders when a high tide drives them within range of your camera. If you're stuck for ideas, a herd of antelope in a zoo could work equally well, providing you have reasonable freedom to explore a range of viewpoints. You could even choose to photograph domestic livestock in a nearby field – the subject isn't important; it's learning to see the designs within a scene that matters. Shoot at least one roll of film, working around your subjects to explore the possibilities in depth. Study your results, pick the three you feel work best and evaluate what it is about them you like. Does your use of pattern and shape work purely in an aesthetic sense? Or does it also convey information about the social nature of the animals? Do your images make sense of a scene which at first sight might have appeared random and haphazard? Or do they impose an unnatural order on natural subjects?

Three zebra drinking

Three is a magic number in compositions, as odd-numbered groups often please the eye more than even-numbered ones. We needed a long lens for this frame-filling image of three zebra heads to isolate the trio from the rest of the herd.
Canon EOS-1N with 500mm lens, Fuji Velvia 50 ISO, 1/125 of a second at f/8

SEE ALSO:
Composition, 83–93 Behaviour, 120–126

WORKSHOP 3: MOVEMENT

Movement puts the 'life' into wildlife photography. Photographing moving animals gives you the chance to experiment with some exciting techniques and really stretch your creativity. Modern lenses have revolutionized action photography, with predictive continuous autofocus enabling you to track a fast-moving animal with remarkable accuracy. But you still need to think fast and possess the ability to make technical and artistic decisions under pressure to get the shots you're after.

Mute swan

It took a shutter speed of 1/1000 of a second to freeze the water droplets thrown up by this bathing swan. Backlighting highlights the droplets and gives the image a monochromatic mood. The dark background was fortuitous, further emphasizing the drops.

Canon EOS-1N with 300mm lens, Fuji Sensia 100, 1/1000 of a second at f/4

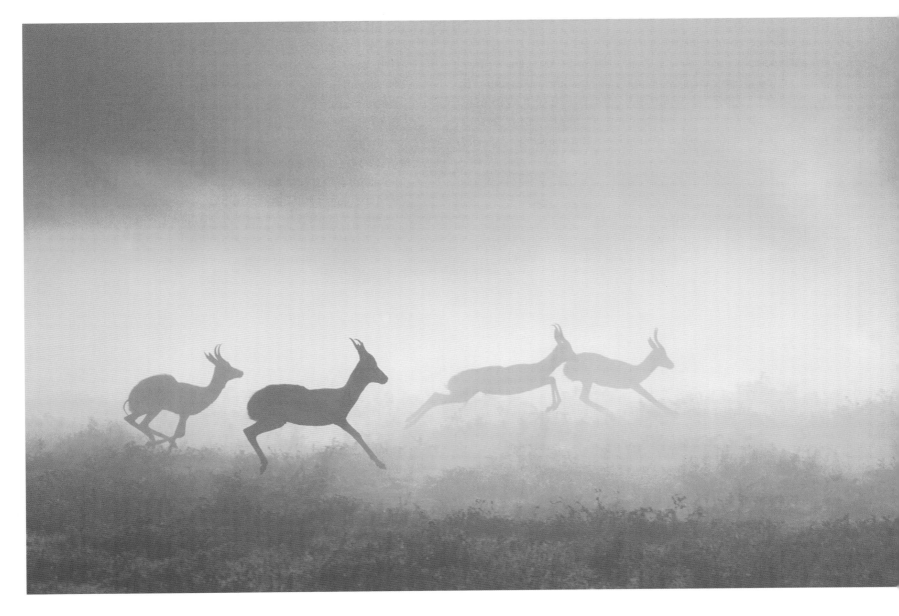

First and foremost, you need to think about what sort of picture you are looking for. Do you want to freeze a moment in time, revealing pin-sharp details invisible to the naked eye? Or strip away those details to create an impressionistic image of blurred brush strokes suggesting great speed? Is it fast, furious action you wish to capture, or a sense of balletic grace? Visualizing the image that will best capture the essence of an animal's movement is the first step in choosing the best technique for the situation.

Springbok running

There was an almost dreamlike quality about these springbok chasing around in the dust at dawn in the Kalahari. Shooting into the light threw the antelope into silhouette, emphasizing their dynamic shapes. It also meant a fast shutter speed of 1/750 of a second was possible only ten minutes after sunrise.
Canon EOS-1N with 400mm lens, Fuji Sensia 100 ISO, 1/750 of a second at f/5.6

Shutter speed

Whatever your creative approach, selecting an appropriate shutter speed is your next big decision. To 'freeze' movement you need a fast shutter speed, but just how fast will depend on your subject. For many animals a shutter speed of 1/500 of a second or 1/1000 of a second will be sufficient, but a flock of finches might need 1/2000 of a second or a soaring eagle only 1/250 of a second.

In practice, the maximum shutter speed available to you will be restricted by available light, by the ISO rating of the film you are using, and by the maximum aperture of your lens. If light levels are low you can choose a faster film or 'push' the film you are using (rate it to a higher ISO and then compensate when it is processed), but this will be at the cost of some loss of quality.

'Fast' lenses, those with large maximum apertures that permit very fast shutter speeds, have obvious advantages for shooting action, but they come at a price. A 300mm f/8 lens can cost three times the price of a 300mm f/4 lens and is much larger and heavier, making it more difficult to handle. Handholding a 2.5kg (5½lb) lens while tracking flying birds quickly becomes exhausting, so you really need to use such a big lens on a good quality tripod with a specialist tripod head. This is even truer of real heavyweights such as 500mm and 600mm f/4 lenses. It's actually a lot easier to find and keep a flying bird in the viewfinder of a handheld 300mm f/4 lens than a tripod mounted 600mm lens. Provided we can get close enough to the subject we'd opt for the smaller lens every time.

Panning

One of the commonest techniques used to photograph moving animals is panning. Panning simply means following the motion of an animal with your camera. By effectively reducing the relative speed of the subject moving across the frame, you can shoot at slower speeds and retain sharpness in at least part of the subject, while throwing the background into a blur. Choose even slower shutter speeds and your subject will appear more blurred. Experiment with shutter speeds between 1/2 and 1/60 of a second on animals such as deer or antelope.

Subject blur

When trying to suggest motion, there's no right or wrong degree of subject blur in a picture – it depends what appeals to you. An image in which the animal's head is reasonably sharp, but limbs or wings are blurred can look very appealing, but there's nothing wrong with going further and having nothing at all sharp if you like the impressionistic effect.

Flying birds make great subjects to practise action techniques on, and seabird colonies make excellent locations to hone your skills. Because birds repeatedly fly along favoured flight paths, according to the prevailing winds, you can usually predict where the bird is going to be, get ready for it and fire off a sequence of shots.

Chacma baboons fighting
In the low light of a rapidly setting sun, the fastest shutter speed possible was only 1/30 second even at f/2.8, so taking the impressionistic route to capture this aggressive baboon behaviour was our only option. This image is actually much more true to what the naked eye sees than a pin-sharp photograph taken with a fast shutter speed.
Canon EOS-1N with 70–200mm zoom, Fuji Velvia 50 ISO, 1/30 of a second at f/2.8

Allow plenty of room around the flying bird, as it's easy to cut off wingtips. Try to lock focus at a distance and fire as the bird comes closer. The slower a bird flies, the more success you will have. On a windy day, large birds will generally take off into the wind and may fly slower than normal, so if the light direction allows, position yourself upwind of a bird you expect to take flight. Look out also for situations where birds hold position for a few seconds, such as seabirds hanging on the updrafts of a cliff face, or kestrels hovering near road verges.

As you gain experience, consider how to raise your action pictures to a higher level. Could you add 'value' to your pictures by shooting in more interesting lighting conditions?

Low light is great for slow shutter speed panned shots and such pictures can have a lovely ethereal quality.

Jackal buzzard
These raptors are fast flying and acrobatic, making it quite a challenge to pull off a simple flight shot, even on a sunny day. On this occasion the bird was hovering on an updraft, making it much easier to 'freeze' it with a shutter speed of 1/500 of a second.
Canon EOS-1N with 300mm lens, Fuji Sensia 100, hide, 1/500 of a second at f/6.3

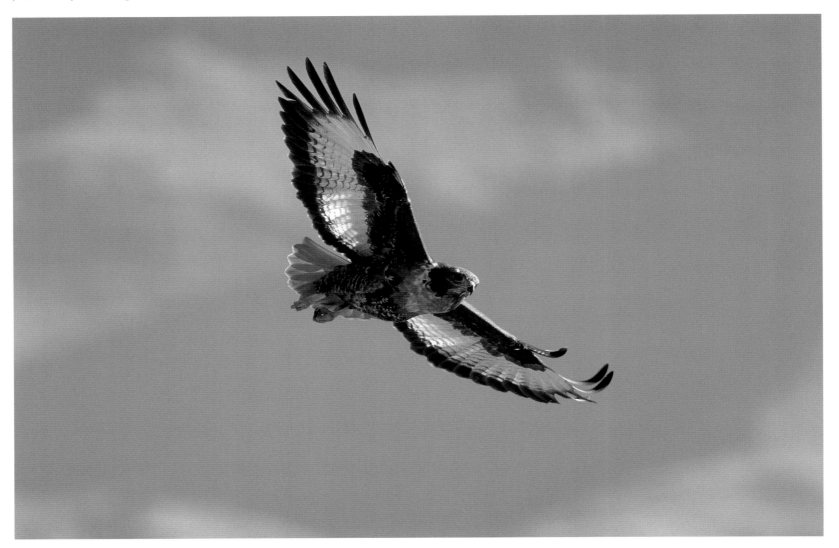

PRO TIPS

▶ Allow plenty of room around an active subject – you can't always anticipate its direction of movement, and you can always crop in later if you feel it's too small in the frame.

▶ Accurate focusing is a higher priority than composition with action shots. At high shutter speeds you have little depth of field, so concentrate on focusing on critical areas such as the head and eyes. Again, you can always improve composition later by cropping.

▶ If you do have time to think about composition, try to place your subject running or flying 'into' the frame. If your subject is moving across your field of view and you focus on its head this will happen naturally.

▶ Carry your camera set to its widest f-stop, so you will have the fastest shutter speed if you need to grab a shot of unexpected action.

▶ Anticipation is key. Some birds dip their bodies before taking off from the ground, some defecate before flying from a perch. Alarm calls often precede an antelope stampede, pawing the ground may be the signal for an animal to charge a territorial rival. Learn to read the signs and you can be poised with camera in hand, ready for action.

▶ Actions are often repeated, so be prepared to fire again.

▶ If your lens has a focus range switch, use it. For example, you might be able to set a 300mm lens to autofocus in the range 1.5m (5ft) to infinity, or 3m (10ft) to infinity. If you know your subject will be more than 3m away, choosing the more limited focus range will speed up autofocus and save vital time.

▶ When panning a fast-moving subject in low light, a touch of flash can lift the image, highlighting some sharp parts in an appealing, if unpredictable way.

▶ For blurred images in bright light you may need to use a neutral-density filter to achieve a slow enough shutter speed, even with slow film.

BEWARE!

▶ Be careful predictive autofocus doesn't track onto the ground behind a moving subject. If this is happening, don't use continuous autofocusing. Instead, autofocus on the critical point, lock focus, and be prepared to refocus if the subjects move nearer or further away. Alternatively, switch to manual focus.

▶ Autofocusing can struggle in low light or low contrast situations. If you can't lock onto your subject fast enough, be prepared to switch to manual focus.

▶ A zoom lens can make it easier to frame moving subjects, but you might forfeit shutter speed if your zoom doesn't have a large maximum aperture.

▶ Don't be tempted to force an animal into flight by deliberately scaring it. Not only is this unethical, but the animal will generally run away from you anyway, and a back view isn't much good. Wait for 'natural' disturbances – a predator, a rival, or a passing vehicle, perhaps, which may flush the subject across your field of view.

ASSIGNMENT

For this assignment your aim is to capture the spirit of a bird, or birds, in flight. First, think of a species you enjoy photographing that's easily accessible. It could be a flock of starlings that roosts near your home, a duck launching into flight over your local pond, gulls mobbing day-trippers for food at the seaside, an owl being flown to bait at your nearest falconry centre – there are lots of options.

Spend some time thinking about the species you have selected and the way it flies, asking yourself what it is you want to capture on film – is it beauty, speed, explosive energy? Are you inspired by the confused, chaotic jumble of flocking waders or a neat geometric V-formation of geese? What techniques could you use to photograph your subject, and which is most appropriate for the effect you want to achieve? Should you fill the frame with a huge flock of feral pigeons, frozen by a fast shutter speed in a hundred different poses, or single out a solitary mute swan flying low against a winter sunset? What equipment and film will you need? How close will you be able to get to your subject? Should you work from a hide, a vehicle, on foot? Is a high shutter speed essential for what you have in mind? Will you need fast film to cope with low light?

Once you've thought through your approach, get out there and have a go. Be prepared to shoot plenty of film, and perhaps try on several occasions; birds rarely perform on demand!

When you get the pictures processed, assess whether you used the best technique for the subject. Did you need a bigger lens, a faster film, more light? What will you do differently next time and what would you do with a different species?

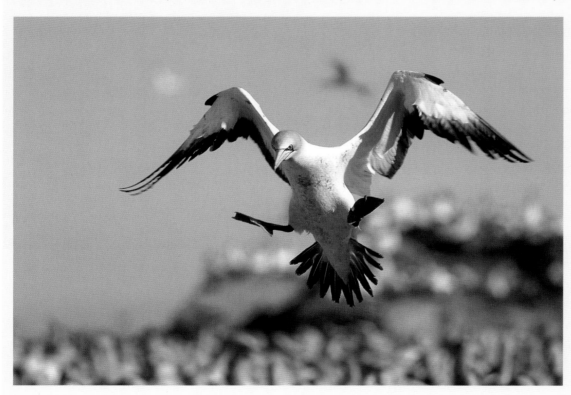

Gannet landing

Busy bird colonies offer lots of scope to practise a variety of action shots, but sometimes you simply need to be alert to something new happening. This was a grab shot – not at all planned. Keeping your camera set to its widest aperture means you can react quickly to unexpected opportunities, secure in the knowledge that you will have the fastest shutter speed possible.
Canon EOS-1N with 300mm lens, Fuji Sensia 100, 1/1000 of a second at f/4

SEE ALSO:

Sharpness, 23–29 Long Lenses, 51–57 Behaviour, 120–126

Capturing animal behaviour on film is, for us, the most exciting and rewarding type of wildlife photography. It's certainly challenging, demanding knowledge of your subject and equipment, good fieldcraft skills and, above all, bags of time and patience. Time spent observing wild animals and learning about their ecology and behaviour is surely one of the main reasons most of us got hooked on wildlife photography in the first place. For the best behaviour shots, you really need wild subjects. Zoos, sanctuaries and game ranch 'models' can only provide a limited range of opportunities or behaviour responses that are heavily controlled.

Successful photography of animal behaviour begins at home. Research is essential to put you in the right place at the right time. Books, magazines and the Internet all provide useful information on the lifestyle and location of your subjects, as can the local knowledge of conservationists, friends and even other photographers. Your own field observations can be the most help of all, so keep records of interesting behaviour you see and photograph, noting details of season, time of day and weather conditions that might help you see similar behaviour again. There's never a wasted day in the field – if the conditions don't allow you to photograph, use the opportunity to observe and learn.

Natural cycles

Photogenic behaviour is wide-ranging, including courtship and mating, raising young, feeding and drinking, defending territory, hierarchical interactions, hunting, hiding and play. These activities often follow natural cycles, whether seasonally or through the day. You can save a lot of wasted effort with a bit of prior knowledge. Many times in Africa we have passed vehicles waiting under the scorching heat of a midday sun for a pride of lions near a waterhole to move from under a bush. Inevitably it will not be until many hours later, and only a few minutes before sundown, that the animals will finally stretch, yawn, rub faces and wander down to the waterhole to drink. By this time, less experienced wildlife watchers have long since left.

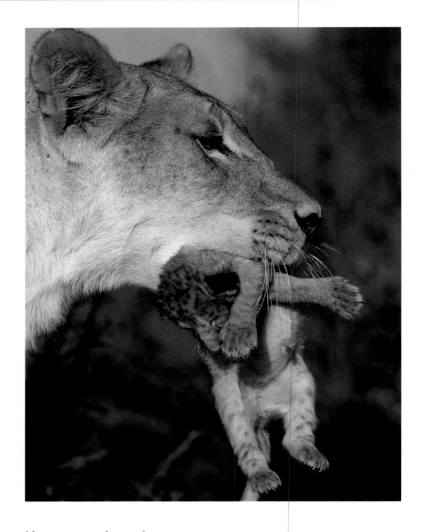

Lioness carrying cub
There's no substitute for time spent in the field if you want good behavioural shots. We spent ten days on the trail of this Kalahari lioness and her two new-born cubs, before we found her carrying this cub to a new hiding place early one morning. We kept our distance, but then she chose to walk right over to us and lead us along the jeep track for two kilometres (one mile) before disappearing into the dunes.
Canon EOS-1N with 70–200mm lens, Fuji Velvia 50 ISO, 1/200 of a second at f/5.6

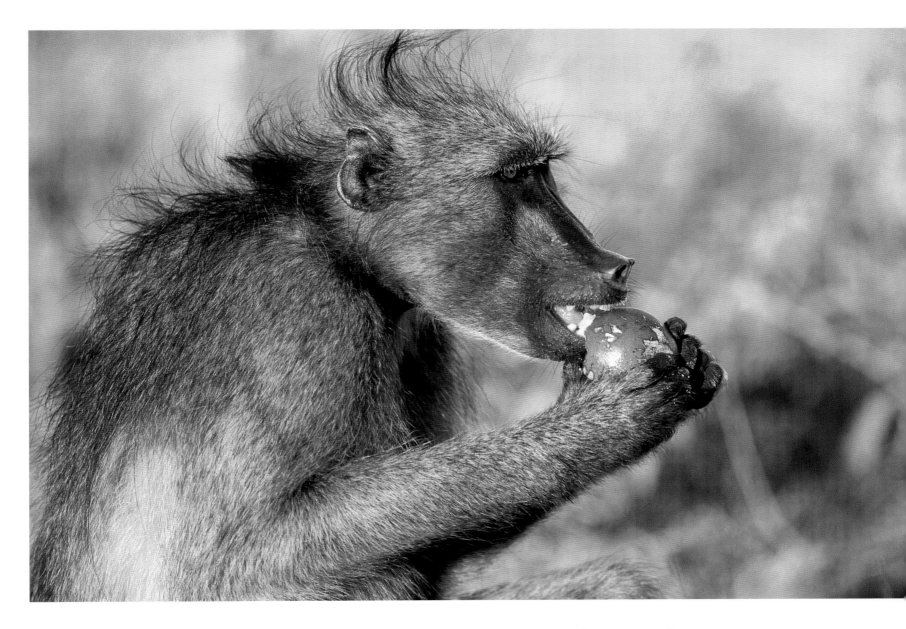

One of the big problems with photographing behaviour is that your presence interrupts or stops the piece of behaviour you hope to photograph. Most wild animals have 'fight-or-flight' circles, marking the closest you can approach before they will flee, or, rarely, attack. Long before you approach this they will be aware of you. Here's where your fieldcraft skills come in. An alert deer staring straight down your lens may be a nice portrait, but isn't much good if what you wanted was a shot of a doe feeding her fawn.

Chacma baboon eating green monkey orange
Primates make excellent subjects for behavioural shots, as they are always doing something and often exhibit anthropomorphic traits. This baboon was far too interested in his food to feel camera shy.
Canon EOS-1N with 300mm lens, Fuji Velvia 50 ISO, 1/200 of a second at f/5.6

Seasonal activities can offer opportunities to approach subjects closer than normal. In early spring, songbirds defending territories and courting females may perch prominently, singing and displaying while tolerating your presence. In the rut, stags are so preoccupied defending their harems, they may prove unusually tolerant of a close approach. At times, these situations may prove dangerous, testosterone-fuelled stags can be very aggressive to any perceived threat. Always err on the side of personal safety, respect for your subject and the rules. Landowners, conservation bodies and national park authorities often have clear parameters governing where and how far visitors can go. These are there for a reason. In other situations, experience will help you judge safe working distances – learn to recognize signs of stress, such as ground-pawing, alarm calls, facial expression and body posture.

Fighting elephants
Getting too close to your subjects can stop them doing the thing you want to photograph. In the case of fighting bull elephants it can also be dangerous, as pumped up with testosterone they can easily turn their attention on you. Having a bull elephant attempt to push our vehicle into a ditch was one experience we don't want to repeat. Show respect!
Canon EOS-1N with 300mm lens, Fuji Sensia 100 ISO, 1/400 of a second at f/8

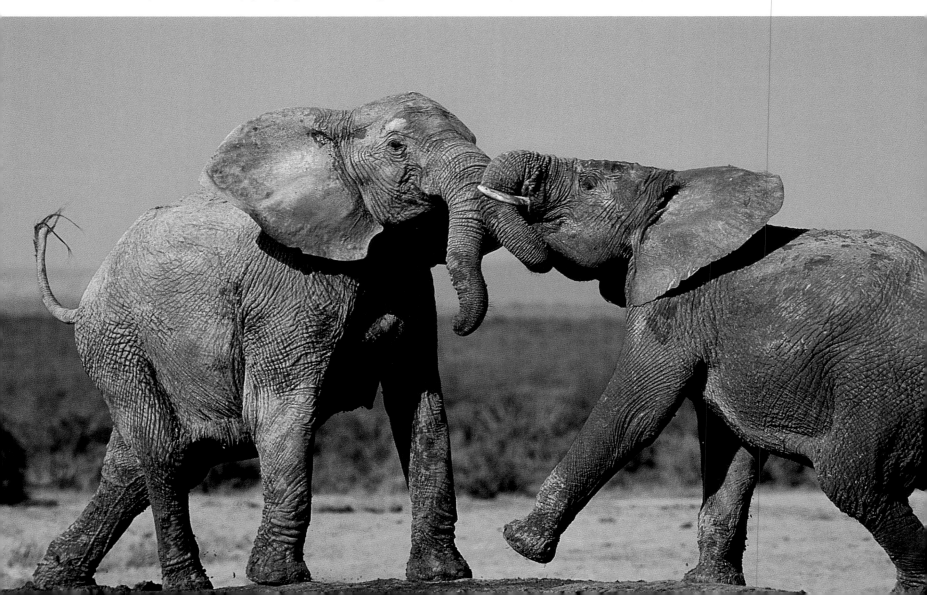

Likely locations

Feeding and watering points are great places to photograph animal behaviour. Look for animals interacting to strengthen social bonds, for tension between competing animals, and for predators seeking easy pickings. Find out the best times to be there. In seasonally dry locations, waterholes may be an excellent source of opportunities at key times, but devoid of life in the wet. A local wetland may be quiet for months until the main flurry of activity during the waterfowl breeding season. Tidal shorelines have a daily cycle, affecting not only the feeding behaviour of wading birds, but also how close you can get.

These permanent locations with predictable behaviour peaks allow you to set up a camera position in the right spot for a clear view, and in the best position for the light (usually with the sun behind you for behaviour shots). All you need to do is be patient until the wildlife start to perform. Don't fall into the trap of assuming nothing is happening if the coast is clear when you first arrive. Before you get settled, check carefully around – is there a hawk perched quietly in a tree, waiting for breakfast to fly in?

Active dens and burrows are also good sites to stake out, and may allow you to habituate animals to your presence over a period of days or weeks, so that they act naturally. Do be patient and careful though, as your own behaviour can easily cause animals to desert their young. For this reason we prefer not to photograph nesting birds, unless we are absolutely sure they are at ease with human presence, such as at well-visited seabird colonies.

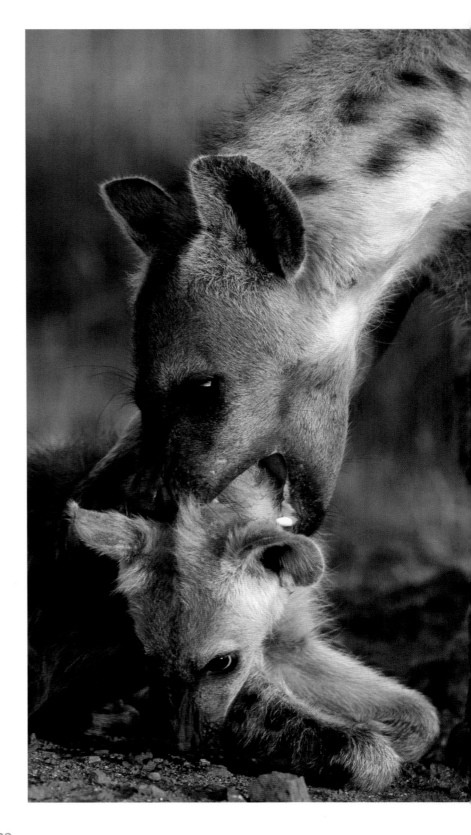

Spotted hyena playing with cub

Hyenas may have a bad reputation, but make excellent parents. Finding a clan that lived in a storm drain by a busy road, we knew our subjects would be habituated to traffic and behave naturally. Each morning the adults would return from their night's foraging to renew bonds with the young hyenas by greeting, mutual scenting and play-fighting. It's well worth photographing different aspects of an animal's behaviour, as well as just the clichéd ones.
Canon EOS-1N with 300mm lens, Fuji Sensia 100 ISO, 1/200 of a second at f/5.6

Glossy starling drinking

Common or garden animals are good subjects for behavioural shots, as they are often very tolerant and you can spend plenty of time with them. This glossy starling was photographed in a rest camp in Etosha, Namibia, a place where water is a magnet for wildlife. The photograph was taken from a raised viewpoint to ensure a clean background that didn't distract attention from the subject's behaviour.

Canon EOS-1N with 300mm lens, Fuji Sensia 100 ISO, 1/400 of a second at f/8

You can create your own hot-spots for wildlife behaviour giving yourself greater control over lighting, location and background. A bird bath in your garden, nest-boxes and a feeding station are fairly obvious ways to bring the action to your own backdoor. There's a great deal to be said for concentrating on familiar subjects, close at hand, that you can photograph regularly to improve your wildlife photography overall.

The keys to a better success rate when photographing animal behaviour are exhaustive research and prior planning. But don't expect too much too soon. As always, time and patience are your most valuable assets.

PRO TIPS

▶ Photographing animal behaviour often means keeping your eye glued to the viewfinder, but do look up occasionally and check the larger scene in case something else more interesting is about to happen.

▶ When staking out a likely location, or stalking wildlife, keep your camera switched on, with the lens you anticipate using attached, so you are ready to grab a sudden opportunity.

▶ Keep film to hand, not buried in your bag – you will inevitably need to change film in the midst of the most interesting behaviour.

▶ Carry a notebook to record details of good locations for photographing animal behaviour, including season, best times of day, lighting and so on.

▶ Make sure you label slides with detailed notes of key behaviour you've been able to document. As your portfolio grows it's easy to forget important details. For example, was a bird displaying to ward off a rival or attract a female – an important distinction if your picture might be published or put on display.

BEWARE!

▶ Young animals make appealing, active subjects. Be careful not to jeopardize their safety by separating them from parents, or attracting the attention of predators (or other people who may behave irresponsibly).

▶ In times of hardship, such as drought, food shortages, or severe weather, many animals become more approachable, but are very vulnerable to disturbance. Put animal welfare first and don't risk driving them away from essential food, water or shelter.

▶ Only bait with food or water where it will not disrupt the natural eco-system or cause possible conflict between people and animals. Many reserves and game parks forbid feeding animals, which can become aggressive and have to be destroyed. Excessive baiting can also attract predators, and cause animals to become dependent.

▶ If you photograph in zoos, be aware that captive animals often exhibit unnatural behaviour. Nonetheless, just before and during feeding times can be a good time for portraits, as animals tend to be alert and active then.

ASSIGNMENT

The most challenging way to photograph animal behaviour is trying to encapsulate the whole activity in a single image. Choose one of the following three themes to illustrate:

- Courtship
- Communication
- Competition

The task is to see how well you can convey behaviour in one frame. Be prepared to shoot a few rolls of film. Bear in mind you need a subject, or subjects, that are reasonably approachable. Read up a little about your subject and try to visualize the shot you want. A garden bird singing from a prominent perch could illustrate communication, but if it is singing to attract a female, do you need to include the second bird in the picture to turn it into an image illustrating courtship? Think about the technical issues. If you want to photograph red deer stags fighting over breeding rights in a deer park, how close can you safely approach, what lens will you need, do you need a fast film to freeze action, should you work from a hide or vehicle? Pre-planning and knowledge of your subject and location will greatly increase your chances of a successful image. After the exercise, analyze your results and evaluate how successfully you illustrated the theme. Did you capture everything you wanted in a single image? Would someone seeing this picture for the first time know exactly what was going on? Do your pictures work on an aesthetic level as well as a purely documentary one?

Australian sealions disputing territory
Working among a sealion colony can be dangerous, as the bulls are fast and aggressive. Using tripods wasn't really practical, as we needed to be able to respond instantly to sudden bouts of photogenic action – or threats to personal safety. An f/2.8 70–200mm zoom is a useful lens in this sort of situation, as it can be handheld at relatively slow shutter speeds if the light is dull.
Canon EOS-1N with 70–200mm lens, Fuji Sensia 100 ISO, 1/200 of a second at f/8

SEE ALSO:

Fieldcraft, 95–101 Movement, 114–119

WORKSHOP 5: A SENSE OF PLACE

If movement puts the 'life' into wildlife, habitat adds the 'wild' element. Photographing subjects in the context of their environment distinguishes them from captive animals in a zoo. Showing habitat has an obvious natural history value, providing information about the lifestyle of an animal and the way it fits into an eco-system. But it can also add an extra aesthetic dimension to wildlife photographs. Some of the most powerful and effective wildlife shots are those in which the animals are but a small component of a larger landscape.

Red kangaroo, South Australia

South Australia's Flinders Ranges National Park is alive with kangaroos and wallabies, and the hilly scenery cries out for environmental shots. Using a fairly long focal length lens (400mm) at range has foreshortened the scene, while careful choice of viewpoint means the lines of landscape all draw the viewer's eye to the 'roo.

Canon EOS-1N with 400mm lens, Fuji Velvia 50 ISO, 1/125 of a second at f/8

It's always tempting, but not always wise, to go for instant impact with frame-filling animal portraits every time. As wildlife photographers we spend large amounts of money on long telephoto lenses, we travel to exotic locations where we can be assured of close encounters with animals, and we invest lots of time in painstaking fieldcraft. After all that, it takes a lot of self-discipline to back off and see the bigger picture.

Certainly photographing animals in their environment isn't the easy option, nor is it merely the last resort when you don't have a big enough lens. To succeed you need to approach your subject with the eye of a landscape photographer. This means giving as much or more thought to the composition, lighting and exposure of your background as you would to your subject. Light in particular is crucial. Landscape photographers can wait all day for a brief moment of perfect light – wildlife photographers have to wait until great lighting and a good wildlife subject coincide. You will need light that complements the scene as well as the subject. While you may be able to modify available light with filters, you won't often be able to use flash for these shots.

Cape vulture, Drakensberg, South Africa
Working from a hide perched high in South Africa's Drakensberg Mountains we were able to experiment with a range of compositions for flight shots of the soaring Cape vultures. Framing the birds against the impressive mountain backdrop gave a much better sense of altitude, location and scale than similar shots composed against a blue sky.
Canon EOS-1N with 300mm IS lens, Fuji Velvia 50 ISO, 1/400 of a second at f/5.6

Linking subject to location

Just as you look for the characteristics of an animal you want
to emphasize when taking an animal portrait, consider what it
is about the animal's habitat you wish to bring out – is it scale,
harshness, colour? Is it a stark environment, or lush and fertile?
Look for a sense of scale in your images – mountain goats on
a craggy cliff can look much more effective positioned high and
small in the frame against a large rock-face, than if you zoom
in tight on them standing on a small section of boulders.

Look for ways you can illustrate how animals fit into
and utilize their habitat, rather than present them merely as
self-contained figures within a space. In what ways is your
subject specially adapted to its surroundings? The mountain
goats choose such difficult terrain because it is inaccessible
to predators. What other opportunities might a habitat present
for food, water, shelter, camouflage or cover? These are all
ways your subject can be linked to its location in your pictures.

Vast, open landscapes make excellent backdrops for
environmental images – deserts, grassland savannah, mountains
and coastline can all offer plenty of scope for interesting
compositions, with your subjects in clear view. Indeed, these are
often the habitat types that can help you to go for the bigger
picture, as a close approach to your subject can often be
problematic in open or difficult terrain. In more confined
environments, such as woodland or forest, where vegetation is
dense and backgrounds potentially cluttered, you may need to
adopt a different approach. You could look around for a clearing or
natural break in thick foliage into which your subjects might move
to feed. Alternatively, make a virtue out of necessity and show how
an animal is camouflaged and hidden by the undergrowth.

Klipspringer with starlings, Augrabies Falls, South Africa
Klipspringers are small antelope adapted to life in precarious
rocky habitats, where they are relatively safe from predators.
Using a low viewpoint and a portrait format for this image
emphasized the sense of a high, exposed cliff. The pale-winged
starlings looking for ticks were a bonus.
Canon EOS-1N with 400mm lens plus 1.4x converter,
Fuji Sensia 100 ISO, 1/400 of a second at f/8

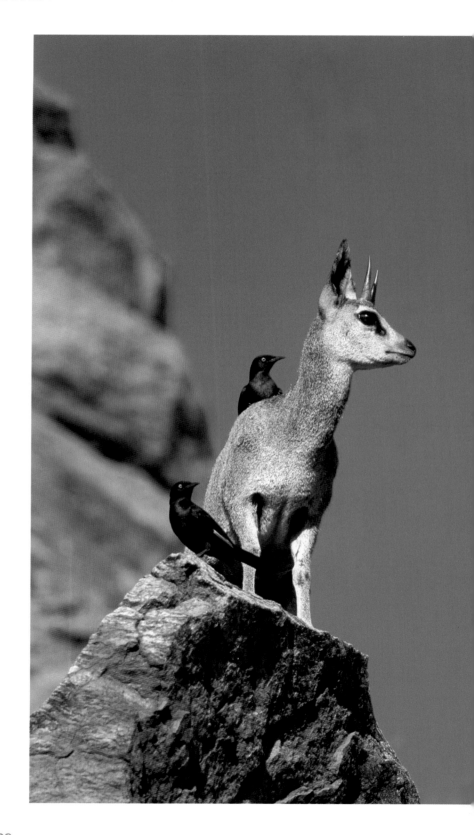

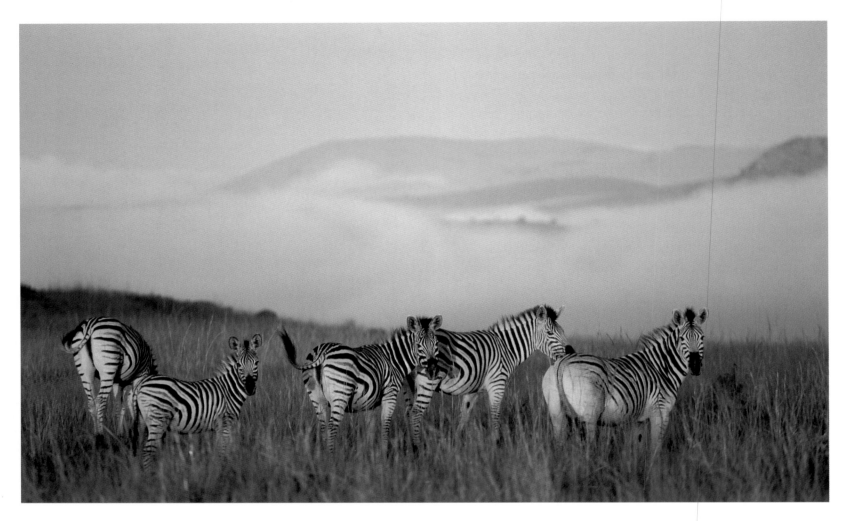

Technical considerations

Water is an important and very photogenic environment for wildlife, but comes with its own set of technical problems. Exposure can be a nightmare, with great variations in reflectivity and tone. We try to avoid metering off water itself, preferring instead to find a dry mid-tone subject from which to take a reading. A polarizing filter is also useful to remove unwanted skylight reflections from the water's surface.

A big advantage of photographing from range is that animals are less likely to be disturbed by your presence. With more time to exploit the opportunity, you can afford a more considered approach to composition and exposure considerations, and may even find time to experiment with different lenses.

Burchell's zebra, KwaZulu-Natal, South Africa
Anticipation and knowledge of your location are huge advantages when photographing animals in a landscape. We knew that in the Zululand hills the valleys are often filled with mist in the mornings, so we went out well before sunrise hoping to find a suitable subject and get in position just as the sun broke through.
Canon EOS-1N with 300mm lens, Fuji Velvia 50 ISO, 1/30 of a second at f/8

Halfmens, Namaqualand, South Africa

The Halfmens, so-named because at a distance it is said to resemble a human figure, is one of the many weird and wonderful plants of the bushman-land landscape in the Northern Cape region of South Africa. To show it in the context of its equally fascinating, photogenic and vast environment required us to use a wide-angle lens – a valuable tool that comes into its own for habitat shots.

Canon EOS-1N with 18–35mm lens, Fuji Velvia 50 ISO, 1/60 of a second at f/11

PRO TIPS

▶ Always try to include some element of an animal's habitat in your picture, even when taking close-ups. It may only be the branch a bird is perching on, or a few blades of grass around a rabbit, but it will help suggest a natural environment.

▶ A clean, frame-filling composition in perfect light may look pleasing, but this isn't always a realistic picture of how we observe an animal in the wild. Use simple compositional devices, such as photographing through foliage, to produce more natural images.

▶ At close range, a long telephoto gives you a restricted viewpoint and little depth of field. But at long range you can use telephotos to isolate interesting elements of a landscape, with a foreshortening effect on the background that can prove very effective.

▶ A background that looks cluttered at close range, such as thick foliage or rocky debris, is often less distracting from further away.

▶ When photographing animals on or at water, look for perfect reflections at first and last light, when there is no wind.

BEWARE!

▶ In a vast landscape there's a danger that a small subject can disappear. Use the conventions of good composition to help you. Placing an animal on the intersection of the thirds, for example, can help compensate where a subject is small. Look for shapes and lines that pull the viewer into the image and towards your subject.

▶ Don't assume 'landscape' photographs must be taken in a landscape format. Portrait format can also be very effective, for example, when photographing in mountain habitats to emphasize height, or with wide-angle shots showing foreground subjects against a receding backdrop.

▶ Look after your equipment when photographing on or around water, especially salt water, which is very corrosive.

ASSIGNMENT

Most of us have a favourite location for wildlife photography, a place that draws us back time and time again. Yet often our photographs don't do justice to the location as a whole, concentrating instead on a single species or just one facet of a larger eco-system. For this assignment, choose one of your favourite photographic locations, and select a species, animal or plant, which is characteristic of the location. Rather than photographing either the place or the species, the aim is to portray both in a single image. Whether it's a squirrel in woodland, a flower in a meadow, or a seal on a beach, try to find the right balance between the main subject and its environment in terms of composition and lighting.

Think carefully about your choice of lens and viewpoint, as the size of your subject in the frame and the perspective you choose is critical in achieving that balance. Do you want to suggest a struggle for survival, or perfect adaptation? Is your subject a dominant member of a natural community, or a small cog in a large machine? Pay special attention to the light and how it plays on the landscape, as this will make or break your picture – you may need several visits to achieve your goal. Assess your results. Would individual shots still work if you took out the main subject to leave just a landscape, or removed the landscape to leave just your subject? Should they?

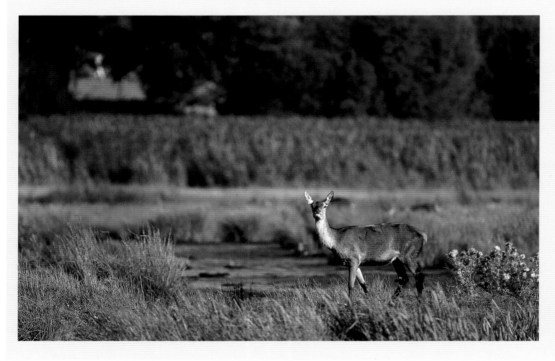

Red deer, Leighton Moss, UK
Red deer are typically depicted on exposed moors or in deer parks, but at the important wetland reserve near our home they are regularly seen among the reeds and meres. As well as taking the obvious close-up photographs, we made sure to pull back and record the larger habitat. In this shot the hind was placed on the intersection of thirds, ensuring that, while small in the picture, she doesn't disappear.
Canon EOS-1N with 300mm lens,
Fuji Velvia 50 ISO,
1/80 of a second at f/11

SEE ALSO:

A Sense of Time, 133–139

WORKSHOP 6: A SENSE OF TIME

The world of nature ticks like a clock. Life moves in cycles according to the seasons. Migrations, courtship rituals, feeding frenzies – all have their set dates on the wildlife calendar and all provide dynamic timeframes for you to capture on film.

Each timeframe is distinct, presenting the wildlife photographer with endless potential for strong documentary or artistic responses, whether photographing the dry season or the monsoon, winter's big chill or new life in spring. Life in the wild is governed by strong rhythms. Even a single 24-hour period has its own beat photographers can tap into, with animal behaviour patterns, mood and quality of light each shifting according to the time of day.

Just as a wildlife image that conveys a strong sense of place can tell us about the way animals are adapted for survival in their natural environment, so a photograph that conveys a strong sense of time can provide valuable clues about life in the wild. Whether your aim is to provide an insight into the natural history of your subjects by illustrating specific annual behaviour patterns or the effect of seasonal changes on their struggle for survival, or whether you simply wish to convey the emotions inspired by a precise time of year or a point in the life cycle, your images will have an added resonance if you are able to convey the impact of nature's rhythms on a species.

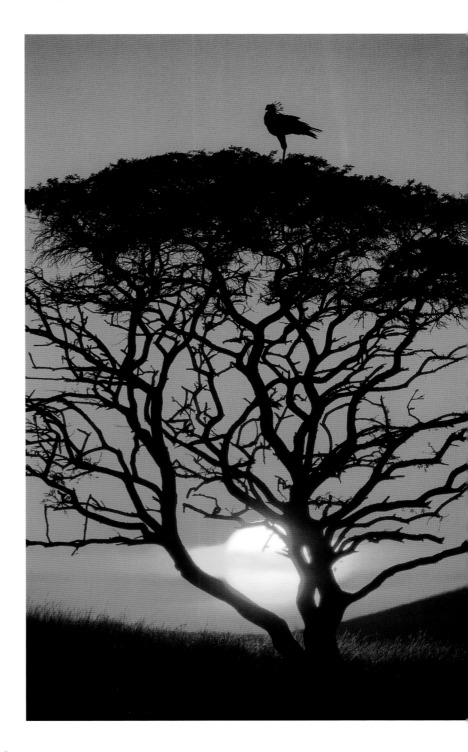

Secretarybird at sunset

Sunsets are over-photographed, but this scene of a secretarybird settling to roost at the end of the day on top of this tall tree was irresistible. The bird has an unmistakable silhouette and its distinctive head feathers are quite clear in silhouette.

Canon EOS-1N with 500mm IS lens, Fuji Sensia 100 ISO, 1/360 of a second at f/4

The wildlife calendar is full of contrasts and dramatic visual changes that you can exploit effectively in your pictures if you're prepared to take a few risks. Go out in all seasons and record on film the different responses you feel about the natural world at different times of year, not just the times of day and seasons you normally enjoy photographing.

Capturing the moment

Portraying a sense of time in your photography has a lot to do with being able to evoke the mood of the moment on film as you experienced it at the time. The effect needn't be bold, it can be quite subtle. You might choose to portray a sense of springtime in an image simply by closing in on a tight green bud to convey the idea of new life and regeneration. Or you might portray the way time seems suspended in winter by photographing the muted colours of winter wildfowl asleep on an icy pond.

You can make your pictures more evocative by capturing the changing moods at different times of day – the brooding sense of threat as dark falls and predators begin to prowl, the sense of expectancy as a new day begins, or the shimmering heat haze of midday when animals crowd thirstily at a waterhole or plod wearily in search of the shade. Include the elongated shadow of subjects in the late afternoon or use delicate rim-lighting to outline their shape towards evening, and you immediately convey a wistful sense of time's passage.

Jackal in the grass (dry season)
Jackal in the grass (wet season)

These two photographs of jackals use the same compositional device, shooting through grass to suggest the animal's furtive nature, but the two shots were taken in very different seasons. The sparse, bleached grasses in an arid dry season landscape give a totally different feel to the lush, green vegetation after good summer rains.
(dry season) Canon EOS-1N with 400mm lens, Fuji Provia 100 ISO, 1/500 of a second at f/5.6
(wet season) Canon EOS-1N with 300mm lens, Fuji Velvia 50 ISO, 1/320 of a second at f/5.6

Whooper swans in winter
Freezing winter mornings, when colour seems to have drained away from the world, provide lots of inspiration for moody and evocative pictures. The pale plumage of these resting swans was slightly underexposed to echo their monochromatic, wintry world, punctuated only by the merest hint of yellow bill and a watchful eye placed on the junction of the thirds.
Canon EOS-1N with 300mm lens plus 1.4x converter, Fuji Velvia 50 ISO, 1/100 of a second at f/5.6

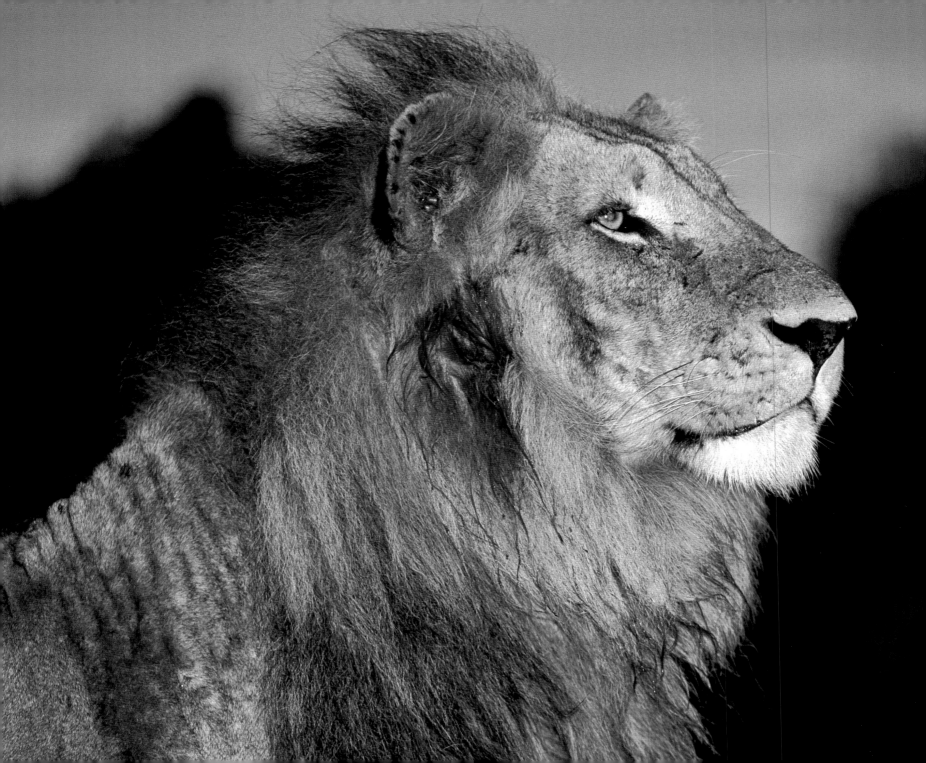

As we've seen, some of the best light for photography is to be had just after dawn and just before dusk, when a low sun provides appealing warmth and shadow detail gives images a three-dimensional quality. Wildlife is often most active and alert at these times. On cold mornings look to exploit misty conditions, as the diffused light lends an ethereal mood. Then there's the twilight time after sunset when crepuscular creatures emerge. This is when the vivid pinks and violets of the sun's afterglow can provide a rich background against which to create dramatic silhouettes. The landscape is transformed into a series of eerie shapes that can lend bold graphic elements to your work. And keep a flash unit handy for when light levels really plummet and the shadowy world of nocturnal wildlife begins to stir.

The more you go out looking with your camera, the more you'll become attuned to the pulse of the natural world and the stronger your individual creative response. Don't worry too much if your efforts to capture the changing seasons and moods of the day are clichéd to begin with – images become clichés because they resonate powerfully with people. If your work communicates the mood and sense of time you hoped to convey then your photography has been successful.

Rim-lit meerkat at dusk

Back-lighting lends mood and a sense of time to wildlife photographs. It also produces a wonderful halo of light around furry subjects. We were able to plan this shot, as we knew the meerkats would return to their den just before sundown.
Canon EOS-1N with 300mm lens, Fuji Velvia 50 ISO, 1/100 of a second at f/4

Night-patrol

We cranked up the flash output for this picture to give a nocturnal feel. It wasn't as dark as the image suggests, but using a greater proportion of flash to ambient light illuminated the lion while darkening the background.
Canon EOS-1N with 70–200mm zoom, Fuji Velvia 50 ISO, 1/60 of a second at f/11, TTL flash

PRO TIPS

▶ Keep a file divided into sections for each month of the year, into which you can archive information about seasonal subjects, along with any topical or season-specific magazine articles that might give you tips, ideas or inspiration.

▶ Exploit seasonal changes to portray wildlife in boom and bust situations, in lean times and in times of plenty.

▶ If you want to see your images published in magazines bear in mind that many titles like to be topical and pictures with a strong, seasonal element are often preferred.

▶ Save on legwork by visiting Internet sites directing you to locations where you can photograph the current season's natural highlights. It's possible to find out where to find the best autumn colour, spring wildflower displays, or largest roosts of migratory wildfowl, simply by going online.

▶ When you're photographing sunsets don't pack up and leave as soon as that fiery red ball sinks out of sight below the horizon – the twilight zone has a magical colour palette which can make for excellent photo opportunities. Use flash if necessary to light foreground subjects.

▶ Look out for possible sunset views earlier in the day – the skeletal framework of a group of trees, perhaps, where you can return at dusk to frame silhouettes.

▶ Keep your flash equipment and fast film handy when driving home at the end of a day in the field, so you're poised to get shots of nocturnal and crepuscular creatures you might encounter emerging under cover of twilight.

BEWARE!

▶ Don't miss out on the best times of days for photography. Make a note of changing sunrise and sunset times throughout the year. On summer days when the light is harsh for much of the day you need to set your alarm clock for the early hours of the morning and/or photograph quite late in the evening.

▶ Check tide times carefully if you plan to photograph coastal wildlife. Looking at the tide tables will not only help you predict the best times to photograph your chosen subjects, it can also help you stay safe.

▶ Many seasonal highlights of the natural world may be short-lived and don't coincide with the same date on the calendar every year. Be ready to exploit annual events at their peak and have a few ideas pre-visualized in your head about how you would like to record them on film.

Mallard duckling
This was the only yellow duckling in the brood. Images like this, which symbolize springtime, are always in demand.
Canon EOS-1N with 300mm lens, Fuji Velvia 50 ISO, 1/60 of a second at f/5.6

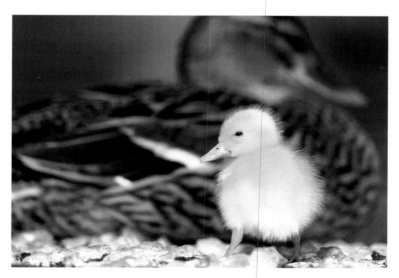

ASSIGNMENT

Photographing wildlife during a particular season of the year, at a time of day when creatures are most active or are coming to rest, or at a key stage in the life cycle, can help you to reflect the rhythms of the natural world in your work and give it variety and pace. It can also lend your images a real sense of mood. For this assignment the aim is to go out with your camera and use a roll of film to photograph one wildlife subject in a way that, for you, sums up the key qualities of the season in which you are working. Consider how all the elements of your photograph might help convey what this season means for you or the way you feel it impacts on your subject – not only time of day, weather and lighting conditions, but also viewpoint, framing, choice of film, filters, flash and exposure. Be honest about your results. Did you succeed in getting across a strong sense of the season in the way you presented the subject? Which image has the strongest mood about it and what makes it more evocative than the rest? Select the three frames you like best and identify one thing you could do to improve each. Ask yourself how you would tackle the assignment differently if you were to repeat the exercise.

Robin in the snow

Robin, snow, Christmas – a cliché for sure, but try telling that to card and calendar companies! Strong, low side-lighting helps to enhance the seasonal feel of this shot. There was no need to use a hide, as the bird was quite used to people and had clearly come to associate them with food – we used a sprinkling of birdseed to encourage it into position.
Canon EOS-1N with 400mm lens, Fuji Sensia 100 ISO, 1/200 of a second at f/8

SEE ALSO:

Exposure, 17–22 Light Direction, 59–64 Quality of Light, 65–69 Portraits, 103–108 Behaviour, 120–126

WORKSHOP 7: STORYTELLING

The language of photography is universal. Its powerful vocabulary of composition, lighting and, in many cases, colour, can be understood the world over, making photography a great medium for telling stories. 'A picture is worth a thousand words' or so the well-worn saying goes.

Every picture tells a story. In wildlife photography a single image can tell the story of a subject's appearance, lifestyle, behaviour patterns, habitat, or a unique event or episode in its life history. A thousand words of information in one frame, maybe, yet the most memorable wildlife photographs are invariably simple. Less is more.

Pare down the content of an image to the bare essentials needed to tell the story and you will communicate more powerfully with your audience. For example, a single, graphic outline of an oiled seabird washed up on the shore sums up the impact of a tanker spill on the environment succinctly and dramatically in one stark image.

Photography is about capturing a decisive moment in time, one that can never be repeated. This has a special resonance for wildlife, particularly for threatened and vanishing species. Consider how a single, iconic image of a rare or endangered species can be so effective in educating opinion and arousing public interest in conservation, for example. But to hammer home a complex message with just a single frame of film can be pretty difficult to pull off. It requires you to communicate in a very precise way, using only visual reference points. In many cases, a story is best told through a series of photographs or photo-essay.

Photo-essays

A photo-essay gives you the opportunity to tell a story in more detail. It allows you time and multiple frames to develop a theme and present an idea from a range of different angles. Whether it's a personal assignment for your own satisfaction, or a project intended for a wider audience, a photo-essay can often stimulate you to tackle new subjects and techniques in-depth, and is an excellent way to develop your photographic skill, since you will be exploring your subject at length.

Bateleur scavenging carcass

This gemsbok had been killed by lions days earlier, and the cats had abandoned it after four days. Scavenging carrion is as important as hunting for raptors surviving in this tough environment. We've observed this eagle and her mate on each of our trips over several years.
Canon EOS-1N with 400mm lens, Fuji Sensia 100, 1/320 of a second at f/8

Springbok with newly born fawn

Springbok lambs have to find their feet within minutes of birth if they are to avoid becoming cat food. This mother is still licking clean the newly born fawn even as it takes its first tottering steps. Springbok breed synchronously, with births seemingly linked to rains, so you have to be there at the right time of year to photograph the event.
Canon EOS-1N with 300mm lens, Fuji Sensia 100 ISO, 1/125 of a second at f/11

Giraffe chewing gemsbok horn

Giraffe have recently been reintroduced to the Kalahari's Kgalagadi Transfrontier Park. The parched soils are deficient in some essential minerals, so these animals are making the most of an old gemsbok carcass, taking turns to chew at the horn to extract nutrients.

Canon EOS-1N with 300mm lens, Fuji Velvia 50 ISO, 1/80 of a second at f/11

Good storytelling starts with a good idea. Wherever there is wildlife there is a natural history or an environmental story to tell. It could be as simple as recording a common species of garden bird through its spring cycle of courtship, nesting and raising young. It might be the story of how wildlife is recolonizing a tiny derelict urban area near your home, or a study of a whole eco-system, looking at the dominant and endangered species, relationships between predators and herbivores, or the impact of climate, weather, or man. The influence of mankind on the natural world, good and bad, offers endless scope for stories.

If your interest is in conservation, how about documenting the way a local reserve is managed to balance the needs of wildlife and recreation? Natural and man-made events offer rich pickings for the storytelling photographer – how does wildlife react to floods, hurricanes, water shortages or chemical spills, for example? You could document the aftermath of storm-force winds through the story of a fallen tree, showing how fungi and beetles feed off the rotting wood, how seedlings colonize the exposed ground, and how butterflies are attracted to the newly formed clearing. Your stories could even be campaigning, showing the local species that could be lost if a proposed new road got the go-ahead, for example.

Consider your audience

Research your story and plan the various aspects you wish to photograph. Drawing up a shooting list before you start is a good idea. Treat this as a guide only, however, and be prepared to respond to opportunities as they arise. Even if you start on an assignment for purely personal reasons, you may find a well-researched, topical photo-story is in demand – the local newspaper, magazine articles, lectures, campaign and publicity material for charities and conservation bodies, these are just some of the possible uses if you hit a nerve. If this is your intention, bear in mind the specific photo needs of prospective end-users when planning your shooting list – you may need to extend your research and what you photograph beyond your own personal enthusiasms.

It's a bit of an oversimplification, but wildlife photography can be broadly divided into two approaches: documentary realism and

impressionism. Don't assume the first of these is the only approach to storytelling: there's nothing that says you can't get creative as well. Since you will need to make a strong impact on the viewer, a photo-essay, whatever your style, demands a variety of compositions, content and pace, to keep your audience interested. It might help you at first to follow the example of news photojournalists, who look for three basic shots: the long shot, an establishing image which shows overall context, the relationships between subjects and scale; the medium shot, which identifies individuals within a setting; and the close-up, which shows detail and can be used for emphasis and impact. Within your photo-essay you may want a single lead shot which summarizes the story, as well as portraits, interaction, detail shots, and perhaps sequences. Try to bring out the connections between living things in your story, rather than studying one species in isolation. Use different lenses, angles of view and perspectives, searching out the most complementary treatment for each individual picture.

A photo-essay can be based on a brief event, a day visit to a nature reserve, perhaps, or on a long-term project, such as documenting the wildlife in your garden through the seasons. The images within this workshop are from an ongoing photo-essay about wildlife survival strategies in the harsh, unforgiving Kalahari Desert. This type of 'story', which includes some rarely photographed behaviour, depends on spending not just hours or days, but weeks and months in a location.

When you feel you have completed a story, ask yourself what is missing, or get a friend to tell you. The image that could turn your story into something special may well be the most difficult to obtain, but the determination to see a storytelling project through can really help you raise your photographic game.

Namaqua sandgrouse chicks drinking
Male Namaqua sandgrouse have spongy belly feathers, in which they soak up water, before flying many miles back to their thirsty chicks with the precious cargo. We felt very lucky to photograph this behaviour, but then we did spend two months camping in prime sandgrouse habitat.
Canon EOS-1N with 400mm lens, Fuji Velvia 50 ISO, 1/60 of a second at f/11

PRO TIPS

▶ In a perfect picture-story every single picture would stand alone. In practice, this isn't practical: some images will be stronger than others. Plan your shots, where possible, and keep them simple, with one idea or statement per frame.

▶ Try to imagine how a magazine editor would lay out your photographs in an article, or how you would present them as a slide show. Would they be used in a timeline, for example, to explain the chronology of a story? This can help you identify gaps in your coverage.

▶ Look out for simple, supporting images that signpost the elements of your story – an otter print on a muddy river bank for a story about healthy rivers perhaps, a sign warning tourists not to feed animals in a photo-essay about the way we treat wildlife. These won't always require a sophisticated photographic treatment, but work better if you can add an extra element such as humour or irony — a squirrel eating a nut sitting on that 'Do not feed' sign, or a road-killed fox lying next to a speed limit sign, for example.

▶ Captioning your slides and prints with detailed information is never more important than when they will be used to tell stories. Include any information relevant to the story, such as season, weather, conservation significance, as well as the usual species, behaviour and location data.

Brant's whistling rat feeding

Small rodents are a vital part of the food chain, providing food for raptors, jackals, small cats and snakes. By spending half an hour parked near a burrow each morning we were able to habituate the whistling rats to our presence, so that they soon started to behave normally and ignore us.

Canon EOS-1N with 300mm lens, Fuji Velvia 50 ISO, 1/160 of a second at f/8

BEWARE!

▶ Setting out to take a series of photographs, rather than looking for single stand-out images, can make you snap happy. Think of the last time you endured someone's holiday photos: endless repetitive images of their family posed in front of the local 'sights'. Make your photo-story assignment a considered affair, investing thought and care into the relevance of each image you take, and edit your results hard.

▶ Don't be over-optimistic about how quickly you can wrap up a photo-story. Unless you are a working to an assignment deadline, time constraints are down to you. The more time you allow, the better your results.

▶ Pictorial truth is especially important in images used to tell stories. Make sure any kind of manipulation of nature, whether it be shooting captive rather than wild animals, baiting animals in the field, using filters to adjust colour, or digitally adjusting images on a computer, does not distort the scientific truth of your picture.

ASSIGNMENT

Wildlife photography often perpetuates an unrealistic, romanticized view of an unsullied natural world, but the reality is that in today's world, the hand of man is evident everywhere. In this assignment the aim is to document the interactions between nature and mankind in a 'wild' location you know. That location could be a small local wildlife reserve, or a big national park you visit on holiday. Don't try to photograph every aspect of man and nature at the location. Instead, think of a particular aspect. You might, for example, decide to show the positive impact of man's intervention on the flora and fauna of your local reserve, with natural history photographs of vulnerable species, environmental images showing land use and physical alteration, and reportage-style shots of volunteer workers erecting nest-boxes or clearing invasive vegetation. Aim to produce a photo-essay of 12 images, remembering to include a variety of format, viewpoint, lens and light. Arrange your individual images in a structured layout or sequence to form a cohesive whole. Try showing your story to a friend for an objective critique. What have you missed out? Did you plan your coverage adequately before you started? Were you able to get all the shots you wanted? What were the problems you encountered, and how would you overcome these on another occasion?

SEE ALSO:
A Sense of Place, 127–132 A Sense of Time, 133–139

Where next?

WORKSHOP: SETTING YOUR OWN PROJECTS

Photographing wildlife is a continual learning process, comprising nine-tenths sheer frustration and one-tenth pure pleasure. But you probably already know this! There's hardly time to consider the question 'Where next?' The more wildlife photography you do, the more it seems there is to do. As soon as you've completed one project to your satisfaction, up pops another goal you want to chase, along with a growing wish-list of things you'd like to achieve or at least have a go at.

We've searched hard to find them, but there are few short cuts to success aside from practise and persistence. We have learned that the best resources you can invest for the biggest returns will be your patience and your time. At the culmination of this book we make no apologies for the fact that this is still our number one piece of advice – along with hopefully inspiring you to get out, have a go and enjoy the experience.

Even when you've mastered the basic techniques of photography and fieldcraft, and have greater confidence and control in your overall approach, there are always new challenges and directions to explore, weak spots to work on and comfort zones to break away from. The process of putting this book together and discussing, often heatedly, our own approach has certainly encouraged us to re-evaluate our

'Two's company' (II) – Slumbering rhino with oxpecker
The theme of partnerships again, here making a powerful point about scale, while illustrating the symbiotic relationship between the cheeky little birds that get a free meal in exchange for cleaning the rhino's hide of ticks and parasites.
Canon EOS-1N with 400mm lens, Fuji Velvia 50 ISO, 1/250 of a second at f/8

'Two's company' (I) – Pride members at play
Not all self-assignments have to be completed in a given timespan – many are ongoing. The theme of pairs and partnerships is one we keep returning to in our own photographs, to exploit moments that make strong connections for the viewer because of the way relationships are portrayed.
Canon EOS-1N with 400mm lens, Fuji Sensia 100 ISO, 1/180 of a second at f/5.6

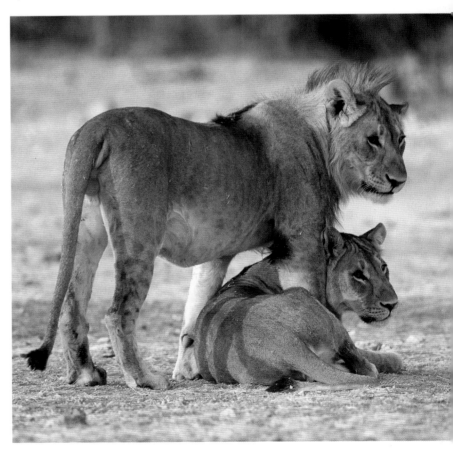

147

personal goals and review those aspects of our photography we'd like to develop or improve.

One of the best ways we've found to do this has been to set ourselves projects or assignments, rather like the ones in this book. It's much more satisfying and productive than a purely ad hoc or opportunistic approach. By setting ourselves specific photographic targets we are more committed to seeing a project through. Before we even leave the house we've spent valuable time planning, pre-visualizing shots to some degree and exploring a wide range of ideas, options and techniques aimed at getting the most from the exercise.

That's not to say we advocate a rather clinical, pre-packaged, formulaic approach to wildlife photography. Not at all. It's just as important to remain receptive and alert to where your mood or the inspiration takes you, and to the opportunities that crop up out of the blue. Careful planning and clear goals are complemented, not contradicted, by instinctive, intuitive wildlife photography.

But that's enough talk for the time being. It's time to go out and enjoy your photography!

'Two's company' (III) – Touching trunks

Young female elephants enjoy babysitting their younger siblings in practise for later life. This shot of a young elephant reassuring another with its trunk fitted the 'two's company' criterion for our running assignment about partnerships.
Canon EOS-1N with 300mm lens plus 1.4x converter, Fuji Sensia 100 ISO, 1/320 of a second at f/6.3

Red deer stag

Spending a lot of time in the African bush doesn't always leave us time to do justice to wildlife found closer to home. One of our major projects is to remedy this, and we've developed shooting lists and self-assignments to help define our approach.
Canon EOS-1N with 500mm IS lens, Fuji Velvia 50 ISO, 1/200 of a second at f/5.6

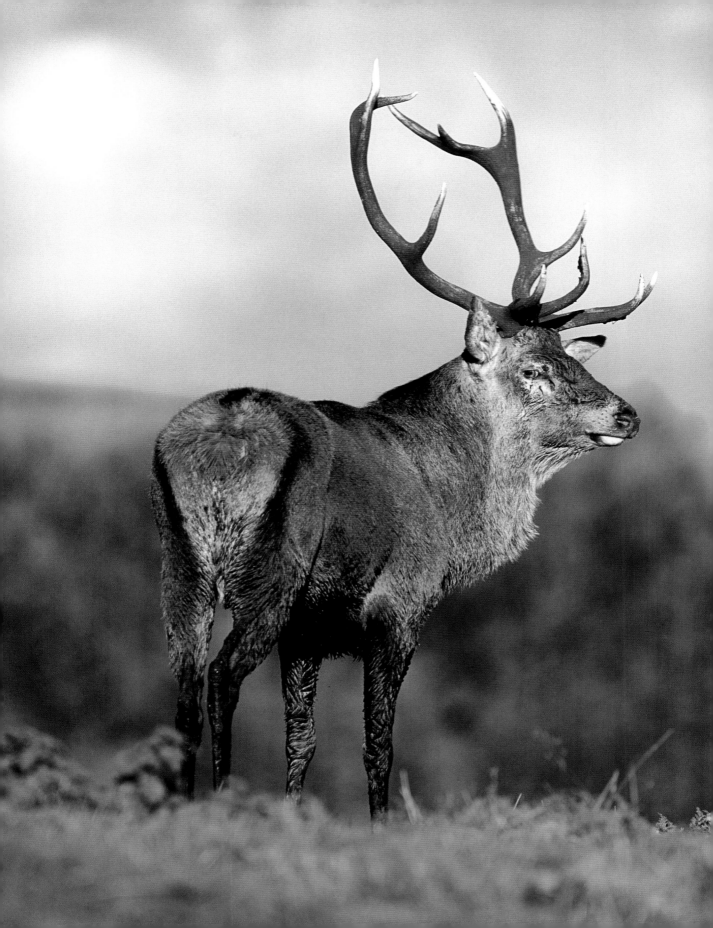

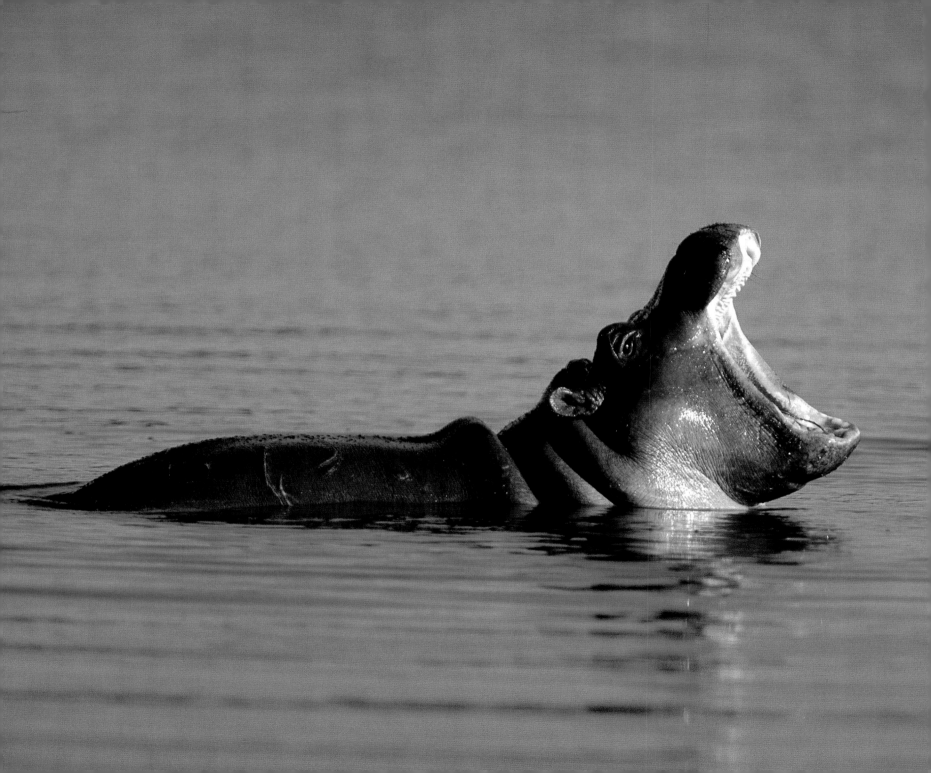

PRO TIPS

- Attend lectures and workshops given by established wildlife photographers, as this can be a great source of inspiration and useful tips.
- Visit art galleries, study coffee-table books by favourite artists, read up on the history of art, take a night class in drawing or another aspect of photography, such as studio work – anything that will help to train your visual awareness and stop you thinking in a straightjacketed way about wildlife photography.
- Watch cutting-edge natural history documentaries on television, and study how wildlife film-makers approach their work. You can learn a lot about composition, even though your own pictures are shot using a stills camera and in less exotic locations.
- Keep an ideas scrapbook for things to photograph. Include anything about places and subjects that fascinate you. Refer to it when you're in need of inspiration.
- Draw up a 'wish-list' of subjects you would like to photograph. Keep it fairly short and update it regularly – once each season is a good idea. That way you're much more likely to realize your objectives.
- For us, proceeding on a project-by-project basis, working a subject as comprehensively as possible, works better than being overly ambitious and spreading ourselves too thinly across too many tasks. But it depends on your personality. Pick a day when the weather's bad at the start of the year and list what you want to achieve in your photography in the coming 12 months. Review progress on your projects as you go.

BEWARE!

- Don't get too hung up about developing a personal style in your work. This will evolve naturally, once your interests develop and you become more experienced.
- Immerse yourself in the work of other wildlife photographers, study their pictures and deconstruct them, use them as a source of ideas, but don't set out deliberately to plagiarize their work. Use it instead as inspiration and a starting point.
- Try to avoid the clichéd approach in your work. We all resort to this more often than we perhaps should, but it's worth aiming for a fresh take when you can.
- Don't try too hard to be creative or innovative in your photography simply for the sake of it. This is hard to pull off and your images can end up looking contrived.

Young hippo 'yawning'

We particularly enjoy photographing animal behaviour, but hippos were one species of which we had poor coverage. On a recent trip to Africa we made a point of spending time at hippo pools to record a range of activity in the hippo pods we observed. It helps to draw up a shooting list of images you'd ideally like to get to plug any gaps.

Canon EOS-1N with 500mm IS lens, Fuji Velvia 50 ISO, 1/320 of a second at f/5.6

ASSIGNMENT

It's over to you for this one. Now is the time to start setting your own goals and projects. To get you started, we suggest you draw up a list of three self-contained wildlife photography projects you would like to tackle in the space of one season or a single three-month period. You could do one a month, but it might be more practical to run the three tasks consecutively. Think carefully about your choice of projects. What would prove most appropriate and rewarding for you? You could take the easy option and pick familiar subjects or techniques you know you would enjoy and find interesting, or set yourself more of a challenge – learning a technique you're not quite comfortable with, photographing a new subject, or choosing a project based on a piece of equipment you find daunting, such as flash. If you are still short of ideas, here's a list of self-assignments you could adopt or adapt:

- Design in nature
- Silhouettes
- Survival strategies
- Buds and blooms
- Garden birds
- Using fill-in flash

Consider your ideas and plan your approach carefully. Allow sufficient time (and film) to realize your goals. After three months you should have a growing portfolio of shots you are proud of, showing a development in your work and greater insight into your subjects. What's more, the exercise will probably have generated a raft of further ideas you want to take forward in your next set of projects!

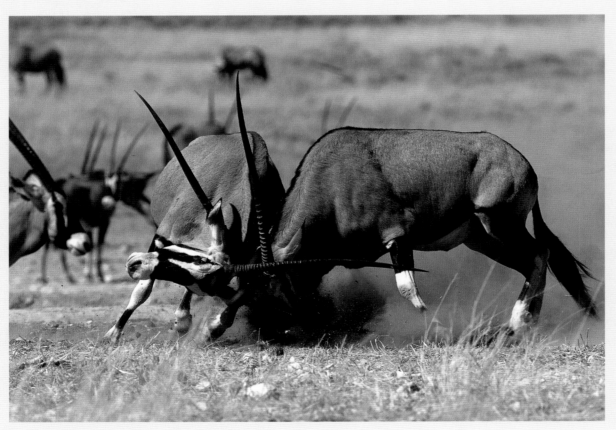

Gemsbok fighting in Etosha
This was part of a project to capture the excitement and energy of animals in action. Explosive action is not always as easy to see as you might think in nature, but you can increase your success rate by researching the times of year when specific behaviour is likely to be at a peak.
Canon EOS-1N with 400mm lens, Fuji Provia 100, 1/400 of a second at f/8

Index

TITLES AVAILABLE FROM
GMC Publications
BOOKS

WOODCARVING

Beginning Woodcarving	*GMC Publications*
Carving Architectural Detail in Wood: The Classical Tradition	
	Frederick Wilbur
Carving Birds & Beasts	*GMC Publications*
Carving the Human Figure: Studies in Wood and Stone	*Dick Onians*
Carving Nature: Wildlife Studies in Wood	*Frank Fox-Wilson*
Carving on Turning	*Chris Pye*
Celtic Carved Lovespoons: 30 Patterns	*Sharon Littley & Clive Griffin*
Decorative Woodcarving (New Edition)	*Jeremy Williams*
Elements of Woodcarving	*Chris Pye*
Essential Woodcarving Techniques	*Dick Onians*
Figure Carving in Wood: Human and Animal Forms	*Sara Wilkinson*
Lettercarving in Wood: A Practical Course	*Chris Pye*
Relief Carving in Wood: A Practical Introduction	*Chris Pye*
Woodcarving for Beginners	*GMC Publications*
Woodcarving Made Easy	*Cynthia Rogers*
Woodcarving Tools, Materials & Equipment (New Edition in 2 vols.)	
	Chris Pye

WOODTURNING

Bowl Turning Techniques Masterclass	*Tony Boase*
Chris Child's Projects for Woodturners	*Chris Child*
Contemporary Turned Wood: New Perspectives in a Rich Tradition	
	Ray Leier, Jan Peters & Kevin Wallace
Decorating Turned Wood: The Maker's Eye	*Liz & Michael O'Donnell*
Green Woodwork	*Mike Abbott*
Intermediate Woodturning Projects	*GMC Publications*
Keith Rowley's Woodturning Projects	*Keith Rowley*
Making Screw Threads in Wood	*Fred Holder*
Segmented Turning: A Complete Guide	*Ron Hampton*
Turned Boxes: 50 Designs	*Chris Stott*
Turning Green Wood	*Michael O'Donnell*
Turning Pens and Pencils	*Kip Christensen & Rex Burningham*
Woodturning: Forms and Materials	*John Hunnex*
Woodturning: A Foundation Course (New Edition)	*Keith Rowley*
Woodturning: A Fresh Approach	*Robert Chapman*
Woodturning: An Individual Approach	*Dave Regester*
Woodturning: A Source Book of Shapes	*John Hunnex*

Woodturning Masterclass	*Tony Boase*
Woodturning Techniques	*GMC Publications*

WOODWORKING

Beginning Picture Marquetry	*Lawrence Threadgold*
Celtic Carved Lovespoons: 30 Patterns	*Sharon Littley & Clive Griffin*
Celtic Woodcraft	*Glenda Bennett*
Complete Woodfinishing (Revised Edition)	*Ian Hosker*
David Charlesworth's Furniture-Making Techniques	*David Charlesworth*
David Charlesworth's Furniture-Making Techniques – Volume 2	
	David Charlesworth
Furniture-Making Projects for the Wood Craftsman	*GMC Publications*
Furniture-Making Techniques for the Wood Craftsman	*GMC Publications*
Furniture Projects with the Router	*Kevin Ley*
Furniture Restoration (Practical Crafts)	*Kevin Jan Bonner*
Furniture Restoration: A Professional at Work	*John Lloyd*
Furniture Restoration and Repair for Beginners	*Kevin Jan Bonner*
Furniture Restoration Workshop	*Kevin Jan Bonner*
Green Woodwork	*Mike Abbott*
Intarsia: 30 Patterns for the Scrollsaw	*John Everett*
Kevin Ley's Furniture Projects	*Kevin Ley*
Making Chairs and Tables – Volume 2	*GMC Publications*
Making Classic English Furniture	*Paul Richardson*
Making Heirloom Boxes	*Peter Lloyd*
Making Screw Threads in Wood	*Fred Holder*
Making Woodwork Aids and Devices	*Robert Wearing*
Mastering the Router	*Ron Fox*
Pine Furniture Projects for the Home	*Dave Mackenzie*
Router Magic: Jigs, Fixtures and Tricks to Unleash your Router's Full Potential	*Bill Hylton*
Router Projects for the Home	*GMC Publications*
Router Tips & Techniques	*Robert Wearing*
Routing: A Workshop Handbook	*Anthony Bailey*
Routing for Beginners	*Anthony Bailey*
Sharpening: The Complete Guide	*Jim Kingshott*
Space-Saving Furniture Projects	*Dave Mackenzie*
Stickmaking: A Complete Course	*Andrew Jones & Clive George*
Stickmaking Handbook	*Andrew Jones & Clive George*
Storage Projects for the Router	*GMC Publications*
Veneering: A Complete Course	*Ian Hosker*

GARDENING

PHOTOGRAPHY

ART TECHNIQUES

Oil Paintings from your Garden: A Guide for Beginners *Rachel Shirley*

VIDEOS

Drop-in and Pinstuffed Seats	*David James*
Stuffover Upholstery	*David James*
Elliptical Turning	*David Springett*
Woodturning Wizardry	*David Springett*
Turning Between Centres: The Basics	*Dennis White*
Turning Bowls	*Dennis White*
Boxes, Goblets and Screw Threads	*Dennis White*
Novelties and Projects	*Dennis White*
Classic Profiles	*Dennis White*
Twists and Advanced Turning	*Dennis White*
Sharpening the Professional Way	*Jim Kingshott*
Sharpening Turning & Carving Tools	*Jim Kingshott*
Bowl Turning	*John Jordan*
Hollow Turning	*John Jordan*
Woodturning: A Foundation Course	*Keith Rowley*
Carving a Figure: The Female Form	*Ray Gonzalez*
The Router: A Beginner's Guide	*Alan Goodsell*
The Scroll Saw: A Beginner's Guide	*John Burke*

MAGAZINES

WOODTURNING ◆ WOODCARVING ◆ FURNITURE & CABINETMAKING
THE ROUTER ◆ NEW WOODWORKING ◆ THE DOLLS' HOUSE MAGAZINE
OUTDOOR PHOTOGRAPHY ◆ BLACK & WHITE PHOTOGRAPHY
TRAVEL PHOTOGRAPHY ◆ MACHINE KNITTING NEWS
GUILD OF MASTER CRAFTSMEN NEWS

The above represents a full list of all titles currently published or scheduled to be published.
All are available direct from the Publishers or through bookshops, newsagents and specialist retailers.
To place an order, or to obtain a complete catalogue, contact:

GMC Publications,
Castle Place, 166 High Street, Lewes, East Sussex BN7 1XU United Kingdom
Tel: 01273 488005 Fax: 01273 402866
E-mail: pubs@thegmcgroup.com

Orders by credit card are accepted